MUSEUMS IN THE NEW MEDIASCAPE

Museums in the New Mediascape
Transmedia, Participation, Ethics

JENNY KIDD
Cardiff University, UK

ASHGATE

Published by
Ashgate Publishing Limited
Wey Court East
Union Road
Farnham
Surrey, GU9 7PT
England

Ashgate Publishing Company
110 Cherry Street
Suite 3-1
Burlington, VT 05401-3818
USA

www.ashgate.com

British Library Cataloguing in Publication Data
A catalogue record for this book is available from the British Library

The Library of Congress has cataloged the printed edition as follows:
Kidd, Jenny.
 Museums in the new mediascape : transmedia, participation, ethics / by Jenny Kidd.
 pages cm
 Includes bibliographical references and index.
 ISBN 978-1-4094-4299-8 (hardback) -- ISBN 978-1-4094-4300-1 (ebook) --
 ISBN 978-1-4724-0599-9 (ePub) 1. Museums--Social aspects. 2. Museums--
Technological innovations. 3. Museums--Moral and ethical aspects. 4. Interactive
multimedia. 5. Narration (Rhetoric)--Social aspects. 6. Digital media. 7. Social media.
8. Electronic games. 9. Museum visitors. 10. Participation. I. Title.

 AM7.K49 2014
 069--dc23

 2014005357

ISBN 9781409442998 (hbk)
ISBN 9781409443001 (ebk – PDF)
ISBN 9781472405999 (ebk – ePUB)

Printed in the United Kingdom by Henry Ling Limited,
at the Dorset Press, Dorchester, DT1 1HD

Contents

List of Figures and Tables *vii*
Acknowledgements *ix*

Introduction: On Museum Media 1

1 The Transmedia Museum 23

2 Museum Communications in Social Networks 41

3 User-Created Content 57

4 Democratising Narratives: Or, The Accumulation of the
 Digital Memory Archive 71

5 'Interactives' in the Social Museum 87

6 Museum Online Games as Empathetic Encounters 103

7 Mashup the Museum 117

Bibliography *135*
Index *161*

List of Figures and Tables

Figures

1.1 'Time Travellers Wanted' marketing poster from ss Great Britain
 2013. Image supplied courtesy of ss Great Britain 32
2.1 Percentage breakdown across Facebook and Twitter for each site
 in the study 46
2.2 Number of posts per site in the YouTube sample 53
3.1 *Read Aloud* (2012), Ross Phillips at the National Media Museum.
 Image courtesy of the National Media Museum, Bradford 66
5.1 Touchscreen interactive in the 'Capital Concerns' exhibition at the
 Museum of London, Galleries of Modern London. Image courtesy
 of the Museum of London 95
7.1 Michael Landy, *Saint Apollonia (de-faced)* 2013, photographic
 paper, catalogue pages on paper, 50.2 × 44.7 cm (19¾ × 17⅝ in).
 Framed. (TDA03495). Courtesy of the artist and the Thomas Dane
 Gallery, London 123
7.2 *Leda and the Marsyas*. Reproduced courtesy of the artist, Jonathan
 Monaghan 125

Tables

1.1 Sites in the sample 24
2.1 Numbers of Twitter followers and Facebook page likes for each
 of the sites in the study, as at 13 August 2013 47
2.2 Primary characteristic of posts noted in the coding process and
 presented as a frequency for both Facebook and Twitter samples 49

Acknowledgements

I owe a great debt to a number of individuals without whom this book would not have been realised. Firstly, to Daniel Meadows, who instilled in me a curiosity about, and respect for, the participatory media forms which are now so ubiquitous. Secondly, to Anthony Jackson, who provided the opportunity to continue exploring participatory cultural practice and performance whilst a Research Associate at the University of Manchester. Most recently, to Juliet Steyn, who has been a wonderful colleague and friend, for giving me the impetus to write the book proposal for what became *Museums in the New Mediascape*.

Since joining Cardiff University as a lecturer (after completing my PhD here nearly 10 years ago), I have been hugely appreciative of the space and encouragement to finish the writing of what has seemed at times an unfinishable text. The ground moves so quickly beneath our feet when we write about digital media that to try to pin it down in book format can seem daunting, at times even foolish. But, nevertheless, this is a narrative completed, and one which I hope will have relevance beyond the specific hardware and platforms it details.

Others who have had a part to play in the research endeavours recounted in this book should be thanked: Irida Ntalla, William Lyons, Sam Cairns, Amy Ryall, Megan Gooch, Joanne Sayner, Alke Groppel-Wegener and Alex Drago, who I also credit for first alerting me to the fact that the transmedia concept might have some validity in the museums context. Thanks also to the research participants who have given their time to the various studies that underpin this book. Many of the ideas and research opportunities featured in this book were seeded in projects funded by the Arts and Humanities Research Council, UK.

Dymphna Evans at Ashgate Publishing, I owe you many thanks for your support with this project, and positivity throughout its development.

To my parents, thanks for all of your help – in many manifestations – which has enabled the writing of this text. Also to my sisters, in-laws and friends for their encouragement, and many welcome distractions.

The book is dedicated to Paul, and to Harriet and Thomas, whose arrivals delayed the arrival of this text, but, I think, made it a better one.

Introduction:

On Museum Media

'The museum' in 2014 is a complex of definitional, representational, philosophical, ethical, aspirational and economical dilemmas. It is a fascinating case for the study of culture, and of 'cultures' variously defined. My areas of research interest in this field relate broadly to museum technologies, exploring the ways in which digital technologies can frustrate, and sometimes even *become*, forms of museological power. That is, I'm interested in how technologies become inscribed with authority; in certain systems, processes, uses and outcomes, and in the discourses that activate them; how they become a part of what Foucault has called an 'archaeology of knowledge' (Foucault 1969).[1]

Across the museums sector since the turn of the twenty-first century we have seen something of a colonisation of the online environment, including increasingly dynamic web portals and associated content: digital archives, social networks, blogs and online games. That activity has not previously been comprehensively framed within discourses from media and cultural studies. Eilean Hooper-Greenhill noted in 1995 that museums have historically been relatively absent from media and communication studies discourses and literature (Hooper-Greenhill 1995). This scenario has seen no great change since that time.

Nevertheless, the cultural sector has not been immune to changes in the conceptualisation of 'audience' that were long embedded in media studies by the year 2000; not least a recognition of 'active' audiences and the desire for multiplicity in representation. Since the advent of the 'new museology' in the 1970s (Vergo 1989) there had been a desire to re-script both the traditional audience/visitor encounter (most recently in terms of 'experience' and 'impacts' such as social justice and well-being), and also the demographic of that visitor, with some – limited – success.[2] In that time, conceptualisations of 'heritage' also underwent significant upheaval, with material and artefactual heritages increasingly recognised as problematic for ignoring the polysemous, contested and controversial nature of interpretation, and concerns raised about how intangible and e-tangible heritages might be curated and conserved. The authority of institutions and their monocular narratives, perhaps even their physicality, came under threat as questions were asked about the nature and

1 For more on how technologies might be understood as instruments of power, see Hecht and Thad Allen 2001.

2 Traditionally, as has been noted time and again, the museum visitor could be typified as well educated, middle class, white and, crucially, 'versed in deciphering the museum code' (Burton and Scott 2003. See also Duncan and Wallach 1980, Bennett 1995).

uses of heritage and interpretation (Hewison 1987, Smith L. 2006). This was of course potentially very challenging to organisations historically synonymous with authority, authenticity, singularity and the project of 'nation-building' (and inevitably nation-*branding*).

Accompanying these developments has run a not unrelated embrace of digital technologies in all constituencies of the museum (see Parry 2007 and the burgeoning literature within Digital Humanities which often features museums).[3] As Dewdney, Dibosa and Walsh note, 'Museum workers, like most information workers, now live and work with computers' (2013: 167). 'New' media have garnered impressive ubiquity, accessibility and familiarity for a significant majority of cultural professionals and visitors alike. Those cultural professionals daily find themselves immersed in the rhetorics of democracy, empowerment, co-production and interactivity that have accompanied that shift, and react with varying levels of enthusiasm, creativity and reflexivity.[4] Digital projects that lead to participation, immersion, experience and sociality have become currency in a cultural-professional landscape that has become more challenging still since the global economic downturn in 2008. Digital media interventions have been seen – rightly or wrongly – as vital in the race to 'prove' public worth, impact, accountability and relevance. Thus, the power and potentials that technologies have been inscribed with for the museum have been multiple.

This book unpacks and explores a number of dichotomies that help to frame and articulate digital media work in the museum: professional knowledge vs. local knowledge; morally 'good' grassroots participation vs. morally 'bad' top-down programming; the powerful vs. the powerless; 'the institution' vs. 'the community' and activity vs. passivity. I question assumptions about what constitutes 'legitimate', 'genuine' or 'authentic' participation. In current digital media practice especially, it seems, the perceived end (empowerment, openness, democracy) always justifies the means.

In this book, for the first time, questions about the museum as media are informed by literature from a number of discrete areas of study.[5] Five of the chapters are grounded in original empirical research carried out since 2010, and

3 Dalbello 2011, Berry 2012, Rosenbloom 2010.

4 See for example Boyle and Harris 2009.

5 From development studies (Cooke and Kothari 2001); museum studies (Simon 2010, Adair et al. 2011, Jones-Garmil 1997, Bennett 1995, Cameron and Kelly 2010, Kidd et al. 2014, Marstine 2011, Message 2006, Henning 2005, Rees Leahy 2012); heritage studies (Kalay et al. 2008); museum informatics (Hornecker 2008a, Hornecker and Nicol 2011, Hsi 2003, Tallon and Walker 2008, vom Lehn and Heath 2003 2005, Parry 2007, Giaccardi 2012); performance studies (Turner 1982, Goffman 1974, Schechner 1973, Jackson and Kidd 2011, Kidd 2011c 2012, Bishop 2012); art history (Rancière 2009, Bourriaud 1997, Bishop 2006); gaming literature (McGonigal 2011, Bogost 2011, Zimmerman 2004, Salen and Zimmerman 2004); media studies (McLuhan 1964, Hall 1980, Fiske 1992, Livingstone 2013, Thumim 2012, Carpentier 2011, Garde-Hansen 2011); and the study of digital media in particular (Jenkins et al. 2013, Gere 1997, Castells 2001, Manovich 2001, Gere 2002, Lessig 2004 2008, Deuze 2006).

all use a range of case studies to enable exploration of those binaries above. It will be seen that across a range of museum contexts and academic disciplines a similar story is emerging; the cultural logic is changing (Jenkins et al. 2013).

Museums Are Media Makers

Museum professionals seldom take ownership of the political, philosophical and ideological implications of their roles as media 'producers'. Yet it is becoming less contested to assert that museums are indeed media makers; scripting, editing, selecting, designing, commissioning and seeking out 'blockbusters' are now significant parts of museological practice. We might note how lighting is manipulated, audio-visual materials are created, oral histories are recorded and stories are told. As Bradburne notes, 'there are relatively few unconstructed and unmediated moments in a museum setting' (Bradburne 2008: ix). Russo extends this idea, asserting that 'the contemporary museum is a media space' (Russo 2012: 145),[6] and Henning recognises the contemporary museum as a 'hybrid space' (Henning 2006: 152) in both the functions that are performed therein and the range of technologies and display techniques that are employed on site. Lynda Kelly notes that the physical site has become only one of the spaces museums now occupy, citing the online 'world' and the 'mobile space' as significant emergent areas of operation (Kelly 2013: 54). The most prominent UK scholar on digital heritage, Ross Parry, has asserted that:

> Museums, after all, are a medium – in their most common state a unique, three dimensional, multi-sensory, social medium in which knowledge is given spatial form. However, they are also themselves *full* of media. (To McLuhan the content of one medium is always another medium). We might even go as far as to say that media define the museum. Through their histories museums have taken their varied shapes and functions from the communications technologies that they have chosen to deploy. (Parry 2007: 11)

He goes on to note that 'it will become more and more difficult to see where the museum stops and where the computer begins' (Parry 2007: 136), the computer being 'constructively disruptive' within that context (Parry 2007: 140).

Silverstone similarly asserts that the museum and media have become 'interdependent' even at the level of the 'process[es] in which each engage' and the dilemmas they face:

> Between information and entertainment (a dilemma about function); between orality and literacy (a dilemma about mediation); between fact and fantasy (a dilemma about content); between a perception of the audience as active or

6 Russo 2012 also presents a comprehensive account of museums as media.

passive (a dilemma about potential effectiveness); between myth and mimesis (a dilemma about narrative); between objectivity and ideology (a dilemma about the act of representation); between commerce and public service (a dilemma about responsibility and role). (Silverstone 1988: 231–2)

Museums thus share a raft of responsibilities with media organisations and similar concerns that will underpin, and resurface in, the discussions presented in this book.

Clearly, few museum professionals would question that they are, as Roger Silverstone noted in 1988, 'in the communication business' (Silverstone 1988: 231), a business understood by Raymond Williams as the 'transmission and reception' of 'ideas, information, and attitudes' (Williams 1962: 9). An appreciation of the communicative aspects of society is crucial to Williams, who asserted that politics and economics alone are not able to adequately define and articulate us: 'men [sic] and societies are not confined to relationships of power, property and production' (Williams 1962: 10).

Although, as Henning notes, museums have not been amongst 'the usual objects of cultural studies' or 'commonly considered as media and studied as such' (2006: 1), there is a logic and use-value in approaching them from the perspective of cultural and media studies, especially if we are interested in the communicative functions of heritage and museums. This is even more so the case if one chooses to look at the impacts and affordances of digital and now social media, and the ethics of participation. Within the media studies literature there has emerged a language and a set of methodological tools which I use in this book to explore whether it can be said a new relationship is emerging between the museum and its publics.

But museums are not just media makers; they are 'object' makers also. It is perhaps this element of materiality that differentiates them from other media makers. As Michelle Henning notes, in the very act of displaying a 'thing' in a museum context, that 'thing' is detached from its use-value and turned into an 'object' (2006: 7). Institutions are then responsible for the ways in which that object will be given meaning within the physical space of the museum and, indeed, within the space of an online collection. Layers of interpretation, and of significance, are forged in that process, during which an object also becomes 'animated' as aesthetic and auratic (Henning 2006: 18). As Shields provocatively asserts: 'If my forgeries are hung long enough in the museum, they become real' (Shields 2010: 34). This reference to the auratic turns us to Walter Benjamin's assessment of mechanical reproduction and allows us to question the extent to which the museum can ever hope to bridge the auratic gulf left by digitisation practices, or indeed, whether it should wish to do so.

The idea of the museum as media is most straightforwardly understood within the museum-communicator and visitor-recipient binary. Yet it will be seen in this book that these distinctions are becoming ever more blurred. As with talk of the producer-consumer in media and culture more broadly (the 'prosumer' or

'produser', as in Hartley et al. 2012), the visitor can no longer be understood simply as recipient, if such a passive modality was ever an accurate one. We are seeing, according to John Hartley, a shift 'from representation to productivity' (Hartley 2012: 3).

Understanding museums within the present mediascape means we have to engage with a number of claims and, over the course of the book, assess them in relation to such institutions. Firstly, that how we experience a text or cultural artefact is being remodelled in (for example) the rise of 3D technologies, wearable technologies, immersive experiences and non-linear narratives, and that such media threaten our reliance on and ability to consume 'wholes' – whole exhibitions, whole collections, whole narratives. Secondly, that our understanding of identity and community is changing. What, for example, does it mean for an institution to have 20 Facebook likes, or 20,000? Thirdly, that the ways we create, distribute, access and assess information are changing, with new ways of managing knowledge creation and information sharing; mechanisms like wikis and tagging are becoming more mainstream. This is especially challenging for museums as institutions grounded in discourses of authority and professionalism. Fourthly, that the way we organise ourselves, our communities, our politics and our culture is shifting. So, if visitors want to galvanise around an issue of concern, their capacity to do so, and to reach others, is greater than it ever has been. Groups and individuals also have a noisier mouthpiece for expressing concerns. Fifthly, as has already been noted, the roles of producer, consumer and distributor are changing; the value chain of culture is being fundamentally reworked as various practices become de-institutionalised and dis-intermediated. Sixthly, one of the more problematic claims of the new media is that they democratise access, participation and the right to representation. The ramifications of such a shift could be paradigm-shifting for institutions like museums, but we must be careful not to overplay their significance at this time.

Stogner summarises the ways in which this wider climate is impacting on user expectations of the museum experience: 'I want to be entertained / I want it now / I want it everywhere / I want it my way (personalizing, customizing, individualizing) / I want to share with others / I want to create something' (Stogner 2009). These desires and their actualisation will be variously at the centre of the chapters in this book as we explore and assess the 'momentous technological and cultural shift that is profoundly reshaping how we represent and perceive the world' (Lapenta 2011: 1), and the 'plasticity' and 'flexibility' of the very idea of the museum (Woodward 2012: 15).

The Changing Museums Context

It is well written that the origins of the current museum lie in the curiosity cabinets ('wunderkammer') recorded in paintings and engravings from the sixteenth century, and which pre-dated the opening of public collections by

more than 200 years (Bennett 1995, MacDonald 1998, Marstine 2005, Henning 2006). However, it was not until the emergence of national museums in the mid-nineteenth century that public access to museums became a realistic proposition for those outside the aristocracy (Woodward 2012). Alison Griffiths' 2008 book on the trend toward 'immersive practices' in museums and other cultural contexts, *Shivers Down Your Spine*, revisits a *Museums Journal* editorial from 1929 which perfectly exemplifies the problematic museums faced during the continued development of the 'modern' museum (Hooper-Greenhill 1992) – that is, the ongoing need to demonstrate their credentials as sites of study, but also as sites that would keep people entertained:

> A museum for study does not need to be anything else, but a museum for entertainment, or ... inspiration, does need livening up a bit. (*Museums Journal* editorial 1929 quoted in Griffiths 2008: 234)

Over the course of the twentieth century, and alongside the development of mainstream media eventually including television, museums began to acknowledge, if not embrace, their 'social relevance' (Woodward 2012: 16).

The later development of the 'new museology' from the 1970s (Vergo 1989, Assunção and Primo 2013) was characterised, although hardly universally, by 'progressive initiatives that fought for the creation of better conditions for local communities to take control of their future by means of work with heritage' (Assunção and Primo 2013: 5). It became common to talk of community museums, social development, democratisation and dialogue, or the museum as a 'contact zone' (Clifford 1997, Gere 1997, Boast 2011), one characterised by imbalance, and post-colonial at core. At one level then, led by wider social and cultural shifts and developments in scholarship, museums have became more complex sites of representation – multifarious and multifaceted.

Many museums have become more willing to talk about museological practice, and to make their processes (such as de-accessioning and discussions about repatriation) more transparent. Barbara Kirschenblatt-Gimblett has characterised this as the shift from 'an informing to a performing museology' (Kirschenblatt-Gimblett 2003), and Rees Leahy notes that this by extension 'makes the museum perform itself by making the museum *qua* museum visible to the visitor' (Rees Leahy 2012: 3). Indeed, as Henning notes, 'The museum is like a theatre' (2006: 27), although we might note one where the 'backstage' is becoming more visible all of the time (as is explored in Chapter 1).

The museum has been a ripe site for postmodern debates about simulation (Baudrillard 1981, 1983) and hyperreality (Eco 1998) to play out. Baudrillard asserts that 'Disneyland is a perfect model of all the entangled orders of simulacra' (1981: 12), its illusions and phantasms; and others have sought to extend that conceptualisation to the museum, noting that it similarly might be understood as an entanglement of significations that have little to do with any external reality.

'True', 'false', 'real' and 'imaginary' cease to be meaningful points of contrast in our present, as is usefully explored in Umberto Eco's *Travels in Hyperreality*. Indeed, the state of un-reality inscribed in the museum has been embraced by several cultural thinkers who wish to re-locate (that is locate again but in a more critical fashion) 'awe, 'wonder' and the dream potential of museums (Kavanagh 2000, but see also Henning 2006). Yet, as much as we might buy into the idea of the hypermediated museum visit, we must also not forget that, for many, museum visitation remains very much a bodily practice (Rees Leahy 2012), one occasionally characterised by discomfort and fatigue, and, according to Griffiths (2008), disorientation and confusion.

In visitation terms, we have come a long way from the guidance presented in a 1832 penny magazine that is recounted by Helen Rees Leahy in her book *Museum Bodies*: that is, that the three rules for visiting the British Museum might be best understood as 'Touch nothing', 'Do not talk loudly' and 'Be not obtrusive' (Rees Leahy 2012: 8–9). Yet Bourdieu's classic work on cultural capital (1984) and Bennett et al.'s 2009 study also indicate the continued importance of social position and cultural capital in the extent to which cultural products can be accessed by visitors: 'A work of art has meaning and interest only for someone who possesses the cultural competence, that is, the code, into which it is encoded' (Bourdieu 1984).[7] Nevertheless, audience development and outreach remain strong priorities for museums intent on widening reach, even as market forces become all the more challenging.[8]

If the rhetoric in the twenty-first century museum now speaks to social justice, value and well-being, we must remain questioning of the extent to which heritage provision should be in the service of the political agenda and associated imperatives (Boylan 1992). The move to articulate the value of heritage and museums in instrumental terms – as economic and social 'impact'– has been marked within larger political discourses that re-frame culture alongside the creative industries and associated rhetorics of innovation and entrepreneurialism, not least when it comes to the location of funds to deliver programmes and activities. As such, we often find visitors and audiences reconceptualised as 'customers', and heritage marked as little more than a 'service' or 'industry' (most famously in Hewison 1987, but see also Mastai 2007). 'Income generation' and fundraising have become top priorities, dictated by the operational realities of work in that sector (Woodward 2012), and the debate about patronage and philanthropy versus the public purse rages on (Arts and Business 2013).

7 See also Widdop and Cutts 2012, who extend this to a discussion of age, gender and ethnicity, but also geography – spatial immediacy to cultural activity.

8 Public participation in the arts data from the US National Endowment for the Arts (2013) suggests this is something of an uphill battle in the face of a decades-long and continuing decline in museum visitation. The outlook in the UK is less bleak (Arts Council England 2013).

The mediated museum needs to be understood within this wider context of the continual renegotiation of cultural value and the rise in museums scholarship, and, more recently, digital heritage scholarship.[9] Digital media are a part of that story, as the Berlin Declaration on Open Access to Knowledge in the Science and Humanities noted in 2003: 'the internet has fundamentally changed the practical and economic realities of distributing scientific knowledge and cultural heritage' (Berlin 2003). This is not seen as inevitably or universally a positive proposition; as Graham Black reminds us, the web's 'existence is a direct threat to the position museums hold as gatekeepers to and interpreters of the cultural memory of humankind', offering an 'alternative to [their] authority' (Black 2012: 6). For better or worse, this latest conception of the mediated museum has amplified the call for the metaphorical and actual 'museum without walls'.

If museums have become increasingly 'people-centred' in recent years (Hein 2000: 66), it is clearly in no small part the consequence of increased competition in the market for cultural experience, and the move toward ever more comprehensive evaluation and study of visitor 'motivations, needs and satisfactions' (Ballantyne and Uzzell 2011: 88). One of museums' key performance indicators has become visitor numbers, and this has amplified the need for such sites to trade on 'experience', whether 'media-enhanced onsite experience' or 'media-driven offsite experience' (Stogner 2009). Yet we know very little about how such 'experiences' are being, well, experienced:

> It is important to reflect on how museums, galleries and visitors have been affected from an experiential point of view: what have museums and galleries become? And what about the role of visitors? How are meaningful and rewarding experiences emerging in this context? (Ciolfi et al. 2011: 1)

According to Hilde Hein, museums increasingly look to manufacture experience (Hein 2000, 2006), later defined by Michelle Henning as 'a concept of subjective aesthetic experience' that is produced in visitors through exhibits that are 'story-centred' (Henning 2006: 91). This subjectivity is at the core of criticisms of the 'experience economy', although it is not always argued that the 'objectivity' of scientific knowledge is preferable (Steyn 2009).

If museums have become more visitor-centred, then we might also note that digital heritage has become more 'user-centred' (and here we are into important terminological distinctions which are revisited below). This, according to Ross Parry (2013), is a welcome move away from technology-centred digital heritage work. Yet Hull and Scott noted in 2013 that most museum websites still 'operate from a knowledge-telling mode ... designed via content management systems ... providing only limited opportunities for interaction or engagement with holdings'.

9 The most recent attempt to define and re-imagine the field of museum studies comes in the form of Grewcock's *Doing Museology Differently* (2014).

They go on to note that canonical categories have emerged on museum websites – 'today's events, "plan your visit", "exhibitions," "gallery talks," "memberships"' (Hull and Scott 2013: 130) – which do not emerge from user-centred design, but represent more the institutional priorities and terminologies of museums.

It is within this wider framework that the increase in media platforms' visibility within the museum can be discerned, although, as Griffiths notes, 'despite the proliferation of flat screens and computer interactives, exhibition methods as a whole have changed very little' (Griffiths 2008: 231); and Russo tends to agree in relation to social media (2011: 330). But we still know little about how and in what ways digitality impacts upon meaning-making in the museum, and, even more so, in museums' online portals:

> But do visitors 'get the texts', whether displayed on screen, written on the wall, or digitally whispered in their ear? Which texts do they understand and in what ways? What does technology add to, or take away from, the meaning-making capacity of the museum? (Bradburne 2008: xi)

And we know even less about how these compare with other forms of learning intervention (Falk and Dierking 2008: 28).

This brief overview represents the many contradictions and tensions that characterise the role of museums in the twenty-first century; as Robert Janes notes, 'museums are highly complex organisations' (Janes 2009:57). They are also caught between their innate conservatism and tradition, the 'noose of familiarity' (Janes 2009: 161) which they are often fetishised for, and the realities of museum practices and discourses in the face of scholarship and the changing political agenda which render them 'in constant motion' (Grewcock 2014: 5). As Grewcock notes and, contrary to popular belief, 'museums have never stilled or settled' (2014: 5). In light of both of these perspectives, it seems fair to assert that 'the future of museums is going to have to be invented, with courage and with difficulty' (Janes 2009: 25). Tom Fleming has put it in starker terms with his provocation to cultural institutions to 'change or die' (Fleming 2009).

Future gazing is of course a difficult – and consuming – endeavour, and not one to get distracted by; but it is worth at least referencing the work of the Center for the Future of Museums (CFM) in the United States on future trends in the museum. Their 2008 document *Museums and Society 2034* is instructive as it brings together predictions based upon demographic trends; shifts toward digital communications; growing divisions, including those facilitated by digital media and its resistance; and, lastly, the trend toward 'myCulture' (CFM 2008). The report's authors foresee changed conceptions of narrative and a concomitant creative renaissance as being at the heart of future museum practice. These have significant and far-reaching implications that will be explored in this book. It is my belief that we are already seeing the impact of these trends at times gently, but sometimes with great turbulence, impressing upon the trajectory of 'the museum'.

The 'Participation Paradigm'

> Museum making in the twenty-first century is challenging, creative, complex
> and, ultimately, collaborative. (Hourston Hanks, Hale and MacLeod 2012: xix)

At the core of this book is the story of how museums are learning to embrace
participation and what Goggin (2012: 28) has called 'generation user' (which is
not the same as embracing technology), shifting, rapidly in recent years, from the
model of the one-to-many, 'unidirectional medium' that Charlie Gere described
in 1997 (page 61). It is also the story of the emergent potential of a new kind of
public sphere that might have culture at its heart. I will address these two proposals
here, using Sonia Livingstone's critically inflected term, the 'participation
paradigm' (2013) within which to situate my own interest in 'audiences', visitors
and interaction.

Livingstone suggests that the present focus on participation in media studies
and audience research in particular is of both a 'scale and significance' that
warrants attention. She also notes that, unlike many other areas of academic
enquiry, researchers in the area of participation are enmeshed in their field of
study, as participants themselves, but also as they seek to impact on the field of
study – encouraging more and better participation, 'less exclusion' and 'more
responsive civic [and cultural] institutions' (Livingstone 2013: 24). It has yet to be
seen of course whether the 'participation paradigm' has the potential to disrupt or
replace other paradigms. Livingstone notes that at the heart of this paradigm is a
reconceptualisation of the place and extent of 'audiencing' (Fiske 1992):

> Where once, people moved in and out of their status as audiences, using media
> for specific purposes and then doing something else, being someone else, in
> our present age of continual immersion in media, we are now continually and
> unavoidably audiences at the same time as being consumers, relatives, workers,
> and – fascinating to many – citizens and publics. (Livingstone 2013: 22)

Although participation is not synonymous with increased use of media, Livingstone
notes that 'audiences are becoming more participatory, and participation is ever
more mediated' (Livingstone, 2013: 25). This has been the case in the museum also
where 'we have witnessed a dramatic rise in the number of participatory media
technologies that museums have employed to engage audiences' (Russo 2011: 327).

Participatory work undoubtedly has issues of power at its nexus (Charles 2012;
Fuchs 2014). Nico Carpentier articulates it as 'a political-ideological concept
that is intrinsically linked to power' (2011: 10). Claims made for participatory
work include repeated assertions of their radical potential for democratisation
and empowerment, and the 'desire of people to exert control over their everyday
lives' (Carpentier 2011: 15). Much has been made of the shift from 'passivity' to
'activity' in participatory culture, but these binaries have proved to be problematic.
Rancière, in his detailed appraisal of participatory art and performance, rejects the

idea that listening is a purely passive pursuit; likewise gazing, or stillness (Rancière 2009: 2). Why, he asks, should viewing be seen as the opposite of knowing, or of acting? Spectatorship, Rancière believes, is an entirely misunderstood quality. Claire Bishop claims such binaries need 'taking to task', as the building blocks of a set of unsubstantiated claims about the benefits of participation:

> To argue, in the manner of funding bodies and the advocates of collaborative art alike, that social participation is particularly suited to the task of social inclusion risks not only assuming that participants are already in a position of impotence, it even reinforces this arrangement. (Bishop 2012: 38)

Moreover, Bishop asserts, participation, rather than being oppositional to spectacle, is now 'entirely merged with it' (Bishop 2012: 277), undermining the claims to socio-political impact that might be made in its name, and investing it with the potential also to be used for commercial interests, as with other forms of spectacle (Debord 1967). Such critiques have emptied participation of some of the 'radical connotations' it had in, say, the 1960s (Mosse 2001: 17).

Nevertheless, there are those who believe passionately in the democratising potentials of 'participatory culture', best articulated by Jenkins et al. in 2006 as:

> a culture with relatively low barriers to artistic expression and civic engagement, strong support for creating and sharing one's own creations, and some type of informal mentorship whereby what is known by the most experienced is passed along to novices. A participatory culture is also one in which members believe their contributions matter, and feel some degree of social connection with one another (at the least they care what other people think about what they have created). (Jenkins et al. 2009: 3)

According to the proponents of such a view, one result of participatory culture might be an increased sense of empowerment: the 'process of change by which individuals or groups with little or no power gain the power and ability to make choices that affect their lives' (Allah Nikkhah and Redzuan 2009: 173).

Talk about participation, and its associated rhetorics, have become rife in the museums and heritage sector, but many of the problematics outlined here remain or are amplified in that context.[10] Takahisa notes that the balance of power is the elephant in the room when it comes to participatory work in museums, with questions of 'control, authority, and access' being central (Takahisa, 2011: 114; see also Lynch 2011, 2014). *The Participatory Museum*, by Nina Simon (2010), has become something of a go-to text in this area, but similarly raises questions about the potential gap between the rhetorics and realities of participatory work. Spock agrees, asking:

10 For a history of participation in the museum, see Simon 2010, Adair et al. 2011, Rees Leahy 2012.

is there something fundamentally disingenuous about museums pursuing these participatory models, if control is bound to remain the prerogative of the museum? (Spock, 2009: 9-10)

To Spock, nothing less than institutional change should be the outcome of such work (Spock, 2009: 6, and similar concerns have been raised by Bradburne 2008), a shift in attitude from doing things 'to' users to doing things 'with' them (Leadbeater 2009, Black 2012). But such a change is not always desirable, or even convenient. Issues of control and authority are at the heart of Henry Jenkins et al.'s critique of how corporate interests more broadly have responded to the rise in participatory culture:

> Some companies continue to ignore the potentials of this participatory environment, using their legal authority to constrain rather than enable grassroots participation or cutting themselves off from listening to the very audiences they wish to communicate with [as in the music industry most notably]. Worse, many marketers and media producers have embraced simplified notions for understanding these phenomena ... Ideas such as 'user-generated content' and 'branded platforms' ignore the larger history and power of participatory culture in attempting to define collaboration wholly on corporate terms. (Jenkins et al. 2013: xi).

Jenkins et al. note that Web 2.0 and its associated discourses have 'heightened expectations about shifts in the control of cultural production and distribution that companies have found hard to accommodate' (Jenkins et al. 2013: 53). Simultaneously, audiences, visitors and users remain fragmented, making it hard 'for them to fully assert and defend their own interests' (Jenkins et al. 2013: 53-4). Nonetheless, if both Jenkins et al. and Takahisa are correct, this is something the public 'is not only eager for, but is coming to expect' (Takahisa, 2011: 111).

The participatory paradigm has at its heart the notion of transaction: being a part of something, contributing, giving of your time, resources and expertise. Yet the currency in such transactions is of course rarely monetary. This is a gift economy; reciprocity, exchange, mutuality and recognition are at its core. It is, in contrast to the free market, something of a moral economy, and one that would be easily exploited. Jenkins et al. note that as more and more corporate interests enter this space, all looking to foster community and enter relationships with their users, knowledge of the norms and values of the gift economy will be paramount. Audiences will make assumptions about what they think institutions (such as museums) are doing in those spaces, and these might not always map onto the intentions of the institutions themselves.

One of the other big challenges of the participation paradigm is around the issue of access:

> the potential of digital history to cross boundaries and to open up new knowledge of the past is also obviously circumscribed both by the boundaries of language and by the 'digital divide' between rich and poor nations. (Morris-Suzuki 2005: 213)

Specifically here we should be alert to issues around access to the tools and networks of communication (mobile phones and broadband access especially), but also access to the digital literacy necessary in order to take part in a digital project, locate information online, or rip, mashup and burn. If digital is going to be an increasingly large part of the participatory paradigm, then we need to ask who it will be in the hands of, and whether it will ever represent a 'progressive model for the museum' (Gere 1997: 65). As Gere went on to note in his 1997 assessment 'Such a model is less straightforward than it might appear' (Gere 1997: 65).

If museums *can* enter such spaces, leverage their norms and galvanise an audience, and become again places of curiosity and creativity, then the 'participation paradigm' in audience research might allow us scope for imagining how the museum might be part of a cultural public sphere (to use Jim McGuigan's re-framing of Habermas' concept of the public sphere 2005, 2011) – a space to articulate and tussle with public and personal politics, and engage with their affective dimensions. Think for example of the debate around participatory programmes in 2007 for the bicentenary of the Abolition of the Slave Trade Act in the UK (see Cubitt 2012, Smith et al. 2011); the National Army Museum's 'Unseen Enemy' exhibition about the impacts and legacies of the war in Afghanistan; or the discussions about ownership and guardianship of our cultural heritage that take place daily on the Arts Council England Facebook page. In this context, participation 'no longer threatens, but has become a resource: participation has been made *valuable*' (Kelty 2013: 24).

To re-visit Sonia Livingstone's overview where in fact we started, it should be noted that although what are presented here are a number of critical stances on participation, and academics are 'often pessimistic about the outcome of participatory initiatives', it is true to say that 'they rarely argue that such efforts should not be attempted' (Livingstone 2013: 25).

Literature from other disciplines is of course also insightful here. The most useful account and critique of the shift towards participation that I have found has in fact comes from Development Studies. Cooke and Kothari, in their edited volume provocatively entitled *Participation: The New Tyranny?*, and Hickey and Mohan in their later rejoinder *Participation: From Tyranny to Transformation?* offer a comprehensive overview of what has been thought and said about participation within the challenging context of development work. Their use of the word tyranny is of course worthy of note here, and Cooke and Kothari are keen to defend it:

> The term 'tyranny' is also accurate. The arguments presented in this book collectively confirm that tyranny is both a real and a potential consequence of participatory development, counter-intuitive and contrary to its rhetoric of empowerment though this may be. (Cooke and Kothari 2001: 3)

They identify opportunities for tyrannical potential throughout participatory work: from the level of individual practitioners' operations, tools and capacity for self-reflexivity (the tyranny of decision-making and control); to the tyranny of the group or community of participants who in their dynamics and processes might

re-enforce the interests of the already powerful; to the tyranny associated with method – that participation might be driving out more efficient or effective ways of getting the job done. They also identify a tyranny at work in the larger discourse around participation. These are of course critiques that we might find echoed in research on participatory projects in the museums context if we look hard enough (most explicitly addressed in Lynch 2011, 2014). The potential for 'tyranny' is thus systemic in participatory work, and we would do well to be alive to it. Mosse has a broader concern with how participatory discourses are being actualised, noting that 'participation' itself is an ambiguous term, open to many readings, 'not a provable approach or methodology' in and of itself (2001: 32), perhaps even an 'act of faith': 'Something we believe in and rarely question' (2001: 36).

The development literature raises some questions we should wish to explore in the museums sector also. Might the 'language of empowerment' mask a 'real concern for managerialist effectiveness'? Does emphasis on the micro-level of participation 'obscure, and indeed sustain, broader macro-level inequalities and injustice'? In a nod to Foucault, we might ask, can participation be tantamount to subjugation? (Cooke and Kothari 2001: 13-14). What do we know about *why* people participate and what the dynamics of those processes look like to participants? More importantly, if we find the answers to these questions difficult to stomach, should we be prepared to abandon a project and its outcomes altogether? As Cooke and Kothari note, 'any meaningful attempt to have participatory development requires a sincere acceptance of the possibility that it should not be saved' (Cooke and Kothari 2001: 15). Finally, Mosse dares us to question whether participation is 'about making public statements and symbolizing good decision-making rather than actually influencing it' (Mosse 2001: 23).

Reflections on participatory work should thus encourage us to see the processes of the museum, and indeed of such projects, as always and inevitably political, ideological and pre-loaded.

Institutional Challenges to the Participation Paradigm

> every modern organization is in favour of cooperation; in practice, the structure
> of modern organizations inhibits it (Sennett 2013: 7)

There are many ongoing challenges to museums' articulation within the participation paradigm outlined previously (also see Pruulmann-Vengerfeldt and Runnel 2011). I overview them in brief here, and they resurface variously throughout the book.

Firstly there are a raft of challenges related to museums' ability to incorporate and make available the technical infrastructures that would enable both staff and visitors to take advantage of digital participation. For staff, firewalls, inadequate (or even non-existent) connectivity, associated costs (and the fetishisation of these costs) can all be stumbling blocks on the path to experimentation in this area. The

limitations of staff's own use of platforms, or their willingness to explore new hardware, might also be contributory factors.

For visitors on site, lack of connectivity and/or free wireless can mean that participatory projects requiring such access fall flat. It seems clear that for web-facilitated participatory work wireless access needs to be 'stable and ubiquitous' (Tallon and Walker 2008) to enable ongoing and considered involvement. There are then a number of technical issues. But there are a number of other associated challenges understood as ethical and philosophical.

There are training needs associated with working in such ways with visitors and audiences. Those working at the sharp end of project delivery have to act in a number of roles: as facilitators, experts, institutional representatives, technicians and perhaps even counsellors. This simultaneity can be intensely challenging, and raises questions about the ethics of participatory work. Training in these areas is paramount, but time for staff development is at a premium.[11]

There are also challenges associated with the kinds of participation that tend to emerge in heritage work. How, for example, might conflict and contestation be understood and managed within participatory programmes (online or offline)? Bernadette Lynch (2014) has written about the place of 'clash' in museums' collaborative work, noting that disagreement is a natural part of communication. Yet it is something museums are incredibly squeamish about. In reality, it should perhaps be the opposite outcome that is more the concern. Participatory projects are in fact more likely to have an emphasis on consensual behaviour and to lack in risk-taking. As such, participants can even end up contributing to their own continued marginalisation, as the institution's ways of working remain unchanged as a result of the 'collaboration' (Lynch 2011). A lack of specificity or thought about what the outcomes of participation might be are often reflected in the Key Performance Indicators that are associated with participatory work in museums, namely numbers of participants, and, according to Nina Simon, approval. Simon notes that this 'is not a robust value. It trivializes the mission-relevance of participation projects. If you focus solely on participation as a "fun activity," you will do a disservice both to yourself as a professional and to visitors as participants' (Simon 2010: 16). Articulating success and failure in such work is thus intensely challenging, as is building in time to reflect on the relative merits of individual approaches.

Lastly, the level of awareness on the part of museum visitors and online audiences can also be a key contributing factor in the relative success or failure of

11 The above challenges are all amply demonstrated in a 2013 report from Nesta which demonstrated that, in England, of 891 arts and cultural organisations surveyed, there were great disparities between institutions when it came to their use of, and perspective on, digital media. One notable finding was that '60 per cent of arts and cultural organisations report that they are primarily constrained in their digital activities by a lack of staff time and funding, and over 40 per cent report a lack of key technical skills such as data management' (Nesta 2013: 5).

digital participation. How to encourage onsite visitors to venture into a museum's online spaces is also an inexact science, that cross-over being hard to achieve and to quantify.

For all of these reasons, the participatory paradigm is a challenging one for museums. Yet to look at the rhetoric in the professional publications for the sector – *Museums Journal, Museum Practice* and *Museum-iD*, for example – is to see that it is one the sector is committed to.

Some Notes on Terminology

A number of terms in use here need clarification from the outset or, at the very least, acknowledging in their full complexity.

The term 'museum' is used here for pragmatic and other reasons. Pragmatically, it serves as a shorthand for talking about any non-profit institutions that, to use the International Council of Museums definition, 'acquires, conserves, researches, communicates and exhibits the tangible and intangible heritage of humanity and its environment' (ICOM 2007). 'Heritage' is then in some way implicit, although it is itself a contested term, and galleries and archives might be seen as assumed also. But more than this the notion of 'the museum' is challenged in a digital landscape where e-tangibility and virtuality feature: is the physical institution so vital to the definition of a museum? Indeed, it is not at all radical to note how those activities outlined above, from acquisition to exhibition, are undermined (or, depending on our viewpoint, democratised) by digitality. The act of curation especially has been simultaneously simplified and exaggerated in the online space, becoming a 'metaphor to characterize online identity and communicative practices' (Hull and Scott 2013: 131).

It has been noted already in this introduction that museums have undergone radical change since the advent of the new museology. This can be seen also in the attendant lexicon used in the academic field to talk about museum practice. In the 1990s museums were reconceptualised as 'contact zones' by James Clifford (1997); places of imbalance where conflict should be expected (a response to post-colonialist discourses); and as visitor-centred (recounted in Ballantyne and Uzzell 2011) or 'visitor-centric' (Stogner 2009: 390). The museum has been characterised or prophesised as 'engaging' (Black 2005), 'responsive' (Lang et al. 2006), 'wired' (Jones-Garmil 1997), 'digital' (Din and Hecht 2007), 'exploded' (Samis 2008), 'participatory' (Simon 2010), 'inclusivist' (Cameron and Kelly 2010), 'connected' ((Drotner and Schrøder, 2013), 'transformative' (Kelly L. 2013), 'relational' (Grewcock 2014) and even now 'postdigital' (Parry 2013b). It is clear that participatory practice and digitality especially have been core to recent conceptualisations of museums work, quite in opposition to the image of the traditional 'classicist' museum (Gurian 2010). Heritage institutions in the 'second museum age' (Phillips 2005) have become more networked, dialogic, reflexive and potentially radical.

But 'digital' and 'new media' require explication also, for they are not synonymous (see Deuze 2006). It is a truism that all media are 'new' at some point in their historiography, and that the rhetoric of 'newness' that accompanies digital media is misleading and often unhelpful, as Kylie Message notes: 'newness itself is always being redefined, reinvented or revitalized' (2006: 12). Computers have been around since the 1950s, the web since the early 1990s. Many 'new' media have become obsolete: CD-ROMs, minidisks and great numbers of computer consoles and handheld devices. Dewdney and Ride surmise that 'new media builds in its own redundancy' (2014: 21) and Chris and Gerstner concur saying, that 'the very concept evaporates as we write about its relationship to media' (2013: 12). New media then is not a theoretically unified category. Neither of course is 'media', speaking sometimes to technological dimensions and at other times to semiotic properties or cultural uses (Ryan 2006: xx). Talk of 'new' media would seem to lead more seamlessly (and frustratingly) into the binaries so often encountered in studies of this ilk; on the one side cyberpessimism, Ludditism and technophobia; and on the other unbounded enthusiasm, utopian visions and cyberoptimism (as identified by Charles 2012 and Goggin 2012, amongst others). Indeed, Kember and Zylinska, in their book *Life After New Media*, question whether it is time we moved 'beyond new media' and their associated fears and fascinations (Kember and Zylinska 2012: xiii).

'Digital' media can be similarly problematic, not least because here it is the technology itself that is seemingly prioritised, 'as if all digital media practice will be first and foremost about, or reflect the character of, digital technology' (Dewdney and Ride 2014: 20–21). It may of course be the other dimensions of the media that we are interested in, such as the social, environmental or cultural.

Throughout this book you will see my preference for the term 'digital' over 'new' media, but I maintain that the 'new mediascape' of the title remains significant. Firstly, I wish to blur the boundaries between the digital and non-digital (not just analogue) aspects of museums' media 'work' in order to present such institutions as media-makers in the broadest possible sense – including, where necessary, as print publishers and broadcasters (for example). As such, it is a part of a wider media ecology that includes mainstream media also, and that is changing daily. Secondly, as Arjun Appadurai notes, the notion of a 'mediascape' allows for a consideration of 'the electronic capabilities to produce and disseminate information', but also 'to the images of the world created by these media' (1996: 35). This reminds us again that there are issues of representation at stake here; the images of the world circulated within the mediascape by institutions such as museums are loaded – with mythology, ideology and, on occasion, intent. They are also, of course, in the 'new' mediascape, often produced and circulated by audiences themselves as self-representations (Thumim 2012).

It is in the realm of the audience-visitor that we meet our most challenging site of definition. We might note that, in the museum, the term 'visitor' is increasingly problematic; those accessing museum services (sometimes exclusively online) might be more readily understood as audiences, users and co-producers of heritage

narratives, even authors. This is intensely challenging to the traditional ordered, authored and pre-scripted understanding of the museum, and what Tony Bennett has called the 'exhibitionary complex' (Bennett 1995). It is also challenging to the perception, which at times still prevails, that a group can be known and made sense of as if it were a 'large, many-headed thing with fixed habits' (Williams 1976: 106). To view any group of 'users', 'visitors' or 'audience members' as a unified concept denies the propensity for 'growth and change' over time which is rife in the sociology of communications (Williams 1976: 107).

With a background in media scholarship, 'audience' is a term I feel most at ease with (despite its troubled past in that discipline detailed in Brooker and Jermyn (2003), Roddick (2001) and Livingstone (2005); but 'visitor' has a (deceptively perhaps) clear function as pertains to museum activities, in the physical realm most notably. 'User' seems to have a clear use-value in those instances where a museum's content is being accessed unwittingly, or with pure 'utilitarian and consumer orientation' (O'Flynn 2012: 144);[12] and 'participant' has differing connotations again, indicating a not inconsequential commitment on the part of the individual to give of themselves in some way for a cause (more often than not) directed by the institution. You will find all of these words used here, although not interchangeably. I am live to their differences, and employ them knowingly, noting Sonia Livingstone's caution in relation to terminology in this landscape:

> Given the mediation (or increasing mediatization; Hepp, 2013) of everything, we should ask not only, 'What is the audience?' but also 'When is it useful and interesting to refer to people as audiences?' (Livingstone, 2013: 27)

What This Book Is Not

This book is not written as a handbook to help museums leverage digital media and associated platforms. Rather, it is a critically inflected and empirically grounded overview of current practice in the new museumscape. That said, it is inevitably limited in its capacity to draw upon and recognise international museum practice in this area beyond those examples that are very visible or commented upon in the literature and professional print output. This reflects the author's limitations rather than a lack of innovative or ethically practised work in other contexts. Similarly, it draws exclusively on English-language literature beyond those cultural theorists whose work has been translated.

This volume also steers clear of a deterministic outlook which holds that technology itself is driving change in the various contexts that appear in this book: social, cultural or institutional. The idea that technology itself has an autonomy and shapes history has been largely abandoned, replaced with a far more nuanced

12 'Users' is also a term at times prioritised by Graham Black in his assessment of visitor engagement 'from visitor to user' (Black 2012: 17).

conception of 'reciprocity at work' (Karaganis 2007: 9). A crass technological determinism would here be reductionist and, worse, seem to absolve cultural professionals of the responsibility to shape, test, rework and think in reflexive terms about their capacity and drive for ethical practice in this area. As Charlie Gere asserts, 'the relationship between technology and culture is subtle and complex' and must be understood as such (Gere 1997: 59); and, as Dewdney et al. remind us, 'tools are fashioned by humans for human purposes and hence culturally code the limits as well as possibilities of their use' (2013: 195).

That said, there is inevitably a distinct emphasis, even in the structuring of the book, on certain technologies and platforms; social media, online games and interactives in particular are dealt with discretely in dedicated chapters. This is a consequence of the organising logics of research design: the need to compare like with like; to build robust and defensible samples; to perform content and other analyses; and, wherever possible, to move beyond the anecdotal. I hope, however, that the book reads as more than the sum of its parts, using a robust evidence base, a broad theoretical underpinning and numerous case studies to reveal a larger picture of many of those who work in museums fundamentally re-scripting their roles and their relationships with users, often with considerable personal resource investment (not least time, and in buying kit which doesn't always come with the job). This larger picture of a connected, vital, proactive and creative workforce has a shelf life that extends beyond that of much of the software and hardware featured in this book.

Some Notes on the Approach and an Overview of Structure

The epistemological bases of this book have been informed and negotiated through detailed empirical study in the cultural sector for more than a decade. Much of what will be presented is 'grounded' in mixed-method research design and analysis, allowing for detailed study of the social and organisational processes that we find at the heart of the museum. This has included the use of a variety of research methods, from discourse analysis and content analysis to large questionnaire surveys, interviews and observations. The grounded theory approach used here should be understood as constructivist (Thornberg and Charmaz 2012) and reflexive; implicating your author-host and her reflections in the interpretations of reality that are presented here. The arguments presented in each of the chapters are progressed by drawing on core cultural and critical thinkers whose work has helped frame the arguments therein.

This book naturally touches on the works of a range of key thinkers in culture and society, employing them to help interrogate practice as it is being framed and articulated within professional discourses, or as it is being understood in the academy. There are few surprises here, representing the continuation of a critical discourse as has been most comprehensively outlined by Henning in her text *Museums, Media and Cultural Theory* (2006).

The chapters attempt to trace a logical path through the multiple and changing terrain of museum media. Each chapter explores a discernible research question (or number of questions) and utilises a befitting analytical and methodological framework which will be elucidated in depth at the start of each, but that are briefly introduced here. The broad approach is socio-technical, activating cultural theory to provide a hermeneutical understanding.

Chapter 1 is on face value perhaps the most radical presented in this volume. It employs recent scholarship from media and communications studies to try to understand the museum as a transmedia text. Consequently, museum knowledge(s) become understood as distributed, co-located, pervasive, granulated, disintermediated, immersive, playful and intrinsically unfinished. I propose that this is not a new phenomenon so much as a bolder and potentially more coherent way of articulating, and arguing for, the museum as multiply situated within the new media ecology. It employs Henry Jenkins' conception of 'transmedia' to outline a possible framework for this articulation, and re-visits models of constructivist learning. It also engages with criticisms of the 'experience economy' that resurface in such a proposition.

Chapter 2 focuses more specifically on the nature and use-value of social media communications for the museum. It presents findings from an analysis of 20 museums' social media output and the conversations facilitated therein. It critically engages with claims that have been made since the dawn of Web 2.0 that social media might facilitate a re-imagination of the public sphere.

Chapter 3 looks at user-created content in particular, informing a discussion of ethics in such practice with a look at how user-generated content has been understood as an intervention in mainstream media and journalistic practice. This chapter also utilises scholarship on alternative media as a framework for understanding what is possible within the cultural landscape when the tools of production become ubiquitous. Chapter 4 then looks at calls to participation that result in digital memory practices. Here, theories of autobiographical, topographical and flashbulb memory are used to exemplify the range of memory practices that are activated in digital heritage practice. This chapter also questions the extent to which the accumulated memory archive that results from such practice has a use-value that is discernible by institutions themselves, and what the ramifications might be if that proves not to be the case.

Chapter 5 takes an in-depth look at one of the more familiar media platforms encountered on a museum visit in 2014. An 'interactive' has become a catch-all term for a range of activities that might be found onsite, but it is screen- and projection-based digital interactives that are the focus here. Literature on computer interactives is reviewed, before findings from a large-scale audience case study are presented that demonstrate the ways in which such interactions are changing – most notably in recognising and embracing sociality within the space of the museum.

The penultimate chapter takes as its focus museum online games: casual games commissioned by museums and hosted on their websites, or distributed via social

media. This chapter raises questions about the extent to which learning, including empathetic engagement, is activated in the online space. It uses gaming theory to explore the realm of what is possible in this regard, and to highlight some key ethical questions that are ripe for further exploration.

Chapter 7 consolidates many of the discussions in those preceding it to present a case for the museum as a remix. It uses literature from media and communications studies to explore the ethical, cultural, technological and legal implications of that proposition, and revisits Walter Benjamin's theories of reproduction. This closing chapter acknowledges that museums exist within a landscape – and sometime market – for content, and raises again the prospect of a museum 'user' as hunter-gatherer: often strategic, openly creative and full of ideas for (if not respect for the integrity of) a museum's multiple fragments. It ends with a number of case studies indicating that museums are becoming more responsive to the desire of audiences to reuse, re-skin and re-vision the museum archive.

In sum, the narrative that is presented in this book is a conflicted one: of playfulness and simultaneous wariness, externality and internality of vision; of letting go and clinging on; of narrative and incoherence; of participation and exploitation; of memory and forgetting. It is also a book about media literacy, and perhaps digital literacy in particular – inescapable currencies in the museum where 'the presence of digital technology ... is both pervasive and permanent' (Thomas 2007: 6).

Chapter 1
The Transmedia Museum

An artistic movement, albeit an organic and as-yet-unstated one is forming. What are its key components? A deliberate unartiness: 'raw' material, seemingly unprocessed, unfiltered, uncensored, and unprofessional. (What, in the last half century, has been more influential than Abraham Zapruder's 8-mm film of the Kennedy assassination?) Randomness, openness to accident and serendipity, spontaneity; artistic risk, emotional urgency and intensity, reader/viewer participation … plasticity of form, pointillism, criticism as autobiography; self-reflexivity, self-ethnography, anthropological autobiography, a blurring (to the point of invisibility) of any distinction between fiction and nonfiction: The lure and blur of the real. (Shields 2010: 5)

The book begins with a provocation on the future of museum narratives in a world where media are becoming pervasive, ubiquitous and storified. As David Shields asserts, this is a landscape where reality and engagement with form and content are being redefined and re-imagined. It is landscape where increasingly the museum cannot be contained within walls or within dedicated websites; where visitors 'read' and interpret the museum at the same time as the museum 'reads' and interprets the visitor (for example through their 'data' and demographics); where the notion of a comprehensive, complete and 'satisfying' museum encounter begins to lose its appeal in favour of museum experiences that challenge, fragment and spill over into the everyday; and where the museum as a *story*teller and maker is itself foregrounded and problematised. This chapter uses the notion of *transmedia* to try to understand these changes.

Transmedia storytelling broadly relates to the extension of narrative across multiple platforms, and the implication of a 'user' in calling that narrative forth from a multitude of entry points – in diverse spaces and in varying states of 'completion'. It is proposed in this chapter that the museum, and historical narratives more broadly, might be easily understood as (already often) transmediated. The stories museums tell – through exhibitions and their associated interactions, performances, workshops, online web portals and micro-sites; social networks, digital archives and games – create webs of engagements and interactions which are variously and incompletely accessed in the decoding, or indeed creation, of meaning by users.

This chapter seeks to explore what the implications of understanding the museum as a transmedia text might be. It is not my intention to suggest that this is a dramatic new way of presenting the museum 'text'. Rather, I seek to render transmediation a visible, and consequently more active, articulation and manifestation of practice.

The chapter offers a definition and discussion of transmedia, and an overview of its potential use-value in museum contexts, before going on to present four characteristics that may be of use here. I wish not to present a distinct taxonomy,

Table 1.1 Sites in the sample

	History Museum	Maritime	Military	Art Museum	Science and Industry	Historic Site	Archives with exhibitions
National / Sponsored	National Football Museum, Manchester / People's History Museum, Manchester	National Waterfront Museum, Swansea	National Army Museum, London	National Gallery, London / Tate Britain, London	Museum of Science and Industry, Manchester	Big Pit, Blaenavon	British Library, London
Council / Charity / Trust	Birmingham Museum and Art Gallery / M-Shed, Bristol / The Cardiff Story, Cardiff / New Walk Museum, Leicester	ss Great Britain, Bristol / Titanic Belfast	Imperial War Museum – Churchill War Rooms, London	The Hepworth, Wakefield	Magna Science Centre, Rotherham	Historic Royal Palaces –The Tower of London	Wellcome Collection, London

seeing such a thing as incongruous with the realities of transmedial practices. Rather, the characteristics present a means of exploring what is currently happening in the realm of museum media, and offering a language for extending into more radical conceptions of such modes of interaction in the future. They are both preliminary and extensible.

These characteristics have emerged from a detailed study of the various outputs (online and offline) of 20 museums in the UK. This focus on the United Kingdom has been necessary in order to allow for site visits and repeat visits. The sample for analysis has been chosen to exemplify (not represent) a number of broad distinctions in museum typology, and with a view to representing both national museums and smaller regional and commercial ventures (see Table 1.1).

Observations from site visits and associated media (including interactives, audio-visual presentations, performances and audio guides) were gathered, alongside a detailed audit and content analysis of various online outputs. These included the institutions' current website offerings (general information, digital archives, interactives, education pages, policy documentation), apps, social media content (more in Chapter 2), memes and contributions to larger initiatives such as Google Art project[1] and Europeana.[2] In sum, a detailed and robust representation of each site and its mediation was analysed.

The initial intention was to explore the relationship between online and on-site content, with a working hypothesis that these distinctions were beginning to collapse, ceasing to be meaningful as the boundaries of both become more porous (Dicks 2003, Farman 2012). This may well be true, but in the analysis the online–offline framework proved reductionist in the extreme. A more elaborate picture emerged, one that required a holistic and more thorough appraisal of each of the cases, and the adoption of a new theoretical model to account for their subtleties and peculiarities. It is my contention that 'transmedia' allows for this as a far more nuanced framework than the online–offline distinction.

Defining Transmedia

The noted communications scholar Henry Jenkins is credited with recognising and categorising what were then emergent modes of cross-platform storytelling as 'transmedia', proposing that some narratives are 'so large' they 'cannot be covered in a single medium' (Jenkins 2006: 95).[3] Similarly, to Pratten, telling stories across

1 http://www.google.com/culturalinstitute/project/art-project [Accessed 12 July 2013].

2 http://www.europeana.eu/ [Accessed 12 July 2013].

3 In 2007 Jenkins used the example of *The Matrix*, which presented key fragments of information across three films, two collections of comic books, animated shorts and a number of video games (Jenkins 2007). Other examples include *Doctor Who*, the *Star Wars* franchise and, more recently, the elaborate marketing campaigns for the *Halo* games

multiple media works 'because no single media satisfies our curiosity or our lifestyle' (Pratten 2011: 3).[4]

Using multiple media platforms simultaneously, transmedia storytelling thus allows for differing entry points for audiences; varying and contrasting perspectives on the action to be offered; and, crucially, opens up opportunities for play. In this conception, narratives can be fruitfully and engagingly told through continuation, experience and participation, relaxing the boundaries between online and offline, audience and producer, even truth and fiction. Such narratives, although to a point constructed, implicate the audience in their telling – challenging them, acknowledging and problematising their agency and making them work in order to piece together meaning. To Jenkins, 'dispersal', 'agency' and cross-fertilisation are at the heart of transmedia activity (2010). What we are left with is 'a diversity of media complicating and complimenting one another' (Clarke 2013: 209).

These are 'emergent forms of storytelling which tap into the flow of content across media and the networking of fan response' (Jenkins 2011). In its utilisation in the traditional media landscape, transmedia has most often been used as a way of offering or filling in a film or television series' backstory: mapping complex narrative universes (through for example multiple fictional websites); offering additional character's perspectives on the story (through, say, their blogs or Twitter feeds); and deepening audience engagement through various means (Jenkins 2011). Transmedia has also been seen as a way of building communities around content: communities interested in 'cognitive investment', experimentation and play (Ryan 2013).[5]

This is a notion of storytelling that has gained ground in recent years in talk about distributed narratives (Walker 2004), deep media (Rose 2011), networked narrative (Zapp 2004) and transmedia practice (Dena 2009).[6] Jenkins has taken some issue with the ways in which his idea of transmedia storytelling has been applied (perhaps most problematically as branding and marketing activity), but has in recent years sought to apply it in differing contexts himself: to politics, in overviewing the Obama campaign (Jenkins 2009); and perhaps most notably for us in his discussion of transmedia education (2010). In this context:

> students need to actively seek out content through a hunting and gathering process
> which leads them across multiple media platforms. Students have to decide whether

(I Love Bees), *Batman* (especially the 'Why So Serious?' campaign) and *Prometheus*. In-depth information about these can be found with a quick online search.

4 See also Suzanne Scott (2013) on transmedia.

5 There are many examples of transmedia storytelling that can be found using a simple search online, but most noted examples include the activities around the *Heroes* and *Lost* series, the 'Why So Serious?' campaign and the ongoing transmedia universe that has been created in the UK around the *Doctor Who* franchise. Rose (2011) provides a detailed history of some high-profile examples. See also Clarke 2013.

6 See also O'Flynn (2012) on transmedia documentary, Perryman (2008) and Coleman (2012).

what they find belongs to the same story and world as other elements. They have to weigh the reliability of information that emerges in different contexts. No two people will find the same content and so they end up needing to compare notes and pool knowledge with others. (Jenkins 2010)

I want to suggest that this mode of enquiry, sociality and play might be increasingly characterising engagement in the mediated museum, and that notions of transmedia could help us understand how best museum narratives are being constructed, accessed and experienced in the twenty-first century museum. I wish not to suggest that this is a purely digital phenomenon; indeed, there have been museum exhibitions that we might conceive of as transmedial in previous manifestations of the museum. Rather, this chapter explores the ways in which that trend is magnified in the 'connected' museum and how, increasingly, visitors come with expectations of the museum as embedded and implicated in historical and institutional narratives that implicate, and go beyond, the institutions that they knowingly visit either virtually or physically. I suggest that 'radical intertextuality and multimodality for the purposes of additive comprehension' (Jenkins 2011), so important in transmedia storytelling, are fast becoming the norm in the museum where 'the story we construct depends on which media extensions we draw upon' (Jenkins 2011; see also Voigts and Nicklas 2013: 141).

Jenkins' concept of transmedia utilises seven core concepts that inform the analysis and discussion in this chapter: Spreadability/Drillability, or the boundless capacity for building content across a landscape, and people's ability to drill ever deeper and deeper into that content; Continuity/Multiplicity, or the use of and adherence to a canon versus the capacity of media to tell multiple versions of stories from differing perspectives; Immersion/Extractability, or the ability of audiences to immerse themselves in narratives, but then to extract elements of it that inspire and 'deploy' them in the everyday spaces of their lives; Worldbuilding, the capacity of multiple media to extend narratives into whole worlds of enquiry; Seriality, the 'meaningful chunking and dispersal' of narrative into multiple, perhaps infinite, discrete chunks; Subjectivity, seeing through new eyes and 'breaking out of historical biases' and then being implicated in the telling; and, lastly, creating a part for themselves in the narrative through Performance. Here, the audience becomes '*visibly present and identifiable* in the universe of the tale' (Giovagnoli 2011: 18) at the same time as the author/creator loses their visibility 'in order to consider – from the beginning – the WHAT and HOW of the tale as a function of the audience, more than the creator' (Giovagnoli 2011: 19). According to Jenkins, the public act as 'hunters and gatherers, chasing down bits of the story across media channels' (Jenkins 2006: 21). This, I contend, is something the museum visitor already does, and heritage 'makers' could more creatively and readily acknowledge.

As has been noted in the Introduction, it is recognised that the museum visit is increasingly a mediated one: 'connected', 'networked' and 'participatory'. Consequently, the boundaries of the museum visit become unclear. When does a museum visit start? When, indeed, does it stop? (Samis 2008: 3). How do visitors

distinguish between the different forms of information that they 'consume' on a visit (whether online or offline), the different voices that they find therein, or the different modes of address: the official and authoritative, the playful, or the voices of the other visitors? How do visitors conceive of themselves as implicated in the museum narrative: when posting their photos during a visit or when pinning a piece of content for later? How do search engines, museum websites, performances on site, interactive exhibits or artworks, QR codes, apps, the exhibition catalogue, the site map or the museum shop and its wares help to construct or complicate the narrative of a visit? Jason Farman notes that 'locating one's self simultaneously in digital space and in material space has become an everyday action for many people (Farman 2012: 17). So are visitors even conscious of those distinctions?

This is an area of museum enquiry that has gathered pace in recent years, but we still have very little understanding of how the museum experience, and museum-facilitated learning, operates within and across the different constituencies of the museum. As Lynda Kelly asks, 'How are museums relating the physical objects on display with deep, rich information available across a range of online platforms, including mobile?' (Kelly 2013: 62–3). Indeed, this nod to the physicality of the museum and its collections reminds us also to look at the visit as a bodily practice, as Helen Rees Leahy notes:

> the eye of the practised museum spectator is always embodied within a repertoire of actions that reflect and respond to the space of display, the conditions of viewing and the presence of other spectators. (Rees Leahy 2012: 3–4)

We might ask, how can the online visit similarly be understood as embodied?[78]

It is in consideration of such questions that the notion of transmedia, with its understanding of the visitor as hunter-gatherer, becomes so seductive, not least because it accords with recent conceptions of museum learning as constructivist, inquiry-led, lifelong, contextual and often informal. In 2008, John Falk and Lynn Dierking, eminent scholars in the fields of visitor studies and museum learning, appraised their findings about visitor expectations as follows: firstly, that 'the best museum is the one that presents a variety of interesting material and experiences that appeal to different age groups, educational levels, personal interests, and technical levels'; secondly, they noted that 'visitors expect to be mentally, and perhaps physically, engaged in some way by what they see and do … they expect to be able to personally connect in some way with the objects, ideas, and experiences provided'; thirdly, that visitors 'expect to enjoy a shared experience, as the

7 Jason Farman argues that 'connecting with the computer is an extremely embodied experience' (2012: 17).

8 We still know relatively little about the online museum visitor experience. Fantoni says, in relation to the Indianapolis Museum of Art, that 'very little is known about this audience: who they are, why they come to our website, how they engage with the site, and what experiences they might take away from their visit' (Fantoni et al. 2012).

members of the group with their varying interests and backgrounds collaborate and converse together' (Falk and Dierking 2008). In this assessment, 'the best' on-site museum experiences emerge as embodied, immersive, social, inquisitive, collaborative, challenging and experiential. They utilise a variety of media, at different levels, with varying entry points. In short, Falk and Dierking go some way towards envisaging the transmedia museum.

What Is a Museum Narrative?

In the 2008 Center for the Future of Museums report, which projects into the 2030s to imagine the museum of the future, the authors assert that 'For most adults over the age of 30, "narrative" is a passive experience ... For Americans under 30, there's an emerging structural shift in which consumers increasingly drive narrative' (CFM 2008: 17). They go on to predict that 'Over time, museum audiences are likely to expect to be part of the narrative experience at museums' (CFM 2008: 18). I don't disagree with these bold and far-reaching statements, but they do demand closer scrutiny.

The previous discussion of transmedia made use of literature that has been produced almost exclusively to elucidate emerging practice in the realm of the fictive arts, including but not limited to television series, computer games and big-budget films. Yet I maintain they are a useful way of thinking about the 'narratives' produced across museum sites: the stories they tell about pasts, communities, nation, place, individuals, identity and our potential futures, but also about the more mundane and technical aspects of our lives. I wish not to contend that museums are in the business of presenting grand narratives of truth about the world, Message's 'monumentalizing narrative' (2006: 28), believing we have moved far beyond such a conception of the museum. Rather, I hold that museum narratives are multiple, incongruous and overlapping, far from ready-made, complete or perfect, and that they are accessed variously and partially in a number of locations.

This is not so contentious if one looks at the literature emerging, increasingly in recent years, which indicates a creeping recognition of a narrative turn in the museum (Kelly 2010b, Rowe et al. 2002, Chan 2012, Henning 2006, Ross 2013). Ross Parry notes that 'museums have tended to resist a fictive tradition that has been a strong part of their (pre-web) history' (2013a: 18). He goes on to assert that:

This is a fictive tradition of using artifice (alongside the original), the illusory (amidst the evidenced), and make-believe (betwixt the authenticated). These are the well-established curatorial techniques of imitation (showing and using copies), illustration (conveying ideas without objects), immersion (framing concepts in theatrical and performative ways), and irony (speaking figuratively, or even presenting something knowingly wrong for effect). (Parry 2013a: 18)

We should note that all forms of history have faced the fictionalising charge in recent years, as Munslow notes, 'history does not … just tell stories about the past, it is itself a storied form of knowledge' (Munslow 2007: 17) which has now been 'destabilised' (Walkowitz and Knauer 2009: 4). Shields asserts that history became 'human, personal, full of concrete detail, and had all the suspense of a magazine serial. The techniques of fiction infected history' (Shields 2010: 13). That should not be cause for alarm in the light of research demonstrating the positive impact of narrative on learning processes (Frykman 2009 looks at the evidence). As Silverstone noted in the 1980s, just as museums produce narratives, so too do museum visitors:

> visitors … fit their experience of the exhibition into their own experiences of everyday life, and in so doing construct, as bricoleurs, their own fragmentary, but meaningful, rhetorics and narratives from the materials which confront them. (Silverstone 1988: 235)[9]

These are their sometimes complementary and sometimes conflicting 'ways of knowing' about the world (Rowe et al. 2002: 98). Continued realisation of this fact and fear about its complex implications are at the heart of the museums' embrace of participation and user-created content recounted in this book.

The Museum as Transmedia

Brunel's ss Great Britain, Bristol, UK – one of the case study sites reported in this chapter – makes for an interesting introduction to the idea of the transmedia museum. It is not known for dynamic or cutting-edge displays on site; indeed, the exhibitions in the main museum were installed in 2005 and are now the subject of an appeal for donations. Yet, it emerged in the study as a site particularly adept at what we might term transmedia storytelling in the heritage context.

The SS Great Britain is moored in a dry dock in Bristol (the Great Western Dockyard), having returned from the Falkland Islands in 1970. 'She' was opened to the public in 2005 as 'the ship that changed the world' (ss Great Britain home page).[10] There are in total eight distinct areas to the physical museum, including a shop, café, and the Brunel Institute (conservation facility and library). Unlike other sites in the study, there has been limited capital investment on site in recent years, and the digital displays are limited, although playful. In the Dockyard Museum visitors can take part in an interactive game steering the ship; they can use manual interactives to turn the ship's impressive turbine; dress up in Victorian-era clothing and be photographed (and are encouraged to post photos on the ship's Facebook page or other social media); and watch audio-visual displays, including a 15-minute

9 I return to the notion of bricolage in Chapter 7.
10 http://www.ssgreatbritain.org [Accessed 13 June 2013].

animation voiced by the people of Bristol.[11] In the dockyard, visitors can descend 'under the sea', walking the length of the dry dock and getting a sense of the scale of the conservation endeavour, the illusion of immersion completed as water flows on transparent Perspex overhead and the sun's rays refract and bend through the water. On the ship itself, visitors can choose to pick up a free audio guide and explore on one of four narrative settings, ranging from first-class passenger through to the ship's cat. Here, they are encouraged to smell the smells and witness the tribulations of life during a voyage. Visitors receive their own passenger 'ticket' which they can have stamped (for repeat entry over 12 months), an artefactual legacy of their visit, with added use-value. The site leaflet[12] includes a QR code, prompts to follow, comment on and share via social media and TripAdvisor, and a map featuring animated drawings of drama unfolding on the dock.

Multiple media are therefore employed and referenced on site, and different modes of experience, moving between online and offline, encouraged.

In the online space, ss Great Britain occupies a dynamic and growing web presence (especially in the most recent manifestation launched March 2012), which extends fairly seamlessly into the social media space with regular posts and conversations with visitors via Facebook and Twitter (see Chapter 2). The website includes the usual visiting, contact and corporate information, and a link to a 'nautical' gift shop. The site is designed to resemble a newspaper from the era of Isambard Kingdom Brunel's Bristol, with a series of archival images from the collection occupying the background. 'The Story' (as it is termed) unfurls via a variety of mediations, including a blog; a timeline featuring links to archival materials; a written history of Brunel's life and work; and other interactive features (including a number of games, completion of which can earn you 10 per cent off an entrance ticket).[13] There are also a number of extracts from passengers' diaries that can be accessed here, and visitors can sign up to an e-newsletter.

July 2013 saw the launch of an ambitious new publicity campaign that foregrounded aspects of experience even over and above the name of the site (see Figure 1.1). Visitors are offered the chance to 'explore', to perform and to become immersed – to play along. We can see from the posters that the website has become a key mechanism of communication.

The launch was accompanied by a call via the blog to keep an eye out for posters and to record their sightings – and responses to them – via social media.

11 'The Incredible Journey' documents the return to Bristol of the SS Great Britain and its installation in the Dry Dock. The film is also available on the museum's website and via YouTube.

12 Available at http://www.ssgreatbritain.org/sites/default/files/kcfinder/files/visit/visitor-leaflet.pdf [Accessed 6 August 2013].

13 Including 'Full Steam Ahead' at http://www.ssgreatbritain.org/full-steam-ahead. The game has been created by ss Great Britain, the Science Museum and Aardman Animations (based in Bristol) and encourages users to enter a 'virtual world'. The game won the 2013 TIGA Games Industry award for 'Best Game with a Purpose' (see Chapter 6 for more on online games).

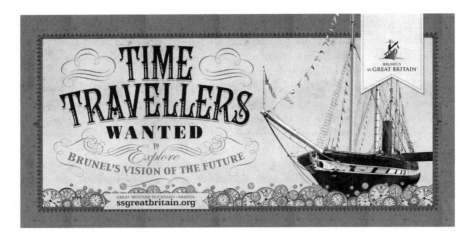

Figure 1.1 **'Time Travellers Wanted' marketing poster from ss Great Britain 2013. Image supplied courtesy of ss Great Britain**

On YouTube, the site's channel features nine videos including information about the Schools and Museums project and a number of very playful initiatives: one a Mr Brunel competition in a local shopping centre, and another a version of the now infamous Harlem Shake featuring 'Mr Brunel' himself.

The organisation has a number of stories to tell that might be variously accessed (or not) by visitors across this range of media: Brunel's achievement in creating the ship; life aboard ship in Victorian times; the SS Great Britain's return to Bristol; its conservation; and its relationship with the people of that city. Visitors to the ship, and to the website, may be interested in all aspects of that narrative, or only in part. Already we see that the narratives and experiences visitors leave with may be partial, and contingent on a range of factors the museum staff can only begin to control.

The broader point demonstrated in this overview of the ss Great Britain offer is not that visitors *must* be able, or motivated, to access the staggering wealth of content available in these differing locations. Rather, it is that there are different narratives on offer departing from users' varying points of interest, modes of learning and their normative patterns of media consumption, and that these impact on the stories visitors construct and take away. This is not new. Some visitors would never volunteer to sit and watch a performance in a heritage context, pay to see a 4D film in an on-site IMAX, or fork out for a guidebook for instance, just as some visitors will never send a tweet during a site visit, might bypass screen-based interactives entirely or avoid reading a text-heavy (or even text-lite) interpretive panel. Some might opt to access additional content via their smartphones, online search tools or books available on site (or accompanying them in their bags). People's experiences of a site narrative are then *already* contingent on a range and

combination of mediations and encounters that cannot be controlled, and that offer possibilities for multiple interpretations. Their entry points are already different. The museum encounter is indeed already, and increasingly, transmediated. In this content landscape the 'hunter-gatherer' is rewarded.

Brunel's ss Great Britain and the other 19 museums and galleries in the study all to varying degrees display four characteristics that we might consider central to the transmedia museum: co-location and pervasiveness; granularity; incompletion; immersion and playfulness. The following overviews use cases from the museum sample to demonstrate each of the characteristics.

The Transmedia Museums Is ... Pervasive and Co-Located

As noted previously, it might be said that the exclusivity of online and offline is beginning to collapse as some museological output becomes pervasive, spreading through groups of people and across platforms: think for example of the use of QR codes to direct people to related online content within the spaces of institutions (seen most elaborately in the sample at the National Waterfront Museum); the encouragement to share responses during a visit via Twitter or Facebook (as at the British Library), or to download an app, as is encouraged in the move toward free wifi connection services at a number of sites in the study. This can also be seen in the on-site collation of a personal online archive to be accessed and maintained online at a later date (as possible at the Museum of Science and Industry).[14] This synergy is also seen in the recreation of on-site experiences online; in the mapping of the web space to reflect the on-site journey (as on the Titanic Belfast website); in the categorisation and mapping of the digital archive (for example Rhagor, the National Museum Wales online archive); or in audio-visual tours of sites available online (Tate Britain has a number of these on YouTube).

The pervasive potentials of museum narratives are of course amplified when one considers the prevalence of mobile 'smart' phones with third- and fourth-generation connectivity, and their potential for disruption. As Howard Rheingold foretold with great clarity in his 2002 text *Smart Mobs*, 'Mobile Internet, when it really arrives, will not be just a way to do old things while moving. It will be a way to do things that couldn't be done before' (Rheingold 2002: xiv).

Co-location recognises the spatial elements of both the online and offline offer, and notes the ways in which their simultaneity is becoming unremarkable; but, more than this, it recognises that the spaces and places occupied by museums are also themselves occupied by other (related, but also often unrelated) activities, institutions, individuals and fragments of historical narrative. The museum increasingly exists in the same spaces as other media, other museums and other content and 'experience' providers. In flickr, Historypin, Europeana or the Google Art Project (for example) a museum's content is only one click away from the content of other museums or organisations, or from content uploaded by visitors

14 Or at the Darwin Centre, Natural History Museum, for example.

(Løvlie 2011). Lest we forget, this is a landscape where *who* is speaking in one's Twitter feed, and what their agenda is, can oftentimes be virtually indiscernible.

This co-location is significant for a number of reasons, most notably because it magnifies the propensity for the museum narrative to be porous, indistinct, multiply situated and partially consumed. Co-location thus offers challenges – how to make yourself heard and how to distinguish your offer from others; but it has its advantages also. Occupying other spaces allows for a scaling up of a museum's offer in ways that are accessible to those sites' users, thus potentially widening reach; and the value of these sites acting as hosts, backing up content, saving on costs and being available 24/7, which clearly on-site facilities rarely are, should not be underestimated. There is also a clear value, for users at least, in being able to move laterally across content rather than having to go to each provider separately: for example, if I am interested in van Gogh's paintings rather than in the National Gallery's collection *per se*, or the history of the Tudors rather than the broad pasts of the Tower of London. This kind of intertextuality can be incredibly valuable, and is increasingly a feature of the landscape as visitors to sites use their smartphones to source backup materials and access different kinds of experiences during a visit (see Fusion 2012 for example).[15] As Bradburne notes:

> Communication tools such as the iPod and Web-enabled mobile phones, which let users augment gallery visits with off-site 'unauthorized' video and audio content, mean the museum spaces are being opened – willingly or not – to voices other than those of the curators. These days, the motivated visitor can arguably reconfigure a gallery visit to meet his or her own specific needs – with or without the museums help. (Bradburne 2008: x)

True transmedia storytelling encourages content providers to recognise the norms of these differing spaces and making the conscious decision to work with(in) those norms. So, the norms of the space of heritage performance differ from the norms or languages associated with the social media space. The way a user is spoken to via an audio guide will necessarily be different to the way they are approached via a text panel or a touchscreen interface. The medium matters because it articulates a series of frames within which visitors organise their expectations and experiences, both on site and in the online spaces within

15 The research reveals the numbers of people now accessing the V&A website from mobile phones, and two-thirds of visitors carry a smartphone in their pockets. One-third of V&A visitors own a tablet (Fusion 2012). Historic Royal Palaces (HRP) have carried out such research also; hence a move to court the mobile visitor – on and off site. In 2013, Kidd and another researcher, Irida Ntalla, carried out similar research at the Tower of London to build a picture of the relationship between online and offline, finding that younger visitor groups especially might be engaged in many different forms of online activity whilst on site, and that a majority of visitors asked had smartphones at their disposal.

which a museum's varying narratives unfurl; and museums do well to recognise and operate within these frames (Kidd 2011a).

Giovagnoli notes that 'telling stories that are distributed on multiple media is like creating a new geography of the tale' (Giovagnoli 2011:16). This new geography can be difficult to map, let alone to control in any meaningful sense, and might necessitate a relaxing of traditional structures of control over mine/ yours, beginning/end and even fact/fiction.[16]

The Transmedia Museum Is ... Granular

Museum encounters are at times seemingly linear, scripted and inflexible, with little or no multimedia provision. Nevertheless, they are still inevitably the summation of 'bits': of material 'evidence'; textual interpretations (panels, printed brochures, catalogues and signage); and encounters with others (museum personnel, other visitors, family, friends). In that sense, the museum has always been characterised by granularity. This characteristic is however amplified and embraced in the transmedia museum.

Granularity has been a feature of content production and dissemination in the digital environment for some time; think for example of book, magazine and newspaper content which is fragmented to be consumed in 'chunks', at different price points and often on demand. It is a way of talking about the distribution of content across different platforms and formats, recognising that the needs and desires of audiences as related to content can differ wildly.

Granular content, especially that which is made, or born, digital, can be flexible and portable. It can be cheaper to produce and distribute and bypass traditional value chains and mechanisms, disaggregated and disintermediated. It might be said that learning is becoming more granular also, as demonstrated in the rise of Massive Open Online Courses (MOOCs) and modular learning models representing a threat to, and opening up of, traditional learning establishments and their processes. In relation to the museum, we might note that this accords with recent understandings of learning as constructivist and learner-led.

So, we might see a museum's narrative fragmented and reconstituted across multiple sites and through multiple perspectives. It is then left to the visitor/user to piece together a discernible narrative (or indeed, otherwise). At the Cardiff Story, granularity is embraced as a means of displaying multiple responses to fragments of artefactual heritage, with visitors being able to access one, or all, of those interpretations via text and audio. At the National Army Museum, soldiers' stories of encounters with improvised explosive devices (IEDs) in Afghanistan

16 This was explored very explicitly in the 2013 Victoria and Albert exhibition 'Memory Palace' which, in partnership with Sky Arts Ignition, brought together a new fictional text by Hari Kunzru with 20 commissioned art installations by graphic designers, illustrators and typographers. It is designed to be 'a walk-in book', experiential, participatory and emotionally arresting.

are accessible in part or in their entirety through iPads in the exhibition. At the Hepworth Wakefield, the People's History Museum and the Magna Science Adventure Centre relevant books are left out for visitors to peruse at their leisure. At the National Waterfront Museum touchscreens are used to tell stories about objects, but the objects themselves can only be seen by opening the drawers below. Fragments of meaning can thus be accessed through a variety of means and in varying juxtapositions, rather than core pieces of content being reproduced intact and *ad infinitum* across different platforms.

In this sense then, the museum encounter – online, offline, on social media, infiltrated by other media texts and historical narratives – becomes somewhat serendipitous and characterised by chance (Løvlie 2011). This can be a useful mechanism for motivating enquiry, moving the visitor from the known to the unknown, the everyday to the unusual, and from the mundane to the harrowing. In the National Football Museum for example one suddenly encounters an installation about the 1989 Hillsborough disaster in Sheffield, all the more moving for its being a point of relative silence within the noisy communications of the wider exhibitions.

Serendipity, losing one's way, encountering conflicting versions of events and not expecting them to be reconciled, even unexpected unsurprise – all are the possible consequences of granularity.

The Transmedia Museum Is ... an Unfinished Work

Understanding the museum as a transmedia storyteller invokes a number of user practices we might deem agentic and participatory. Here, visitors are implicated in the construction of a text; without them, it remains meaningless. The turn of the twenty-first century saw a shift in the museological discourse toward interactivity, participation and access in the museum. As outlined in the Introduction, this shift is more than mere semantics.

Transmedia texts are, by their very nature, continuous and incomplete. As the points of access differ for users in different spaces, the start and end points might vary wildly, and the route the narrative takes is up for grabs throughout. Whereas the traditional museum encounter began at the front door or enquiry desk, now it might begin online, in the museum's visitor information pages or on a site like TripAdvisor. Of course, it might not be a physical visit at all, beginning and ending in the online space, with sojourns into social networks, search facilities and wikis en route. All of these experiences affect the meaning of the 'visit', and the interpretation and understanding of museological knowledge.

The museum as an unfinished work is now acknowledged and sometimes playfully worked with in the spaces of the museum. At the National Football Museum, the visitor looks in through a glass panel at a mocked-up curator's office, and is subtly asked to consider museological practice. In the People's History Museum, visitors can watch the conservators at work, in the act of simultaneously editing and constructing history. The museum becomes implicated very explicitly

in the narratives that are being constructed, and the ongoing nature of history 'making' is evident. Museum blogs similarly give insights into museum processes and procedures, and for the Birmingham Museum and Art Gallery, a host of YouTube videos detail the ongoing work of the conservators.[17] At the Cardiff Story, there is an open call for members of the public to get in touch and to donate items to the collection. The fact that the museum is actively collecting shapes and frames the way they talk about what they do and the way they approach the audience. At the National Gallery an installation encourages visitors to take part in the active destruction and devaluation of the artworks (see Chapter 7).

My own research with museum professionals has noted an increased reflexivity in museum practice (Kidd 2011b); they are acutely aware of the charges against the museums' fictive agents, the fact that the stories they tell are constructs and that the collections themselves deal only with versions of the truth, or create their own truths. It might be said that the museum has become more playful in consequence of this acceptance, and that the digital environments within which museums increasingly operate demonstrate and embrace randomness and incompletion, much like the cabinets of curiosity that were their forebears (see McTavish 2006).

The Transmedia Museums Is … Immersive and Playful

The museum has always been immersive and full of play, somewhat counter to the fetishisation of the 'traditional' museum as dry, dusty, stiff and impenetrable that I have often seen in my research with visitors. However, virtuality has made talk of immersion both more frequent, and more flippant – fast becoming an overused word in the museum's lexicon.

The virtual galleries found on museum websites in the early 2000s perhaps remain the most straightforward attempt yet to manifest the immersive museum. These were heralded as the dawn of the global museum encounter, allowing 'visitors' access to sites and experiences that would not have been possible previously, but simultaneously, as ringing the death knell of the material and physical realities of museum practice – and indeed museum visiting. Hosted either by museum websites or 'built' in platforms like Second Life, their use in recent years has been on the decline as museums have re-thought the relationship between the virtual and the physical, realising that being wedded to the structures of the museum, both archaeological and institutional, does not necessarily translate into fulfilling online experiences. As McTavish notes, virtual museums 'do not offer visitors increased freedom of movement or thought; they reinforce rather than transform conventional relationships between museums and their public' (McTavish 2006: 233). She goes on to say that 'virtual reality galleries presuppose and may even produce an ideal visitor – one who is

17 In the US context see for example the Museum of Modern Art's Inside/Out blog at http://www.moma.org/explore/inside_out.

well behaved, predictable, and obliged to enjoy a primarily visual experience of gallery spaces' (McTavish 2006: 233). Ross Parry presents a rather more radical conception of the virtual museum as not so much a 'known space', a recreation of an existing space in the non-virtual world, but rather a '"knowledge space", a sort of three-dimensional mind-map within which to think' (Parry 2007: 71). Parry's conception of the virtual museum accords more pleasingly with the idea of the transmedia museum, that the associated 'world-building' doesn't re-create or mimic the offline physicality of the museum; rather, it creates a 'knowledge space' where multiple fragments of meaning can be accessed and produced, perspectives gleaned, contributions made and opportunities for creativity carved out.

Of course, immersion can also be physical and sensorial, going beyond just sight and sound (Kidd 2014):

> the twenty-first century museum visitor is understood to be engaged and immersed within the experience, rather than a passive spectator or acquiescing recipient of it ... we witness a movement from a museum space that is prescribed, authored, physical, closed, linear and distant, to a space that instead tends to be something more dynamic, discursive, imagined, open, radical and immersive. (Parry 2007: 72)

As such, it becomes more playful and mischievous also. Interactive artworks at the National Media Museum in Bradford and at the National Gallery encourage users to step up and play. Visitors can take part in a Hide and Tweet game at the National Waterfront Museum. At the Cardiff Story the 'City Lab' suggests experimentation (as well as research). Clarke notes that transmedia narratives often have a 'conspiratorial rhetorical mode' (2013: 209) characterised by subversion, secrecy and a break from the norm. Some of the activities outlined in this section might be understood in such a mode: to 'hide and tweet' is to be involved in something necessarily covert; and to engage in wilful acts of destruction of art gallery property takes courage in an environment where such things are prohibited, and where one is all the time being watched by museum staff and other visitors.

Ross Parry (2013) has noted that museums are more likely to embrace acts of playfulness and performativity on site than in their online environments, and that emerged as true in the sample for this chapter. Playfulness is of course easier to keep an eye on, control and shut down in person than in the online environment where it might become mistaken for the authentic and authoritative voice of the institution, leave a permanent record or become promiscuous.

All of that said, playfulness on site is at times stifled by institutional policy, most notably the policy that still operates in many museums to disallow photography. Such a policy seems out of step in museums that are encouraging participation in, and even live commentary on, experience via social networks (including the sharing of photos). Griffiths argues that 'our desire to become immersed in spaces [like museums] that inspire awe and a sensation of being elsewhere is unlikely

to fade'. She notes that to make the most of the encounter, 'We'll just have to remember to turn off our electronic devices when we step inside' (Griffiths 2008: 12). This is perhaps an oversight – might there be an argument that we are *more* present when we are taking photos and sharing? That we are *more* usefully engaged by an artefact when we can find out more about it through search? Indeed, was presence ever akin to immersion in and of itself in the first place?

Questions Raised

This notion of the transmedia museum raises many questions and challenges for museum practitioners and researchers: Might moving between museum content and other associated content, social networks and playframes render the museum unreliable? Might we need to distinguish between transfictionality (Ryan 2013) and transfactionality? Does distributed equal diluted? How important is textual cohesion? Does this assume that textual cohesion was ever a possibility?

Perhaps it might be said that the transmedia museum is anomalous. Does it undo the institution, rendering it no more than a piece in an elaborate jigsaw of meaning? Does the transmedia museum reify experience in and of itself (Steyn 2014)? This reminds us that the question of how heritage is packaged and 'consumed' is a matter of intense and seemingly irreconcilable tension. The 'experience economy' (Pine and Gilmore 1999) renders the visitor the object, to be 'done to' by heritage. What then, is the role of material heritage and the state of 'knowledge' in that scenario? Does the museum become nothing more than a destination, a simulation of culture that is both proximal and unfathomable? Yet this belies an assumption that more and better engagement can be found in the practice of gazing (Dicks 2003: 9) and a fundamental, perhaps even elitist, mistrust of the visiting public to know what is good for them.

Critically, does the notion of transmedia rely on the museum being at its core nimble and agile, words that one would not normally associate with cultural institutions and their processes? Some museums have readily and quite completely brought into (often at some cost) multimedia as a way of communicating and diversifying their content offer.[18] Others have been slower off the mark.

Henry Jenkins has warned that 'the more a media producer moves in this direction, the greater the challenges of coordination and consistency become' (Jenkins 2011). Might the transmedia museum simply become an example of 'chaotic storytelling' (McGonigal 2011), difficult to make sense of, rely upon and to access, both intellectually and technologically, across multiple and dispersed media (Løvlie 2011). Does it matter if only a handful of visitors access particular

18 The Brooklyn Museum is an oft-cited example of a museum that has embraced multiple media, as are the Rijksmuseum in the Netherlands, the Museum of London, the British Museum and the Museum of Modern Art (which will be discussed variously in this book).

lines of content? We would be wrong to assume that a majority, or even a significant minority, of museum visitors will access these multiple sites of content.

As Mike Jones soberingly asserts summarising his experience at the coal face:

> I think the mistake many multi-platform projects make (and many museum projects also) is to assume the audience are motivated, assume they are already interested and so they neglect to light a fire under their arse, they forget to give the audience really good, motivated, compelling reasons to engage. (Jones 2012)

Museums also have a lot of work to do if they wish for users of what is essentially dispersed and episodic content to be aware of their involvement in creating, curating and distributing that content in the first place.

Above all, the question of power remains stark. Transmedia as drillable, immersive, bendable, inquisitive and performative implicates the visitor as the centre of a narrative world with agency and creativity at their disposal. But of course, agency and creativity are often a part of the illusion the story-world creates, and are potentially inconsequential:

> what we see here are communities who follow the trail laid out by the media producers, from website to merchandise to multiplex … this relationship is entirely shaped from 'above'. (Brooker and Jermyn 2003: 324)

The remainder of the chapters in this book will explore these themes and questions in various ways and along differing trajectories. The following chapter takes as its focus one aspect of the analysis not detailed here, that is, the ways these museums utilised and gave value to social media communications. Here I question how the individual production of narratives can usefully butt up against those of others so that our meaning-making is challenged.

Chapter 2
Museum Communications in Social Networks

Where is the museum that emphasises what we do not yet know? Where might we hear a voice suggest intriguing unknowns or unresolved questions surrounding its objects? That might be the most educative, transformative museum of all. (Carr 2001)

Carr's vision of a museum as an open work calls for a reappraisal of the dynamics and architectures of knowledge that have been established and defended within the museum for centuries. We have, in the twenty-first century, seen conversation within the heritage sector about how the museum as a knowing archive might be problematised, and what the implications of such a re-visioning might be: a shift toward the anarchic or, conversely, the reification of the mundane? The longer-term reality is unlikely to be as radical as either proposition. The questioning voices that Carr calls forth in his provocation are perhaps most easily located in the noisy, messy, communications space of the social network, a space increasingly being recognised for its ability to elicit conversation, openness, transparency and community considered to be of 'value' to museums.

As has been noted in the Introduction, the wider social, cultural and political landscape has forced museums to become more audience-centric. Audiences are, more than ever before, implicated in the practices and processes of history 'making': being engaged, consulted, collaborated with and, crucially perhaps, listened to also. As a part of this endeavour there has been an increased emphasis on dialogue, conversation and even democracy. Perhaps unsurprisingly, the 'tools' often tasked with facilitating such practices are various social media (Kelly L. 2013, Giaccardi 2012, Parry 2011). This is also no doubt a consequence of museum professionals' acknowledgement of the increased pervasiveness of those media as spaces within which a majority of visitors now find themselves spending their (work and leisure) time: socialising, consuming, organising and doing business on a frequent basis. Social networking sites (SNS) are a 'ubiquitous feature of everyday life' (Dewdney et al. 2013: 167). However, according to Drotner and Schrøder, a critical appraisal of museums' interventions is necessary, not least because their potentials are so far-reaching. It is worth reproducing that appraisal at some length here:

> it is important to reach beyond the normative, and often binary, understanding of social media as a cause of celebration or concern, and to acknowledge the possibilities fashioned through their diversity of services and modes

of communication. In terms of museum communication, social media fundamentally invite museums to re-orchestrate their communicative models away from a transmission model defined from an institutional perspective (what we want to impart) on to a user perspective (what people may want to know). This reorchestration lets museums begin to find new answers to what they communicate, how and to whom they communicate, where and when their communication takes place, and, importantly, for what ends. (Drotner and Schrøder 2013: 3–4)

Here Drotner and Schrøder echo Carr, envisaging a new architecture of knowledge and foregrounding the notion of communications that is at the core of this chapter: 'which modes of museum communication do social media facilitate?' (Drotner and Schrøder 2013: 1). According to Drotner and Schrøder social media potentially impact museums' work in all areas: acquisition, conservation, research, exhibition and communication. It is the last of these that is the principal concern here. However, implicit in that investigation is another set of concerns: around voice (curatorial, institutional, professional, playful), resources, community, boundaries and ethics. As Ross Parry attests, 'the ethics of social media are still absent or at best, only emergent' (Parry 2011: 321).

This chapter extends the discussion in the last with a detailed study of what emerged in the analysis of the social media spaces of those same 20 institutions, demonstrating and problematising museums' current uses of social media using output from within those spaces.[1] Using a sampling period of one week during July/August 2013 (a busy period in the UK museums' calendar), all activities on the social networking site Facebook and microblogging site Twitter were analysed (a total of 701 posts). Comments on those posts (a total of 940) were also coded, as well as likes/favourites, shares/retweets. Each post was coded for who was speaking, the type of content presented (texts, images, links, video), the tone of the post, its links to the museum website and archival content, links to external websites and archival content, and for discussion that emerged in responses. Crucially, each post's central 'communicative function' was noted: was it principally marketing activity or conversational, or perhaps promoting external content?[2] In addition, videos posted to those museums' YouTube channels over the previous six months

1 It should be noted that for Birmingham Art Gallery and Museum, New Walk Museum, Leicester, Tate Britain, Imperial War Museums and the Tower of London the larger consortia to which they belong became the focus in this study as these sites did not have discrete presences in the social networks under study.

2 The range of options coded for was: 1. Marketing; 2. Job advertisement; 3. On this day in history …; 4. Highlighting other media content; 5. Responsive – conversational; 6. Responsive – closed; 7. Highlighting other related content; 8. Linking to a blog or podcast; 9. Requesting contributions; 10. Highlighting a past event; 11. Highlighting current engagement on site; 12. Link to a review; 13. Highlighting other cultural events; 14. Addressing criticism; and 15. #FF (follow Friday hashtag on Twitter).

were also coded (a total of 150 videos across 16 channels), as well as associated comments (a total of 226 comments, comparatively more than were received in the other social network sites in the sample).

The analysis does not try to contrast findings between museum typologies (e.g. history museums as compared to art galleries) as the sample is not weighted to allow for the consideration of the museum typology itself as a variable. Rather, findings about the overall tone, voice, content and characteristics are presented in order to understand something of how social media communications are currently being utilised, framed and organised by museums. Neither does the analysis look at the ways in which social media content is then made use of and linked to in physical locations on site. Some examples of that practice have already been picked up in Chapter 1, and will be referred to in other chapters also.

It will be seen that even as 'the museum' covets and articulates a move from a broadcast model of communications to a social media model, evidence shows that the current use of such media *can* neutralise, contain and flatten that promise (as has been noted previously: Kidd 2011a, Richardson 2009a). Of course, that is not always the case, and the analysis also revealed instances of more considered, playful and creative use of those media which are discussed in the chapter.

The Emergent Discourse about Social Media in the Museum

> Web 2.0 is fundamentally challenging the very nature of our public institutions.
> (Kelly 2010a: 408)

There has been a burgeoning discourse about social networks and their implications for museums both within the academy and the profession. This has manifested in numerous training events, workshops and conferences, online discussions, professional publications and (more latterly) scholarly discourse also. This discourse echoes, and at times problematises, the 'promise' of social media as recounted in the literature from within other disciplines, most notably perhaps in media studies where much is made of the potentials for 'many-to-many' communication (Kovach and Rosenstiel 2001, Bowman and Willis 2004, Gillmor 2006)[3] and in marketing literature which, although useful, often lacks the empirical base or rigorous intellectual framework found in other disciplines (for example Halligan and Shah 2009, Scott D. 2013). Within those discourses many claims have been made, and questioned.

Of principle noteworthiness might be the many claims about social media's capacity – and preference – for openness as an emerging default. This is a potential articulated within a number of spheres, not least in relation to politics: as transparency, accountability and as participation. Social networks have been seen (although not unproblematically) as our most feasible opportunity to date

3 On Twitter see Java et al. 2007.

for facilitating a genuinely open public sphere within which all people are able to contribute to, critique and influence the political consensus (Papacharissi 2002 2009, Bohman 2004, Gerhards and Schäfer 2010).[4] Jim McGuigan has also attempted to revive discussion about the potentials for a cultural public sphere within which all people have the 'opportunity to communicate [their] hopes and plans' for a more democratic culture (1996: 3). This is a concept that speaks to the new museums' rhetoric quite explicitly.

In relation to the museum, there has been an assumption that openness is 'a good thing', to be pursued and guarded and, if possible, made normative – whether at the level of acquisitions, disposals, exhibition conceptualisation and design, programme feedback or even institutional policy-making. Openness perhaps best manifests as dialogue, and so it can be seen why social networks might be articulated as a part of that equation. Of course, dialogue also means having conversations that are difficult: accepting, and embracing, conflict as a natural part of communications (Lynch 2014). Such conflict is something that, in the museums sector, we all too often see framed as a problematic to be anticipated, and to be contained:

> no one can contest the merits of openness, but how to balance this with a clear curatorial vision, a commitment to excellence, and the retention of existing brand values? To open the doors a little wider is to encourage vulnerability as much as innovation and opportunity. (Fleming 2009: 20)

To Tom Fleming, who is an advocate of such openness, becoming porous is to become in some way vulnerable. This might be a very real concern, but in the majority of cases is not grounded in actual institutional experience but rather in a fear of the unpredictable and ungovernable discourses of the social media space. Porosity breaks down the barriers between public and private and between institutional and individual voice. This can be a means for facilitating community and collaboration, but also, potentially, frustration and noise.

Much has been made of the capacity of social media spaces for community, and these are claims I have assessed elsewhere (Kidd 2011a), concluding that although community has a currency and value within museums' assessments of the potentials for social networks and the connectivity at their core, what kind of 'value' they are being invested with is less clear. This notion of community, reified and all-powerful, is both sought and feared within the museum lexicon (Kidd 2014). An understanding of what museums mean by community within such spaces has not generally been forthcoming. As Baym reminds us, 'The mere existence of an interactive online forum is not community' (Baym 2010: 74).

An associated claim is that museums' operations (at all levels) might be democratised in and through social networks, in a shift from 'infrastructure for

4 For more on the Internet and democracy, see Ferdinand 2000, Anderson and Cornfield 2003, Bohman 2004, Hindman 2009, Carpentier 2011, also Taylor 2014.

you' to 'infrastructure by you' (Fleming 2009). Pruulmann-Vengerfeldt and Runnel (2011) propose that this might be a possibility at the institutional level; but also, beyond that, helping to contribute to a wider liberation and politicisation of the individual. This kind of extra-institutional impact is of course difficult to measure, but perhaps more importantly raises questions about the role and remit of museums as related to issues of citizenship, social justice and wider political movements and agendas which are not unproblematic for (especially public) institutions.[5] Moreover, more democratised communications do not in themselves equate to more, or better, democracy, as Natalie Fenton has noted: 'Networks are not inherently liberatory; network openness does not lead us directly to democracy' (Fenton 2012: 142).

Perhaps most straightforwardly, one of the more prominent frames for social network communications (at least within professional training lexicon) has been that they might provide valuable word-of-mouth publicity for museums (see Jansen et al. 2009). Such as might be, but museums need to be live to the fact that users of such spaces are often averse to 'commercial' messages, and have their own, sometimes difficult to penetrate, systems of communication in place (often unwritten). Communities have existent expectations about what the nature and use-value of communications will be within those spaces (Bergstrom 2011). This is now well understood by many museums (as demonstrated below), but by no means all.

This brief overview of the claims being made about social media for openness, democracy and community demonstrates that such claims remain mythic within the museological discourse; their 'truth' remains to be established or adequately tested through scholarship. In the following section, I begin to demonstrate how that might be possible.

Findings from the Analysis of Facebook/Twitter Posts

The analysis of 701 posts and their associated content (including embedded links, images, videos and responses) revealed much about the tone, frequency, nature and indeed use-value of museum-user communications within social media spaces. The starkest initial observation was, in the Facebook/Twitter analysis, how completely the Twitter posts outnumbered the Facebook posts: by nearly 500 per cent in total. A vast differential was the case across the sample, as can be seen

5 Exemplified in the exchanges by museum professionals in the discussion about proposals for their 2012 conference at http://www.museumsassociation.org/conference/23012013-conference-session-webchat, where David Fleming, Director of National Museums Liverpool, asserts 'The only people who complain about conference sessions being too political are those who seem to be unable to grasp that museums ARE political, like it or not!'

**Figure 2.1　Percentage breakdown across Facebook and Twitter for each
site in the study**

with a look at the percentage of posts to both Facebook and Twitter for each of the
museums (Figure 2.1):

It can be seen from this graph that two of the sites did not post to Facebook
or Twitter at all during the sampling period. The institutions have been kept in
the sample however because they do have accounts with both social networks to
which they have posted recently, but which just did not receive posts during the
content analysis period. It is also worth noting at this macro-level that although
Facebook posts were fewer, the number of responses they garnered (in the form
of likes, shares and comments) was significantly higher than for tweets. This is
interesting given the fact that (as shown in Table 2.1) the number of followers
reached on Twitter more often than not outnumbers quite significantly the number
of people who 'like' a Facebook page. This rather anomalous observation perhaps
evidences museums' preference for reach over and above the extent and quality
of the conversation that is initiated by the post as a result, and should give us food

Table 2.1 Numbers of Twitter followers and Facebook page likes for each of the sites in the study, as at 13 August 2013

	Twitter followers	Facebook page likes
NAM	3,801	3,016
CS	4,408	810
HRP	21,023	23,454
BP	2,057	2,374
TB	15,477	34,281
SSGB	4,271	2,542
M-Shed	7,196	1,438
LAM	4,896	2,243
BMAG	14,224	8,867
MAGNA	3,739	946
WELL	13,986	17,958
NFM	8,327	2,483
PHM	7,876	2,805
BL	453,611	103,861
IWM	35,072	24,398
TATE	906,213	596,960
NG	121,133	212,206
HEP	31,665	7,188
NWM	2,590	708
MOSI	11,244	4,112

for thought about what key performance indicators and 'quantifiables' are being assessed and given value within the networks.

All museums' posts tailed off over the course of the week, with far fewer at the weekend across both social networks. Monday saw a great number of posts as visitors' comments from the weekend were retweeted. The sites with the highest total posts were the consortium for the Imperial War Museums and Birmingham Museums. The most posts for individual sites came from Titanic Belfast (with the most), the British Library, the Museum of Science and Industry, Manchester, the National Football Museum in Manchester and the People's History Museum, also in Manchester. Whether anything can be read into the frequency of posts for sites that are co-located in the same city is difficult to say, beyond noting that looking to local competitors and heritage colleagues *might* be in evidence here. On a

related theme, it was notable how often many of the sites linked to related content elsewhere: to other cultural events (again more so on Twitter) or archival materials, even retweeting other museums' and heritage organisations' posts. This seems less to do with competition, instead evidencing that museums and galleries feel part of a cultural sector or local arts 'scene', with larger narratives about their collections, and the heritages they stem from and cultivate, being constructed across and in the spaces in between the sites themselves. This of course fits well with the conception of transmedia heritage worked with in the previous chapter. Such linking was interesting to note at two sites in particular where on-site activity and content was embedded within local narratives, news stories and online content: in Birmingham where posts about the continued work on the Staffordshire Hoard proved popular; and in Leicester where posts about the developments related to the archaeological unearthing of Richard III's body were also hugely popular. Both narratives have unfolded in recent years with significant national and even international attention, and, it should be noted, great intrigue, curiosity and fascination.

Working with metrics such as those in Table 2.1 can be useful for recording (and no doubt reporting) engagement in its crudest form. As is clear, however, such reporting as a key performance indicator tells us little about the qualitative elements of that engagement, its tone and the vibrancy of the conversations that occur as a result of museum interventions in social media spaces.

The principal characteristic of posts can be seen in Table 2.2.[6] In total, 42 per cent of all posts were predominantly marketing related (although not all directly from the institution; some were retweets). This breaks down as 39 per cent of Twitter posts and 57 per cent of posts on Facebook. Other figures of note here include the number of posts on Twitter that highlight engagement on site (13 per cent of Twitter posts, negligible on Facebook) and the number of posts responding to visitors, at 12 per cent of the total number of Twitter posts. This latter figure is further broken down as roughly 30 per cent conversational in tone and 70 per cent closed responses. It is difficult to argue then that there is a vibrant or considered conversation happening between users and museum staff, although there are some local differences.

This opens up for more critical assessment those prior claims made about the extent to which museums employ social media as a mechanism for increased openness, democracy and debate. Clearly these platforms have the potential to facilitate such interactions, but the evidence does not suggest that these are becoming commonplace.

The significance of marketing activity within both spaces is worthy of further comment. Natalie Fenton (2012) asserts that we are accustomed within mass

6 The decision to code for only one characteristic per post proved not to be too problematic (as feared), although for some posts the line between marketing activity and other forms of activity was rather blurred (for example, detailing a past event, or linking to a blog). Separating voice and characteristic allowed for their cross-tabulation, and revealed some complexities that are drawn upon below.

Table 2.2 Primary characteristic of posts noted in the coding process and presented as a frequency for both Facebook and Twitter samples

		SNS	
		Facebook Count	Twitter Count
	Marketing	60	232
	Job advert	2	13
	On this day ...	14	22
	Other media content	4	37
	Responsive – conversational	1	25
	Responsive – closed	0	59
	Related theme	7	46
Characteristic	Linking to blog or podcast	3	22
	Requesting contributions	4	13
	Past event	4	4
	Engagement on site	3	80
	Review	0	6
	Other cultural events	3	21
	Other	1	11
	Addressing criticism	0	1
	#FF	0	3

media to being approached as consumers, and that this increasingly characterises communications in social networks also. But there are questions of integrity that need to be addressed if the lexicon of social media use by museums also speaks to community, collaboration and conversation (which is not to suggest that such priorities are mutually exclusive). Miller's thesis contends that when marketing and commercial messages and interests dominate in such spaces, what becomes important is not dialogue or communication, but the 'maintenance of a network itself [as] the primary focus'. This then moves institutions 'away from communities, narratives, substantive communication, and toward networks, databases and phatic communication' (Miller 2008: 399): that is, speech that aims to achieve a general mood of sociability rather than enabling productive and long-lasting communications. Here we see small talk rather than meaningful or authentic conversation, and this indeed is something we should be alert to within the cultural landscape.

What was noted from a more detailed study of the specifics was that the tone museums used in both spaces was rather different. On Facebook, the tone was invariably more formal than on Twitter, where a far more relaxed voice tended to be used by all parties (including audiences). Responses on Twitter, from both visitors and the sites themselves, were pithier and more playful, as were many of the posts themselves. The formality of posts on Facebook can be attributed to their

principally marketing focus: highlighting forthcoming events, workshops or other promotions.

It was seen that although content sometimes appeared on both sites as a direct reproduction (especially marketing or 'On this day ...' posts), more often than not the post had been packaged for the specific platform and with the particular norms and affordances of that platform in mind. This is reassuring given repeated guidance in the literature to respond to – and emulate – the nuances of communications in different networks:

> Online participatory platforms influence user and community behaviour both implicitly through the tools that are and aren't offered and explicitly through community management. Every online social network has rules about acceptable content and ways that users can engage with each other, and those rules have serious implications about the overall tone of interaction on the site. (Simon 2010: 122)

Because of its more dynamic and fuller display, Facebook posts tended to be wordier, and use a combination of different media and links. This was less the case on Twitter where it was more frequently only one type of content per post (text, an image or a link mostly). This is no doubt because of the 140 character limitation on tweets, and the norms of communication within that space. What we see is that each of those media again has its own particular nuances, affordances and 'sets of agencies' which we might wish to be live to (Parry 2011: 320). As Ross Parry notes, these things can also be culturally contingent.

It was noted that on Twitter especially, institutions had multiple voices and tones of address, altering to match the needs of the particular post or communication. Institutions thus displayed more dynamism and responsiveness on this platform than on Facebook (or YouTube for that matter). Such activity included retweeting staff posts (from individual or departmental accounts) about what they were doing on site, from facilitating workshops to eating ice creams in the office. This shows a development from previous research (Kidd 2011a) which questioned the extent to which institutions were able – and willing – to adopt different voices in such spaces. Most tweets, from institutions and those visitor/user posts that are retweeted (inevitably not all users tweeting about a site are visitors also), are relaxed in tone, even playful on occasion.

In both social networks, the use of exclamation marks in posts by the institution was notable for its frequency. Tweets especially demonstrate a willingness on occasion to engage in relaxed conversation with users. This is less often the case however than a friendly acknowledgement of a tweet and an expression of gratitude for getting in touch. In all instances on Twitter and Facebook that could be accessed, questioning posts from members of the public or other organisations had been responded to with an answer, and conversations ensued where necessary. There was only one post coded that was addressing a criticism of a site. This

widescale acknowledgement and actioning/intervention has also seen development in recent years as compared to previous research (Kidd 2011a).

Linking activity was very common in both locations, through the posts of institutions, visitors and other commentators. This leads the curious into a rabbit warren of additional content: reviews, blogs, podcasts, archival materials and other media content for example. Especially on Twitter, links to YouTube, Google Art Project, Google+ hangouts, Pinterest, WordPress blogs and (via retweets) Instagram and Foursquare were common. There were 21 links to mainstream media content, overwhelmingly BBC content that could be found online. Links to blogs were most frequently for museums' own blogs (must notably at the British Library and the People's History Museum), it being much rarer for institutions to link to an external blog without being prompted. This is perhaps a nod to traditional notions of authority and belies a mistrust of external content that does not come from those readily understood as 'official' sources (including the BBC).

Some 36 per cent of posts linked to the museum's own website (especially common in marketing posts which link to booking details and the like), but the vast majority of posts do not link to museums' archival materials. I wouldn't wish to suggest that it is always appropriate to do so, and certainly such linking is unlikely to become a feature of *visitor* posts any time soon; but there may well be missed opportunities here for staff to make connections with what is happening on site or with materials from the archive. It is very rare for museums to post links to external archives, although not uncommon for them to link to external websites: wider media, cultural institutions or other posts on Twitter that are relevant to the broad subject matter of the site – so, for example, tweets from the Football Association retweeted by the National Football Museum, or posts related to the centenary of World War I retweeted by Imperial War Museums. Again, these link to many of the themes explored in Chapter 1 related to the co-location of museum narratives, and their granularity.

The study revealed that multiple languages were used in social network spaces, especially evident in the comments function on Facebook for those London-based institutions that have a ready international reach and many followers. For the Cardiff Story, there was a concern with providing dual language services on Twitter (curiously, not on Facebook).

Comments on Facebook, especially for those art galleries in the study, were very often related to the images used in museum posts. These often bypassed the particular event or question the museum was seeking to highlight, instead viewing this as an opportunity to offer their evaluative response to the artwork and its quality, the artist more generally or the collections housed within the institution. Many images are also posted by members of the public in these spaces – on Facebook especially they might post an image of an admired artwork, or indeed their own; but most frequently across the whole sample, images posted are photos taken on site – of visitors' companions or of the surroundings.

One finding that emerged very clearly was that individuals were keen on having their posts or comments acknowledged by the institutions. Responses from institutions are often retweeted or shared, 'favourited' or liked, or commented upon further, sometimes entering into a conversation with the institution. That sense of feeling valued is demonstrably important to people, and, of course, is useful in promotional terms. Indeed, the amount of marketing content in these spaces that comes from visitors and other local organisations is becoming significant, blurring the lines between promotional activity and conversation, and making the marketing voice of an institution rather more opaque.

Findings from the YouTube Sample

The YouTube sample is necessarily very different from the Facebook/Twitter survey in terms of its overall size and some of the categories used for content analysis. There were four sites in the overall study that did not have a YouTube channel, and a further three that had made no posts in the six months under analysis (indeed, one had made no posts for three years). This is not entirely surprising when one notes that overall, the frequency of posts is far lower than in the other networks under study. Even the most active sites are posting no more than a handful a week, far fewer posts than on Twitter or Facebook.

The most prolific in the sample was Tate, which had posted the most films (463 in total on the channel), followed by the British Library (224) and Historic Royal Palaces (175).

The posts universally (as we would expect) contain videos, and differing levels of accompanying textual interpretation. The videos vary hugely in length, from the shortest at 21 seconds to the longest at more than 54 minutes.

In terms of the content of the videos, this was a very different content landscape than for the other SNS previously recounted. On YouTube, only 16 per cent of videos were straightforwardly understood as marketing, although an additional 43 per cent of videos related directly to exhibitions and collections. These did so in a way that was often understood as having a secondary function as marketing activity, but that primarily foregrounded historical narratives and museological practice. The other videos can be broken down as 16 per cent oral history content; 14 per cent detailing conservation and other behind the scenes activity; and 3 per cent (the longer posts) presentations and discussions on site.[7] It is interesting that this very different landscape was evident in a platform where the entry point is more likely to be search, and where time-sensitiveness (for example to a promotions campaign) might be less significant when it comes to finding content.

7 The additional 8 per cent are made up of others, including recruitment, learning programmes and rather more random contributions.

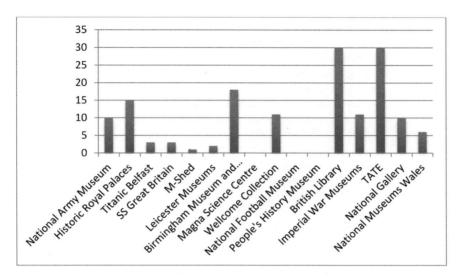

Figure 2.2 Number of posts per site in the YouTube sample

As with the Facebook/Twitter sample, the larger national and/or London-based institutions had more subscribers to channels, with the National Gallery, Tower of London and Tate having the most (2,062, 4,026 and 16,737 subscribers respectively). These figures pale into relative insignificance in comparison to those presented in Figure 2.1 for the Twitter/Facebook sample.

By far the most 'popular' YouTube film came from the Wellcome Trust, with 50,237 hits and 1,481 subscribers compared to the next highest at 15,675 for the National Army Museum, which has only 360 subscribers, and then Amgueddfa Cymru (National Museums Wales) with 11,308 and 18 subscribers. This clearly demonstrates that within this landscape content is king. It is a common refrain of the marketing literature that success in social media spaces is not about top-down 'outbound' or 'interruption-based' techniques (Halligan and Shah 2009), but about creating novel content that people want to talk about and share within their networks. That way, people will find you via 'inbound marketing' techniques and participation rather than propaganda and public relations. In this model, communication can happen (sometimes subtly) directly with audiences in a form they are predisposed to appreciate. In this landscape then, as can be seen by the number of views, it is content itself that drives action (Scott D. 2013). In the case of Wellcome, the National Army Museum and National Museums Wales, it is not direct marketing to a set list of subscribers that has ensured the most hits, but the content itself and people's sharing activities that have created a buzz and brought people to it. No amount of subscribers is going to automatically ensure that YouTube content is shared.

That said, although content was being shared (on occasion) by significant numbers or individuals, there was little in the way of conversation happening around that content (at least within the YouTube platform). The most watched Wellcome Trust film had the highest number of comments by far, but still only 35 in total. One other film from HRP stood out with 26 comments, but the vast majority had only a couple at most. Indeed, 54 per cent had zero comments and a further 19 per cent had only one, indicating a lack of conversation and potentially community around the content within YouTube at least. This does not preclude the possibility that the conversation is happening elsewhere, but it is worth noting again that during the Facebook/Twitter sample period it was not really seen in evidence there either. If conversation is happening around such content therefore, museums need to think about how best to locate it in each instance, following the links and those who do comment into other spaces and communities that may be of interest.

How is Communication Framed in Social Media?

> most museums remain slow to recognize their users as active cultural participants in many-to-many cultural exchanges and therefore social media have yet to make a significant impact on museum communication models, which remain fundamentally one-to-many. (Russo et al. 2008: 23; internal citations omitted)

In the above quotation from 2008, Angelina Russo and her co-writers propose that museum communications have yet to fully respond to and take account of the affordances of social network sites; but what differs (if anything) in 2014? The discourse emerging from the profession – and the developments we have seen in the museological lexicon in recent years (embracing collaboration, crowdsourcing, co-production and multi-vocality) – attest to change, at least in the rhetoric. The evidence recounted in this chapter demonstrates that, in practice, around the edges of museum practice interesting things are starting to happen. I contend that the most significant of these changes is around institutional voice, not least in the acknowledgement that museums might also benefit from becoming multi-vocal. Museums, in recent years, have recognised that visitors are not blank slates; that they are conflicted, heterogeneous, lifelong learners who are entitled to alter their perspective in response to external stimuli. Yet why would we not acknowledge that museum professionals are all of these things too (Kidd 2014)? Opening up to multiple museological representations offers opportunities to be more playful, more responsive and more authentic within social media communications, attributes that are in keeping with the emergent norms of those environments. I suspect we are becoming more relaxed about the impact such a shift *might* have on a museum's – or a curator's – authority. In this respect we see evidence that Fairclough's vision of museums' use of social media might be plausible:

> Social media starts by offering a way to 'widen the audience', 'reach new constituencies' but it ends by changing heritage and by asking everyone to participate in its construction, encouraging openness not closure of interpretation and valuation, making flux, uncertainty and doubt critical. (Fairclough 2012: xvi–xvii)

This should be true for those who work in museums – and who are implicated in their narratives – also. Museum professionals are becoming better able to articulate what it is about social networks that both intrigues and frustrates them; and the sharing of experiences via forums like Culture Geek, Museums and the Web and MuseumNext[8] attests to more reflexivity and less defensiveness in practice. This is about more than 'learning how to use social media effectively' (Giaccardi 2012: 5). Rather, it is about addressing a new series of problematics which emerge once the spaces become more familiar. What kinds of sociality are being facilitated in online networks, and how do these differ from those encouraged in traditional 'analogue' museum communications (Dewdney et al. 2013: 169)? What does it mean for people to encounter cultural heritage within the everyday contexts of their lives (Giaccardi 2012, Iversen and Smith 2012)? And lastly, within those contexts, how can museums organise their activities 'so as not to be overwhelming in an information economy already characterized by infoglut' (Samis 2008: 10)?

There is, however, much work to be done here if the goal of more and better community online is to be achieved. A start point might be embracing reflexivity in strategising for social media so questions can be asked and addressed about what it is hoped will be achieved by presence within such locations. So, we might ask: is the objective marketing on-site activities? Or maybe to locate and provide support within a local network of heritage professionals and providers, even cross-fertilising activities? Is the purpose of exchanges within social networks to facilitate dialogue, ask questions and explore responses with visitors and users? Or to contribute toward a discourse about a particular topic or historical narrative? Is it to campaign on behalf of the institution (as in Black et al. 2010)? Perhaps it is to promote a wider political agenda, or to respond to one? In all likelihood, institutions will be seeking to achieve multiple objectives, so must question the extent to which one sole museum's voice can carry such disparate and perhaps conflicting agendas, and respond nimbly as they inevitably shift.

As museums learn to better navigate this terrain (which they will) the likelihood of encountering the allusive cultural public sphere perhaps becomes a more realistic prospect. In future it is likely that sometimes discussions will take place on sites hosted by museums, and sometimes they will take place elsewhere. But, crucially, a museum's varying voices will be in evidence in the debate, and *that* won't be a big deal at all.

8 http://www.culturegeek.com/, http://www.museumsandtheweb.com/, http://www.museumnext.org/.

Chapter 3

User-Created Content

As was explored in the Introduction, there is a continuing concern within a variety of cultural institutions with the rebalancing of representation and a broadening of curatorial and narrative practices (as will be explored further in Chapter 4). This chapter aims to overview the territorial and authorial struggle that I call here 'user-created content'. It is concerned predominantly with the rhetorics associated with the 'user-generated content' (UGC) movement and the rise in 'remix' culture (see also Chapter 7). Both are touted as spearheading a radical overhaul of the ways in which we collect, value, filter and appropriate cultural content, and new media are a central tenet of both movements. Such activity, according to Russo et al., showcases 'the ability of an individual or a community to create, upload and share digital cultural content' and 'demonstrates a proven and growing demand for creative expression, the exploration of identity, and cultural participation' (Russo et al. 2008: 27). The praxis at the heart of the debate about user-created content matters for many reasons, not least because it threatens to redefine visitor perceptions of historical authority and authenticity (or so it is posited in Adair et al. 2011, Giaccardi 2012, Cameron and Kelly 2010).

As has been noted previously, museums do not stand alone in the face of an increasingly mobile and dextrous digital public, and this chapter again uses literature from a variety of disciplines to understand and frame the issues as they pertain to that context. Central to the argument in this chapter is a further reappraisal of the terminology, noting a potential shift from 'audiences' and 'visitors' to 'authoring' and 'creative practice', as Tallon notes: 'today's museum visitors are less audience than they are author – active participants in meaning making and content creation' (Tallon and Walker: xiv). This shift is, however, not a seamless one, and nor is it universally and always embraced by the institutions that are the subject of this book.

What is User-Created Content?

The preference here for 'user-created' rather than '*visitor*-created' or 'user-*generated*' content (even 'participant-generated content', O'Flynn 2012: 149) is more than mere semantics, instead implying a philosophical shift and a recognition of self-ness at the core of such 'making'. But let us start at the level of the lexicon nonetheless, and a confessional of my own knotty relationship with it.

User-generated content is a term I first encountered whilst working for a small interactive television company in London in 2001. It was, as Mandiberg notes,

a term that became a 'corporate media favorite' (2012: 2), referring more to the products than the processes of participation. As an organisation we considered ourselves at the cutting edge of what was possible when it came to the use of cable and satellite technologies in the delivery of local services (indeed I still maintain we were). We were keen to enter into a dialogue with our 'users' and to engage them in the patterns and practices of their own representation. This was a hugely challenging venture at a time when people were unaccustomed to such invitations, and one that, in consequence, we really had to push. So, we were 'pushing', 'inviting' and the content that was produced as a result was 'generated' via prompts, instructions and calls to action. In hindsight, the creativity on offer was very limited, as were opportunities to shape or genuinely collaborate in the process. Since that time, my sensitivity to the terminology in use has been ratified both in conversations with media producers and with those in the academy.

In this chapter, I use the term 'user-created content' to indicate the extent to which much of the content originates in individuals' capacities as users of cultural institutions but is nevertheless their own (variously) creative endeavour, uniquely brought into being. Although there are times when this is actively prompted by institutions, I suggest it is done so more knowingly than in the heady days of UGC and that beyond this, increasingly, much of the content that is produced and shared is done so *outside* the spaces of engagement most readily legitimised by those institutions (via YouTube, Instagram or Tumblr for example). As such, they may be 'users' of the institution in more active, pragmatic and strategic ways than are inscribed in the term 'visitor': the collections may become source material; the website a host for a personal gallery/collection; or the museum itself the set for a film uploaded to YouTube. User-created content is a clunky term, but does at least allow for a consideration of the breadth of activities outlined here, without implying any judgement on the use-value or quality of the resultant outputs.

With the above reflections on the terms in use here in mind, it is useful to review what is currently 'known' about user-*generated* content in other arenas.[1] The loudest and most rigorous attacks on and defences of such content have undoubtedly originated in the journalism and media studies scholarship (and around news media in particular).

What Might We Learn from Research into UGC in the Media?

There are a number of claims made about the potentials of UGC for media and journalism that are no doubt familiar to those working in the heritage sector: that it might provide a means to diversify content and the range of voices on offer; that it might give voice to those disenfranchised and marginalised by corporate media; that the media might benefit from the omnipresence of the citizen journalist; that

1 It is worth noting here that UGC is 'internally heterogeneous' (Lobato et al. 2014: 4), taking on many differing forms and formats, purposes and politics.

news might become more immediate, relevant and truthful to the experiences of people on the ground; that it might engender increased social connections between people (as in much of the talk about Web 2.0); that it might decrease gatekeeping to the production of news and to the setting of news values; that increased production of online content might translate into increased civic engagement in both online and offline contexts; that it might similarly result in increased participation in the life of one's community; that it might result in increased psychological empowerment; and that it might facilitate a reconceptualisation of the audience member as an active citizen rather than an active consumer. The last of these is a particular preoccupation of much of the media studies literature; that there might be a value in talking about a people 'formerly known as the audience' (Rosen 2006). This phrase, used most famously by journalism scholar Jay Rosen, has become something of a manifesto for proponents of UGC and Web 2.0 – the implication being that UGC recognises the multifaceted, distributed, social, increasingly vocal and increasingly powerful nature of digital citizens.

Most of the literature is, however, inconclusive about the extent to which this shift has taken hold in any meaningful way within the media and journalism. Indeed, some of that literature argues that, under the auspices of empowerment, democracy and interactivity, quite the reverse has taken place: that in most instances 'Participation [in UGC] (irrespective of its level) does not automatically equal either production or power' (Jönsson and Örnebring 2011: 141). In fact, according to Jönsson and Örnebring, calls for UGC in mainstream media continue to be made within a context of consumption: 'Users are identified as consumers but approached as citizens' (141). We perhaps think we have power, voice and the attentions of the media; but subtly, and troublingly, our contributions are undermined and undervalued, or sought only at the level of the innocuous and banal (Jönsson and Örnebring 2011, Paulussen and D'heer 2013). Leung says that it is possible that 'through participation, empowerment may emerge', but issues a warning that 'a lack of *meaningful* participation ... can be disempowering' (Leung 2009: 1331).

The literature reveals a staggering number of *negative* associations made by media professionals who took part in the various research projects, who mostly view UGC and its possibilities in very conservative terms (Thuman 2008, Wardle and Williams 2010, Williams et al. 2010) and are highly sceptical about its quality and value (Paulussen and D'heer 2013, Olsson and Viscovi 2013).[2] Lest we forget, talk about 'loser-generated content' was rife in newsrooms and elsewhere in the mid-2000s (Petersen 2008). UGC is understood as always *potentially*: inaccurate, false or untrustworthy; imbalanced and lacking objectivity and impartiality; libellous;

2 '[U]sers' contributions are scarcely appreciated by news journalists. The comments are considered to have low news values; fact-checking and ethics are poor. Journalists also think that the language within them is bad, in terms of spelling and style. They also claim that xenophobic and racist attitudes are very common' (Olsson and Viscovi 2013: 286; internal citations omitted).

lacking in authority; outside editorial control and standards; and overblown in terms of its use-value. The research shows that media professionals often reject UGC as 'real' journalism and see it only as 'raw material', with editorial control remaining very much in the hands of the 'experts'. Consequently, it is no wonder that moderation has been such a key part of the discussion about UGC (Thuman 2008), although this is now changing, with the BBC especially spearheading post-moderation in the United Kingdom). Nevertheless, UGC comes to be seen in the media landscape as 'material to be processed' (Williams et al. 2010). Moderation is a costly business in resource terms, and is seen by the professionals as an onerous, uninspiring and time-consuming task. According to the research, UGC remains very much outside the mainstream or on the margins, as Wardle and Williams conclude: 'journalists have remained journalists and audiences have remained audiences' (Wardle and Williams 2010: 792). Olsson and Viscovi conclude that 'the way that UGC is dealt with, as well as the role it is allowed to play within newspapers, relies heavily on what role journalists (with their norms, standards and established practices) allow it to play' (Olsson and Viscovi 2013: 286). So much for the prosumer in this context; UGC is pure source material and is processed as such.

So what might we conclude from all of this that would be valuable, or give a nod to how we might like to proceed in the museums sector, where discussion of UGC (or user-created content/UCC) is demonstrably more in its infancy. I suggest that there is one academic paper in particular that begins to offer us some guidance. It emerges from research into the BBC's coverage of the Arab Spring by Hänska-Ahy and Shapour (2013) and presents an alternative narrative of what is happening at the BBC with regard to UGC. A series of interviews with BBC news editors and producers who had turned to social media as a means of documenting the Arab Spring show they had been forced to *negotiate* a new stand-point on UGC.

The use of UGC in this context (which ultimately became one of the major stories of the Arab Spring) began in an ad hoc manner, but over time became much more of a collaborative endeavour by the various newsmakers operating in that context. As the BBC became more confident in their use of UGC, so too did the creators of that content. The workflows of the newsrooms had to find ways of accommodating the content, and so too the creators had to find ways of meeting the 'requirements' of the journalists. It became clear that content that could not be verified would not be shown, so protesters began using establishing shots to verify their positions and timings. As it became apparent that content of higher quality would be more likely to air, so the protesters started producing higher quality output. The BBC became better able to find and prompt UGC that would tell the story in ways that allayed the fears recounted earlier (see Hänska-Ahy and Shapour 2013 for more).

This might seem like a cynical practice of containment and institutionalisation – shaping the use of the media so it fits the pre-existing frames and requirements of journalists; and so it might have been. But it might equally be understood, the researchers say, as the creators learning how to 'game' the system – to utilise it

to tell their story; even to set the news agenda in their favour. This indicates a new, and more creative, tension. Those who were involved in the protests used the institutional framing of the BBC to mark authority, legitimacy, and to give voice to the content that they had created. At the same time, the ability to tell the story using this content conferred legitimacy on the BBC as a news organisation even when they could not be there on the ground – a more symbiotic relationship perhaps than we started with.

This is an example that can be understood further if we review Snow et al.'s theory of 'frame alignment' (1986), which I have used before to understand participatory media practices – social media in particular (Kidd 2011a). Snow et al., writing within the discipline of social movement theory, extend Irving Goffman's frame analysis technique to assess the meaningfulness or use-value of participation. In organisational research, Goffman's work allows us to begin to analyse whether the frames being projected by an institution match the frames within which users organise and understand their participation: 'the individuals' framing of activity establishes its meaningfulness for him [her]' (Goffman 1974: 345). Such an analysis allows us to understand how texts, events, objects and situations are processed cognitively in order to arrive at meaning (Johnston 1995: 218).

Snow et al. propose that if the frames that participation is organised within (by, say, an institution) are out of alignment with the frames within which it is interpreted (by, say, users), successful participation can be difficult to achieve, and both parties will be ultimately dissatisfied. Conversely, in the example above, we see what can be achieved when 'frame alignment' is reached and understanding powerfully negotiated.

User-Created Content in the Museum

In the museum studies and heritage literature a more nuanced discussion about what visitors' content looks like and how it might best be incorporated is beginning to emerge (Ridge 2007, Simon 2010, Adair et al. 2011). I suggest that it would be productive to use the above realisation about frame alignment as a start point, regardless of the type of content that is being created or, indeed, 'generated'.

As will become a theme in this book, it is worth reminding ourselves that user-created content is by no means new in the museums context. We might note for example the ubiquity of on-site comment cards and visitor books which purport to give users a platform to contribute, and to influence.[3] However, as again will become a running refrain, it is the scale of user creativity enabled by digital media

3 Still very much in use, and in the news in 2013 after American pop star Justin Bieber visited the Anne Frank House in Amsterdam and wrote in the guestbook 'Truly inspiring to be able to come here. Anne was a great girl. Hopefully she would have been a belieber.' The Anne Frank House posted the comment on Facebook and caused quite some controversy (Williams 2013).

which makes it worthy of further study within the museums context at this time. Indeed, we might note that the opportunity to comment or sign a visitor book has itself, at least in part, migrated to digital platforms, such as the Anne Frank House Guestbook now available online[4] and the United States Holocaust Memorial Museum Pledge Wall, available both on site and online.[5]

Using examples, this section overviews and complicates a set of binaries that are often set up in discussions about user-created content. I wish in this chapter to introduce some increasingly everyday platforms for user creativity which set the groundwork for an exploration of more extensive narrative forms of user-created content in Chapter 4. Each form of user creativity will be outlined briefly in order to explore one of the complex binaries at play in the debate about such content. I will look in turn at public curation and the amateur/professional binary; crowdsourcing and the grassroots/top-down binary; participatory art and the authenticity/quality binary; and lastly photo sharing sites and the open/closed binary.

Public Curation and the Amateur/Professional Binary

There are now a great number of examples of public curation – here defined as curation *by* the public, often *in* public – which tend to 'blur the boundaries between public and curator', indeed 'allowing for models that potentially could establish a more direct reflection of the demands, tastes, and approaches of an audience' (Paul 2006: 13).

The Rijksstudio facility offered online by the Rijksmuseum in the Netherlands is one case in point. A collection of 125,000 digital artworks is available online in quite remarkable quality for members of the public to 'collect' within their own 'studio'. Users can, if they wish, use the Master Matcher facility to provide some recommendations (choosing from multiple choice images in response to provocations such as 'In another life I was a ...'), view other users' studios or delve into the archive via common thematics or available metadata (name, date and artistic movement for example). All the while, a user can be saving artworks to their studio in full or in part (in the detail). The default for collections is public, and all 'collectors' are encouraged to share their collections via their social networks. They can then also download the images and 'get creative', implying a cross-over into a more extensive form of user creativity (see Chapter 7). There are more than 106,000 public Rijksstudios as at September 2013. The Google Art Project of course operates in a similar manner, and sites like Art Steps[6] allow users to present collections of their own, or others' artworks and photographs in their own virtual museum. Here we have the creation of what Ross Parry has called the 'personal

 4 Available at http://www.annefrank.org/en/Social-media/Guestbook/ [Accessed 24 September 2013].

 5 https://donate.ushmm.org/page/signup/pledge-to-prevent-genocide-now.

 6 http://www.artsteps.com/ [Accessed September 2013].

museum' – a 'place where authorship and authority could be shared rather than made the preserve of the curator alone' (Parry 2007: 109).

Interestingly, the Rijksstudio facility also encourages users to pin artworks via Pinterest, a site we might credit as in part responsible for bringing talk of 'curation' more confidently and pervasively into the public lexicon. Rather than seeing, or at least acknowledging, spaces like Pinterest as a threat to the very notion of the collection (as a 'whole') the Rijksmuseum is embracing its functionality, and the ways in which its artworks might spread amongst and between Pinterest's community of users as a result. This is unlikely to have been thought desirable even 10 years ago, especially when one notes the populist and often consumerist tone of the activity taking place there. Sites like Pinterest – full of endless shopping lists, wants and fetishes under the banner of 'things you love' – re-frame (frame again) artworks and museum objects as commodities, things to possess, and to trade.

All of the above in subtle and not so subtle ways complicate both collection and curation as professional praxes, opening them up to 'amateurs' who *may* have little interest in – or respect for – the intricacies of collections management, or the computational systems that underpin such processes. To such individuals, the expert–novice dichotomy is perhaps neither useful nor relevant. On this thematic, Ross Parry quotes Howard Besser from 1997 saying:

> And when members of the general public have (from their own home) access to a wealth of digitised images and scholarly information, many will begin to make their own links and juxtapositions among these images. This may further erode the authority of the curator as the leading figure who places images within context. A possible result may be an erosion of high culture in general, with the curator's role becoming somewhat akin to that of a film critic. (Besser in Parry 2007: 109)

More collaborative public curation projects have of course been trialled. Perhaps the most oft-cited are those run by the Brooklyn Museum, most notably the Click![7] and GO[8] exhibitions (2008 and 2012–13 respectively). Click! featured online submissions from artists that were then evaluated online by members of the public, ranked and then installed in the exhibition. GO was a 'community-curated open studio project' and featured more than 1,700 artists opening their studios so that members of the public could visit and nominate them for inclusion in the final exhibition.[9]

7 http://www.brooklynmuseum.org/exhibitions/click/ [Accessed September 2013].

8 http://www.brooklynmuseum.org/exhibitions/go/ [Accessed September 2013].

9 I have included both examples here rather than in the section on crowdsourcing according to Brabham's definition of crowdsourcing as excluding those activities that are more akin to voting (2013). They do make rather exquisite examples of organised public curation however.

In another example at Wakefield Museums, England, a more hands-on approach again is seen as fitting in the 'Curate Your Own' project. Here, participants in the project have been working closely with the museums and the communities they represent to digitise and document artefacts of importance in preparation for a virtual museum installation in 2014.[10]

The above examples demonstrate the ways in which, in subtle and not so subtle ways, museums are opening the door to the various interests and expertise of their communities of users (local and global). Within that process, there is a necessary negotiation of authority between parties. Museums will become more confident about what and how much they are willing to 'give' and ask for in such negotiations, as of course will users.

Crowdsourcing and the Grassroots/Top-Down Binary

There is now much talk about the possibilities and affordances of crowdsourcing as a model of participation within the museum,[11] but it is worth reviewing for a moment some definitional issues. What does it mean to talk about crowdsourcing, the wisdom of crowds, cognitive surplus and collective intelligence, and what might be the implications for the museum?

According to Daren Brabham, one of the foremost writers on crowdsourcing, it can be defined as the 'deliberate blend of bottom-up, open, creative process with top-down organizational goals' (Brabham 2013: xv). Both of these elements are, according to Brabham, co-present in the best examples of the form; indeed, it is between these constituencies that the power must be situated:

> For mutual benefit to be enjoyed, I argue, the locus of control in the creation of goods and ideas in crowdsourcing must reside *between* the organization and the community in a shared space that maximizes the benefits of top-down, traditional management with the benefits of bottom-up, open creative production. (Brabham 2013: 4)

For Brabham, projects that simply ask the community to vote or to express opinions do not fit the criteria, being instead 'marketing activities' that operate in a purely top-down fashion (2013: 9).

For museums that are steeped in authority, and that have traditionally been best characterised as top-down management structures and processes, this is of course an intensely challenging yet exciting prospect: an opportunity to genuinely meet

10 http://wakefieldmuseumsandlibraries.blogspot.co.uk/2013/05/curate-your-own. html [Accessed September 2013].

11 There is also increased talk about crowdfunding as a model for individual projects, and even for launching whole new museums. A search on Kickstarter will reveal many live and already funded campaigns.

users in a shared space of authority: to acknowledge their capacity to contribute: and to resist the urge to assume that they might mess it up.

Proctor argues that such projects might be more radical than preceding forms of participatory practice in the museum, putting the wisdom of the crowd 'in dialogue rather than in competition with formal institutional knowledge' (Proctor 2013: 105).

The Notes from Nature 'citizen science' project is a particularly addictive crowdsourcing endeavour.[12] Here, 'transcribers' are sought to read and note the collection details of a number of specimens from museum archives (including from the Natural History Museum, London, and the Museum of Natural History, Colorado). As at September 2013 there were 3,713 transcribers, and the transcription process was 22.5 per cent complete (of 277,097 total transcriptions). Incentives for involvement are articulated as 'improving our world', 'contributing to real science' and the reward of online 'badges' once particular targets are reached. This is not dissimilar to the Victoria and Albert Museum's untitled crowdsourcing initiative[13] which has been running for a number of years, again delving into the archives and performing 'maintenance'. Here, contributors crop images from the collections so that they are more attractively displayed online.

The Natural History Museum is also involved in another citizen science project that we might note here. The OPAL project utilises an app[14] in order to secure participation from people whilst they are out and about, asking them to explore their environment and to report (via the app) if they come across six 'Species Quest' bugs which are particularly of interest: a two-spot ladybird or a green shieldbug for example. Contributors can use the app to take a photo and submit it directly to the project. These observations then appear on an interactive map. In these examples, in quite subtle ways, one can see that the intellectual and physical investment of users is genuinely working towards improving the museum, and even the state of 'knowledge'. It is also likely that those users will feel a sense of ownership over the collection in ways they have not done previously. According to Nina Simon (2012), such projects demonstrate that museums have the potential to create and cultivate both public and civic value, and thus make real change.[15] This, Simon suggests, is what will ultimately set the participatory work of museums apart from the plethora of other outlets available for creativity.

Participatory Art and the Authenticity/Quality Binary

In 2012 the National Media Museum in Bradford, England, opened its permanent gallery dedicated to the internet: Life Online.[16] As a part of the gallery, and its

12 http://www.notesfromnature.org/#/ [Accessed September 2013].

13 http://collections.vam.ac.uk/crowdsourcing/ [Accessed September 2013].

14 http://www.opalexplorenature.org/bugs-app [Accessed September 2013].

15 This is reminiscent of the discussion about the cultural public sphere in Chapter 2.

16 I have written about this previously in Kidd 2014.

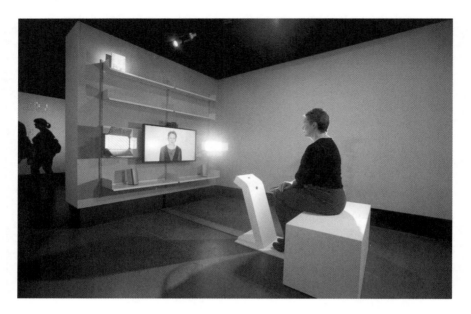

Figure 3.1 *Read Aloud* **(2012), Ross Phillips at the National Media Museum.**
Image courtesy of the National Media Museum, Bradford

associated temporary gallery space, the museum hosted a series of collaborative artistic works, one of which was Ross Phillips' *Read Aloud* (Figure 3.1). Contributors were tasked with reading one line of a book (not knowing which book) aloud to camera. Over time, as more contributions came in, the book began to take form. The resultant stories were available in the gallery and were also posted online.[17] This was a project that had been commissioned by the National Media Museum for the gallery, and presented with all of the associated accoutrements of display: white cube gallery space, interpretative materials and the larger framework of the other collaborative works surrounding it. As such, it was given an authority. Yet the actual contributions had the now familiar aesthetic of the everyday within which a very different kind of authority is inscribed – that of authenticity.

Authenticity is of course a knotty concept, having been theorised extensively in a range of disciplines (summarised in Kidd 2011c). Here I employ the term to complicate the notions of 'reality' legitimised in material and artefactual heritage, and which are set against notions of performativity such as those found in practices of self-representation, art and other creative practice. This traditional understanding of authenticity has been undermined in the digital environment where 'reality' and 'aura' are problematised and multiplied. As a part of the wider diversification of representation we have seen across the media and culture, authenticity has been

17 At http://www.readaloud.info/ [Accessed September 2013].

relocated to the site of the individual, *their* truth and interpretations having an increased legitimacy and currency as 'the real'.

In my own research I have documented the historical tension between letting such an understanding of authenticity inform, even shape, cultural processes and representations whilst simultaneously seeking seemingly objective 'quality' in outputs (Kidd 2009a). There is often an assumption that projects which do good work with communities or individuals will necessarily suffer when it comes to the assessment of quality.[18] This tension is even legitimised in theories of participatory endeavour that divide projects along either *process* or *product* trajectories (Ambrosi and Thede 1991, Rodriguez 2001).

What we might note is that in many of the projects outlined in this chapter a utilitarian compromise has been struck between quality and authenticity that better enables the project to achieve its participatory agenda. I suspect that museum 'users' and 'users' of digital cultural products more broadly – such as of YouTube – are becoming better able to read across both of these axes, and to make assessments about where and under what circumstances the trade-off (if indeed there has to be one) becomes unworkable; but that of course needs further investigation within the museums context.

Photo Sharing Sites and the Open/Closed Binary

Museums now commonly use and encourage the sharing of content on photo sharing sites such as flickr and Instagram. Indeed, as Jim Richardson notes: 'Photo sharing website Flickr has long been a favorite social media space for museums, it is cheap, easy to use and has a large and active community of users' (Richardson 2009a), and it is common for a number of activities, including sharing archival materials; encouraging contributions to exhibitions and other curatorial functions; locating 'authentic' materials for advertising and marketing purposes; and engaging audiences in games. Instagram is a newer arrival, but has been similarly well received.[19]

Instagram is a photo sharing site that encourages users to transform the look and feel of photos with filters. The site has proved immensely popular for the sharing of seemingly aesthetically 'beautiful' images, tinged with a hint of nostalgia. Many museums have accounts on Instagram where they can share their own photos (the Louvre, the Guggenheim and the Museum of Modern Art for example), but the most remarkable feature is the ability of 'ordinary' members of the public to share their photos taken on site also (as with flickr).

18 This assumption is brought into even sharper focus when one looks at projects that involve creative practice with children and young people, such as in the Tate Kids portal at http://kids.tate.org.uk/ [Accessed September 2013].

19 See http://nitrogr.am/blog/30-museums-on-instagram/ for an overview of the 30 most active museums on Instagram as at 25 June 2013.

Photo sharing sites have challenged museums in a number of ways. Firstly, they have challenged the notion that photography is not an activity that is appropriate within museum settings. Secondly, through these and other platforms such as YouTube they have removed from institutions the capacity to control their public image (if, indeed, they ever had that ability); and thirdly, the staggering uptake of such sites by visitors has necessitated discussions about how best to take advantage of the content shared therein, the activities encouraged on site (such as social tagging Chun et al. 2006) and the communities of interest that arise around them. This has meant a very real appraisal of the parameters of the museum as 'open' and as 'closed'.

In this last binary especially we see an increased hybridity and co-location between museum-owned/located and user-originated source materials and ideas. What emerges is the potential for a practice best articulated and understood within what has become known as a 'remix' culture. This will be explored further in Chapter 7.

Conclusions

This is of course not an exhaustive list of the kinds of facility being activated for user-created content. It does not include, for example, more discreet and difficult to locate forms of museum fandom, or blogging for example. Neither is it a comprehensive exploration of the binaries at play here. We might, for example, suggest that there are additional binaries around profundity and triviality: how meaningful the activity is understood as by all constituencies; are we simply 'amusing ourselves to death' (to extend Postman 1985); or perhaps there is an emergent binary around 'official' museum and 'unofficial' museum, the difference becoming harder to discern in the online context (as in, say, the Museum of Flickr, which has its own very tongue-in-cheek list of museum rules.[20]

A number of questions arise for further research, and for debate within and beyond the sector. Is the museum interested in the quality of process or the quality of product when it comes to user-created content? Do the creators feel the same? Are projects audience led, technology led or content led? How does such content fit within institutions' workflow models and their key performance indicators? And what if we find it doesn't?

Satwicz and Morrissey have noted that, in a nod to framing and alignment as proposed above, not enough thought is given in the museums context to ascertaining, and articulating, why user-created content is being encouraged and curated:

20 Including: 'No food or drink. No running. No Loud Talking. No flash photography. No diving. No staring No pointing … Don't Slouch. Call Your Mother … Please do not tap on the glass (You'll mess up your monitor)' (Eden 2013).

in most cases, museums and designers have not articulated or assessed the actual benefit, identified who benefits (museum, current visitors, future visitors, contributors, or consumers), or articulated indicators of that benefit. Is the goal to increase learning (an educational goal) or to build community among current users (a social goal) or to entice new audiences (a marketing goal)? What is the range of possible interactions and outcomes? In what ways does public curation afford opportunities for new outcomes? (Satwicz andMorrissey 2011: 198)

So, for example, as a curator with my own Rijksstudio, should I be expecting to learn, to share, to interpret for my potential 'audience'? How will my collection be made sense of and sustained by the institution? Those frameworks of meaning in relation to my participation remain ambiguous. These are questions that underpin, in more urgent ways, the analysis in the following chapter.

More broadly, as in the media studies literature discussed in the opening paragraphs of this chapter, we might ask how content creation in museum contexts might translate into other kinds of participation, not least civic and societal participation. Do all of these moments of micro-creativity collectively indicate the possibility for more active and vibrant democratic participation? Howard Rheingold, noted scholar of pedagogy and participation, believes that:

a participatory culture in which most of the population see themselves as creators as well as consumers of culture is far more likely to generate freedom and wealth for more people than one in which a small portion of the population produces culture that the majority passively consume. (Rheingold 2013: 218)

Raymond Williams said in 1976 that 'the people who really matter, in any culture, are the active contributors' (Williams 1976: 123). In 2014, that number is rapidly on the increase.

Chapter 4

Democratising Narratives: Or,
The Accumulation of the Digital
Memory Archive

Museums curate both tangible and intangible artefacts of memory from a range of different sources, and increasingly facilitate others in related practices of creation and curation also. The stories that museums tell are diversifying, multiplying and cross-fertilising across platforms and through varying constituencies (Bennett 1995, Smith L. 2006, Vergo 1989, Walkowitz and Knauer 2009, Marstine 2006, Knell 2004, MacDonald and Fyfe 1996, Janes 2009). One consequence of this has been a growth in the personal narrative archive that has been unprecedented even since the advent of oral history and other techniques in the early part of the twentieth century.[1] This is demonstrated in requests such as those by HMS New Zealand,[2] the Canadian Museum for Human Rights,[3] the National Museum of the United States Army[4] and the Museums of Los Gatos[5] to 'share your story' online, and the call by the Victoria and Albert Museum to 'share your memory' alongside the 'Memory Palace' exhibition[6].

This chapter seeks to contextualise that activity, asking what it is about personal narrative that we find so compelling, and exploring how such narratives intersect with and are shaped by new technologies in the practice of the museum. It is perhaps in the realm of the personal narrative archive that the authority and authenticity of the museum voice is being most actively challenged, yet (perhaps for that very reason) these emergent narrative forms and outputs often remain the most invisible across museum platforms.

After considering both narrative and memory in light of the digital, this chapter will present research into three museum initiatives that embrace and seek to archive personal narrative memory: one from the United Kingdom, another from Australia and a third from the United States. Together, they raise a number

1 This practice is perhaps most famously demonstrated in the work of StoryCorps in the United States. See http://storycorps.org/ [Accessed July 2013].

2 http://www.hmsnewzealand.com/submit-your-story [Accessed September 2013].

3 http://share.humanrightsmuseum.ca/ [Accessed September 2013].

4 http://thenmusa.org/soldiers-stories/ [Accessed September 2013].

5 http://www.museumsoflosgatos.org/site/history-museum/share-your-story/ [Accessed September 2013].

6 http://www.sky.com/memorypalace [Accessed September 2013].

of questions. What use-value is attributed to projects purporting to archive digital memories in the museum? Do those digital memories constitute personal memory or collective memory (or social memory as understood in Olick et al. 2011 and Zerubavel 2003)? What and whose stories get told (and preserved)? Whose 'truths' are recorded (even 'untruths')? And how are such archives being institutionalised, housed and sustained?

This chapter takes as its focus personal narratives, individual memory and how the museum operates as a point of intersection between the two, as a facilitator of narrative memory.

Personal Narrative and Selfhood

Storying has been the source of both personal and societal wonder and challenge for many centuries, with storytellers serving 'not only as entertainers, but also as sacred functionaries, historians, teachers or healers' (Lwin 2012: 226), creating spoken and written bridges between the past and the present, and the living and the dead, for the purposes of education and entertainment. Indeed, storying remains critical to our sense of what it is to be human: 'Without stories, we would not be human' (Sloane 2000: 189, but see also Murray 1999, Fulford 1999 and Finnegan 1997). Story helps us to connect our experiences and make sense of them in relation to other events and individuals around us. It is crucial – say theorists such as Dan McAdams (1993) and Ruth Finnegan (1997) – to the creation of a notion of 'self'. Moreover, according to Finnegan, the self is 'formulated and experienced through self-narratives' (Finnegan 1997: 69).

It is a truism to assert that we now experience narrative endlessly: in our leisure time, through work, through our politicians, our faith and our education (both formal and informal). According to Richard Fulford, 'we live under a Niagara of narrative' (Fulford 1999: 149). Museums are cases in point here, with storytelling sessions a frequent part of the museum experience that are seen to have 'specific communicative, persuasive or educational purposes that exist together with or behind [a] recreational façade' (Lwin 2012: 227). We find story put to use in other areas of the museum lexicon also, not least when it comes to articulating and activating museums' institutional pasts.

Narrative memories can be differentiated from more routine or habitual memories of the everyday in that 'they are affectively coloured, surrounded by an emotional aura that, precisely makes them memorable' (Bal et al. 1999: viii).[7]

7 'Memory' itself is of course a broad and contested terrain which there is not space here to unpack, being what Confino has called 'perhaps *the* leading term, in cultural history' (1997: 1386). Here I work with Erll's understanding of memory as 'an umbrella term for all those processes of a biological, medial, or social nature which relate past and present (and future) in sociocultural contexts' (Erll 2011: 7). We might also note Confino's succinct definition: 'the ways in which people construct a sense of the past' (1997: 1386).

The telling of these narratives is often rehearsed and almost universally socially constructed. Zerubavel notes that people tend to remember in a 'socially appropriate manner' governed by 'social *norms of remembrance*' (Zerubavel 2003: 5). This allows the teller to maintain a sense of mastery and authority as the 'director-narrator', a term used by Mieke Bal to describe the role of the 'rememberer' in these instances (Bal et al. 1999: viii). The majority of research undertaken in this field has concentrated on narratives of trauma as a specific psychological practice (Bennett and Kennedy 2003), but there has been significantly less research carried out into how museums have utilised and made sense of forms of personal memory making (digital or otherwise) as aesthetic and archival practice.

Narrative memories have never been more encouraged than in our current social climate where 'self stories proliferate' (Frank 1995 quoted in Crossley 2003: 109). Numerous books, websites, television programmes and museums encourage the divulging of personal narrative in the hope that individual and social coherence can be achieved. The creation of 'life story' as a practice of identity construction and solidification (particularly in the latter stages of life) is seen by Dan P. McAdams as an 'act of psychosocial and social *responsibility*' (McAdams 1993: 268), the result of which can be a positive ordering of experience and even *healing* (for more on the creation of life-story or narrative healing, see McAdams 1993, Crossley 2003, Finnegan 1997, McLeod 1997, White and Epston 1990). Recognised by Zerubavel in 2003 as 'emplotment' (a term first used by French philosopher Paul Ricoeur 1984), the purposeful making of connections and imposition of narrative form can help individuals to locate meaning. This type of undertaking thus becomes a 'retrospective mental process' (Zerubavel 2003: 13), itself perhaps an integral part of the life narrative being created. This process is of course open to accusations of nostalgia, escapism, even narcissism, at the same time as the rhetoric surrounding such practices speaks of responsibility and empowerment.

The notion of self has been reconfigured in recent academic discourse, and is now recognised as comprising a fractured, contradictory set of *selves* (Sarup 1996, Hall and du Gay 1996, Crossley 2003, Weedon 2004). It is perhaps fruitful, in this discussion, to imagine self in those terms used by Martin Conway in his study of autobiographical memory: as 'a set of memory structures which represent specific-self knowledge' (Conway 1990: 90). In this conceptualisation, we note that self and memory are entwined, with both having personal significance particular to the individual. Narrative remembering is one way in which we can come to know our selves, a process informed by the specific social and cultural context within which we remember.

Marie-Laure Ryan asks, 'But what has the computer done for narrative'? (2006: xii), and we might note in response that 'fractured' narratives of self are perhaps more easily and urgently represented through digital practices, enabling exploration of dislocation and multiplicity with unique personal significance, and as publicly or privately as we might wish.

This chapter seeks to explore how the museum archive documents and distorts these processes.

The Democratisation of Narrative

The 'forking paths of nonlinear narrative' (Johnson 1997: 127) digital media facilitate can be used to represent multiple viewpoints; and they can also, potentially, make a contribution to the democratisation of our cultural institutions, as Mark Poster said, enabling a 'new loci of speech' (Poster 2001: 614). This democratisation is seen as a desirable, if not inevitable, outcome of the 'new mediascape', but is by no means a new phenomenon. As Rabinovitz and Geil assert, it is crucial to avoid the myopic 'rhetoric of newness' and an outright denial of continuity in these practices (2004: 2). 'Citizens' 'alternative' or 'radical' media (Rodriguez et al. 2009, Rodriguez 2001, Atton 2002 and Downing et al. 2001) have long histories of operating outside, and occasionally synchronising with, the mainstream. Nevertheless, democratisation of narrative on a scale unprecedented is seen as being an increased possibility in our technological climate:

> The kaleidoscopic power of the computer allows us to tell stories that more truly reflect our ... sensibility. We no longer believe in a single reality, a single integrating view of the world, or even the reliability of a single angle of perception. (Murray 1999: 161)

At its heart then, this is a discussion about groups and individuals' rights to representation. Representations typical to mainstream media and culture help to produce and circulate meaning – what it is to be European for example – to the rest of the world, and perhaps even to those living within the continents' (various) borders: 'It is through our systems of representation, rather than "in the world" that meaning is fixed' (Hall 1997: 7). And so it is for the museum also where representation and memory are ensnared (Steyn 2014).

The cabinet of curiosity (the origin of the modern museum) was, in practice, a frame for the presentation of that which constituted the 'spectacular'. Both natural and man-made elements from around the world were presented alongside one another seemingly at random, in part because their systems of classification were yet to be established. Through hundreds of years of museum development this notion of the spectacular has remained at the heart of museum practice, and this has proved to problematise institutional purpose, as recognised by Ames: 'Museums are compromised institutions, caught between their twin desires for both authenticity and the spectacular' (Ames 2005: 44). The new museology movement, however, represents a step toward recognising that the everyday truth of the 'ordinary' is 'intrinsically interesting' in itself – a phrase coined by Richard Hoggart in recognition of the 'ordinary' in cultural studies (1957: 120). As Thomas J. Schlereth acknowledged in the 1980s, 'In the past two decades museums have become increasingly interested in the objects of everyday life' (Schlereth 1984: 110). As a consequence of this recognition, there has been a shift toward what Tony Bennett calls 'representational adequacy' or 'parity of representation for all groups and cultures' within the various different activities of the museum, 'collecting,

exhibition and conservation' (Bennett 1995: 9), a recognition that there are perhaps no grand narratives of truth about the world (see also Hooper-Greenhill 2000). Widening a museum's appeal is no mean feat given the recognised sexism, racism and Eurocentrism within 'traditional' collections,[8] and the reluctance of some to cross the (oft-intimidating) physical threshold into buildings that still maintain architectural nods to their 'civilising' Victorian function.[9]

The new museology movement has sought to reconcile this history, beginning to confront it with the multitude of narratives which we now recognise as comprising 'truth' in actuality. As a part of this, 'the visitor is recognised as bringing a lived reality to the museum experience rather than the morally and intellectually blank slate assumed by museums in the late nineteenth and early twentieth centuries' (Burton and Scott 2003: 56). This means that museum output, including research and curatorial responsibility, has become increasingly about dialogue with the communities a museum serves (and also, crucially, those communities *not* being served). As part of this shift it has been acknowledged that access is not only about being *seen* to represent, but also about democratising the right to speak and to create:

> a museum can continue to fulfil its goals of collecting, preserving, studying, interpreting and exhibiting, without necessarily shaping, constructing and creating all of the content. A museum's role can be to support – not to create. (Bradburne 2000: 389)

This kind of endeavour, according to Bradburne, 'signals a far-reaching and courageous re-examination of the museum's "top-down" role' (2000: 387).

Digital Memories

> we embody create and are emplaced within digital memories. As our lives have become increasingly digitized, so digital memories become us. (Garde-Hansen et al. 2009: 1)

Digital media are recognised as having a sizeable and ever-increasing effect on the ways in which memory can be, and is being, represented and reconfigured in

8 As recognised by Vergo, who said: 'In the acquisition of material, of whatever kind, let alone in putting that material on public display or making it publicly accessible, museums make certain choices determined by judgements as to value, significance or monetary worth, judgements which may derive in part from the system of values peculiar to the institution itself, but which in a more profound sense are also rooted in our education, our upbringing, our prejudices' (Vergo 1989: 2).

9 The historical development of the museum – architecture, patronage, form and function – is detailed in Tony Bennett's *The Birth of The Museum* (1995). See also Hooper-Greenhill (2000) and Message (2006).

the early years of the twenty-first century (see for example Amelunxen et al. 1996, van Oostendorp 2003, Rabinovitz and Geil 2004). Our very ideas about the form, permanence and malleability of memory are being infinitely and creatively explored through multiple forms of digital media. We are now able to encounter many differing forms of representation independently and/or simultaneously (visual, textual, aural, even sensual) which coherently (or otherwise) constitute representation (van Oostendorp 2003). Indeed, it is possible that memory is being distributed.

Digitality is at the heart of our current 'memory boom' (as recognised by Andreas Huyssen). As Huyssen notes, 'We cannot discuss personal, generational, or public memory separately from the enormous influence of the new media as carrier of all forms of memory' (Huyssen 2003a: 18). This *carrying* of memory for a presumed infinitum is a task the digital media ably take on, at the same time as they aid the collapse and shrinkage of time and space, resulting in what Huyssen calls 'the crisis of temporality' (Huyssen 2003b: 21). Digital media thus have an integral role to play in what is remembered, the form in which it is stored and, later, how it will be retrieved. Indeed, as Garde-Hansen et al. note in *Save As ... Digital Memories*, our very understandings of what is 'past' are reconfigured in the digital:

> The digital suggests that we may need to rethink how we conceive of memory; that we are changing what we consider to be the past; that the act of recall, or recollection and of remembering is changing in itself. (Garde-Hansen et al. 2009: 1)

Digital archives are exemplary of this shifting focus. Be they public or private, such archives have an increasing role to play as holding places for those artefacts of memory which contribute to our sense of cultural and individual significance. They also take on a wider, collective significance as source materials and 'content providers' (Tan and Müller 2003: 55). This development and its implications for both professional and amateur media producers – terms that may yet lose their distinctiveness – have yet to be fully explored or (no doubt) exploited. As we all become archivists, so too we all become curators in a process of 'musealisation'; and, as a part of this process, questions are inevitably asked about the place of truth, accuracy and authenticity. This is a primary concern with archives defined as autobiographical in focus where the 'memory archive' can easily be dismissed as a 'cabinet of delusions' (Huyssen 2003a: 6).

Gaynor Kavanagh has noted that there are problems associated with viewing memory as 'source material' or as 'product' within museum contexts, noting that museums' short- and long-term agendas tend to steer such co-operative endeavours often to their cost (Kavanagh 2000: 4). Appropriation of personal memory 'products' is common, and raises questions about the ethical principles that underpin such work and its legacies (Kavanagh 2000). Similarly, there can be problems with viewing digital reminiscence work purely as 'process', not least because the museum has such a profound impact in directing that process: how it is framed, delivered (on site, online or in workshops), understood and given

significance for contributors (or not); and that process's impact on how solid and scripted the memory itself becomes.

Neiger, Meyers and Zandberg take as their focus 'collective memory in a new media age' and note that collective memory – by virtue of being publicly articulated as rituals, ceremonies and mass media texts – is 'an inherently mediated phenomenon' (2011: 3) They propose that collective memory, first theorised by Maurice Halbwachs in his seminal work *On Collective Memory* (*La mémoire collective*), is being 'concretized' on the Internet in the same way that it has been materialised through physical structures such as museums and monuments (2011: 5). This of course has ramifications, and raises questions for Neiger et al. around agency and context.

Collective memory serves a number of functions according to the literature (which is exceedingly rich in this area). According to Zerubavel, the acquisition of collective memory is essential to the location and maintenance of social identity, to being assimilated into communities, and to gaining a sense of a common past (Zerubavel 2003: 4). Sometimes referred to as social memory, the communal nature of the remembering itself is also significant, a fact I have seen confirmed in my own research (Kidd 2009a 2011c).

The remainder of this chapter will look at three examples of digital narrative archives to explore what kinds of collective memories are being concretised therein. If collective memory is only ever one interpretation of the past, then whose version is it? How is the process of collation and curation being managed, framed and negotiated? And what function is it serving in each instance?

The Digital Memory Archive: Three Case Studies in Mediated Narrative Memory

In this discussion I employ three very different digital memory archives – and processes – being hosted by museums. Each is used to explore a different aspect of the memory literature, making sense of individual narrative contributions within the larger 'collective' memory produced through the project and within the larger narratives constructed by the museums themselves. In each case, contributions from 40 individuals were coded, noting the tone, perspective, tense and theme of the contribution; the source materials used; any responses from 'viewers' online; and their unique positioning within the totality of the archive (so, a total of 120 contributions were analysed). The literature references autobiographical, topographical and flashbulb memories in order to explore what *kind* of memories are being invoked by each of the calls to remember.

Tyne and Wear Archives and Museums: Culture Shock! Digital Storytelling as Autobiographical Memory

Digital stories are short multimedia films recognisable by their 'scrapbook' aesthetic (Meadows 2003). More often than not, they consist of a voiceover and

images (photos, clippings, scans, home video) and are sometimes accompanied by a musical soundtrack. At around three minutes long, and with a script of approximately 250 words, their tone is often intensely personal, and their narrative deliberate. The emphasis on photographic elements from the tellers' lives necessitates an intimate and autobiographical feel to many of the stories. This autobiographical element will be the focus here.[10]

The Culture Shock! digital storytelling project ran from 2008 in the North East of England, and was facilitated by Tyne and Wear Archives and Museums. The goal of the project was to collect up to 1,000 stories,[11] to 'preserve them in perpetuity' as accessioned digital artefacts and to circulate them via the web. Originally, all stories in the collection were to be inspired by museum objects, but this was revised in time for two reasons:

> first because participants did not conform to the premise that there *must* be something that inspired them in the collections; and second because it limited the range of stories according to the variety of artefacts people were able to engage with in a time-limited visit to museum stores. (Culture:Unlimited 2011: 15)

Another of the project objectives was to 'understand how a participant-driven, personalised, digital project would fit into museum practice' (Culture:Unlimited 2011: 18), including what might be learnt about its influence on those contributors less fluent in the museum code, those of varying demographics, and on digital collections management. I wish to suggest that they reveal something also about how autobiographical memory is collected, shared and institutionalised within the museum.

Autobiographical memories can be characterised and are facilitated by self-reference. Although there is no absolute and accepted definition, Conway (1990) usefully highlights the following as features that such memory might include: personal interpretation, variable veridicality, long memory duration, imagery and something of the experience of remembering. To Singer and Blagov (2004), 'self-defining memories' are vivid, affectively intense, repetitively recalled, linked to other similar memories and often represent unresolved conflicts or enduring concerns. The variable veridicality (possible unfaithfulness to fact) which Conway sees as inherent to autobiography is of course an interesting consideration for museums, and one that has received little consideration in the literature. It could of course serve to undermine the authority of the archive as a whole, or perhaps its very unfathomability reasserts the authenticity of the archive and thus its own particular 'truth'. Either way, the potential for layering, duplicity and the embrace of the authentic, and indeed the capacity for partial and selective representation, offers a useful point of consideration given recent critiques of the larger museum project (see Introduction to this book).

10 I have written elsewhere about the history of digital storytelling and its impacts (Kidd 2009a) and how it might be understood as autobiography (Kidd 2009b).

11 Later revised to 600 (Culture:Unlimited 2011).

The Culture Shock! digital stories under analysis could all be easily understood as autobiographical. The emphasis on both personal story and unique individual artefacts contributed by participants (photographic, video, objects, the teller's voice) translates into stories that are affectively intense, often of enduring personal import, yet *true* only in so far as the teller deems appropriate. The 'I' of the director-narrator comes through very strongly, and the past tense dominates; memories are the preferred subject – especially for older participants. This accords with previous research (Kidd 2009b) that noted definite trends related to the age groups of participants. Younger participants tend to write stories about hobbies, identity construction and stereotypes:

'As I grow older I begin to wonder. Am I half of a pair? Or am I one set of two pairs? Am I half of a whole? Will I always be defined by my twin? Will I always be half of a pair? Will I ever be defined as an individual? Am I identical or am I opposite?'

'When I'm on a horse, I feel free. I feel I'm myself.'

'This goes to prove that even though I have a disability, it doesn't stop me from doing the things I enjoy, and I like taking a challenge.'[12]

Older participants are more likely to engage in life-writing and reflection (as below).

'Right, I'm Joseph Settrey from Rowlands Gill. I used to work at Marley Hill.'

'I miss those days so much, sometimes I get tears in my eyes. I wish I could be care free like in my childhood.'

'I love my mam and dad and miss them so much.'

Most have a reflective tone, with stories about family, journeys, place, illness and trauma being common. Only two of the 40 stories in the analysis can be considered explicitly fictive. As noted above, materials are principally sourced from family archives, with personal objects also playing a key part in many of the narratives.

It has been suggested that in order for autobiographical memories to become authentic or even felicitous there needs to be an element of 'narrative witnessing' (Kacandes 1999: 55). That is, there must be a teller and a listener in order for narrative of this kind to be successful. The digital storytelling process allows for various forms of witnessing: the other workshop participants and the museum staff in the first instance, and then in most instances family also. The opportunities afforded by the digital archive indicate a potential for *global* witnessing, but there is little or no evidence to suggest that this might be felicitous in the same way

12 Extracts from stories are reproduced here and indicated with quotation marks.

that immediacy of witnessing and response might be. Nevertheless, it appears that the stories have received a modest audience online. Stories have been viewed an average of 2,322 times, with one having been seen 6,688 times. Many of the stories in the analysis had received comments from viewers, one with 20 comments. Those stories that might be considered more affectively intense tend to elicit the most comments – testament not only to a witnessing, but also to some level of empathetic engagement (see Chapter 6 on empathy).

Within our various social and personal realms we are rarely, if ever, encouraged to think crucially and critically about the nature of our *self* and how it has been informed by our individual *histories*, a concern with the personal often being dismissed in favour of dialogue about community and inclusion. But artistic work can inspire such reflection: 'I do believe that the process of storytelling often engendered by participatory video gives light to instances of intense self-investigation' (Rodriguez 2001: 118–19). It is no surprise then that we see the 'self-defining memory' taking prominence (although not universally). It follows that the use of 'considered narrative' (Meadows 2004) often leads to *the* story of a life being the focus: the one-off statement that one feels able to contribute that (crucially) might make you feel you have made a difference. This is especially true given that most participants will be making a one-off intervention into their own personal photographic archive as a source.

Australian Centre for the Moving Image: 15 Second Place as Topographic Memory

15 Second Place is a project, ostensibly for students, that encourages them to reflect in film the places and spaces that give their lives meaning: to demonstrate how we orient ourselves in space. If our understanding of space is shaped by memory, and our memories shaped by locale (as in topographical memory, Lindsey 2003), then 15 Second Place proposes to build an archive of short, often cryptic, insights into experience and personal reference bounded by location. According to Bidwell and Winschiers-Theophilus, user-generated content as it relates to place may 'promise a rebalancing of power relations that affect the ways places are ascribed heritage significance'. This is not least because 'such content selects and interprets places diversely' (2012: 199). 15 Second Place might be seen as one such venture, embracing such diversity in interpretation, projection and representation.

15 Second Place was launched in 2011 by the Australian Centre for the Moving Image (ACMI), which has a history of collaborative video and digital storytelling projects. Funded by the Department of Education and Early Childhood Development, the project seeks to involve young people in an inquiry-based creative process through a focus on place: '[b]ased on the premise that place is fundamental to giving people an understanding of their environment'. The simplicity of the project and the ubiquity of the tools for contribution (most mobile phones and many cameras now have the capacity to shoot 15 seconds of film) mean that the creative process can be driven by the students themselves, in the

locations that are important to them. There is an app that contributors can access which allows them to film and upload video directly via smartphones. Those who access the archive as viewers can browse by theme/tags, by 'challenge'[13] or via a map (powered by Google). They can share films via social media, create playlists and leave comments, making this simultaneously a personal and social form of documentary and place-making.

The project currently features 684 video snapshots of places, mostly from within Australia (650), in particular the Melbourne area where the museum is situated (597). The project does however encourage submissions from other geographical contexts, presenting them on a world map. The project strapline is 'Capture the mood of where you are'; this is then a project about ambience and relationships with place. As such, the videographer remains absent, being inaudible and invisible in their 'place', an absence of self *beyond* that selection of place. This lends most of the films analysed an abstraction, a playfulness and a dependence on imagination even as the places, which become the subjects of the films, represent the everydayness of life in a city. The venues knowingly foreground the backdrop of our lives: coffee shops, parks, stations and disused buildings, accompanied by the noises of the city. As such, the emphasis in the project literature on exploration of aspects of 'creative practice that transform our streets such as street art, flash mobbing, public art, projected works, and big screen imagery'[14] is a touch misleading. The films analysed were stiller, more reflective and more cryptic than is anticipated in a stated focus on such practices. They are also predominantly unedited, beyond the addition of a closing credit by ACMI that lasts approximately three seconds.

In presenting a theory of topographical memory, Bruce Lindsey asserts that 'Topography remembered is a kind of knowledge' (2003: 41), going on to note that 'landscape and the shape of the land literally makes an impression on our memories' (2003: 48). Lindsey makes reference to Virilio's Method of Loci as a way of memorising spatial relationships. Here memories are attached to physical locations as a way of circumventing forgetting. These connections are typically difficult to make cognisant, and even more so to verbalise. 15 Second Place has created a near silent archive of topographical memories that, on viewing, can in fact be very unfamiliar and unrecognisable. In many of these films, even at only 15 seconds, the landscape holds our vision for slightly longer than is comfortable, leaving the 'witness' in this instance disoriented, having seen through another's eyes but unsure of what in fact they saw. A number of the films look skyward, upward through trees and along rooftops to the sky, a line of sight which has been said to represent and instil feelings of hope (Winter 2013); but more typically they look horizontally. The archive does not constitute a spatial map, and neither could it; rather, it encourages film-makers to reappraise

13 The project organisers set monthly challenges for contributors to (for example) film 'Places that look like Faces', 'Words on the Street' or to 'Focus on Sound'.

14 http://www.acmi.net.au/media-15-second-place.htm.

the ways in which they 'see' and are 'seen' within the various places of their memory. As with the Culture Shock! films, it is not uncommon to find objects used as a way into the interpretation of that place: a coffee cup, a fork, a cuddly toy. Their role in the construction of place, and of memory, is however rendered largely ambiguous in this instance.

9/11 Memorial Museum: Make History as Flashbulb Memory[15]

Flashbulb memory describes the phenomenon whereby people recall, with startling detail and intense feeling, a moment in time. These memories are long-lasting, vivid and often emotionally recalled. Flashbulb memory has been written about previously in relation to the public's recollections of the attack on the twin towers on September 11 2001, as a way to describe the intensity and ubiquity of memory as it relates to that 'event' (see for example Hoskins 2009). Barbara Kirschenblatt-Gimblett notes that 9/11 was the most photographed disaster in history in her 2003 article on flashbulb memory and photography, saying '9/11 has created the powerful sense that one is a witness to one's own experience and obligated to record it in some way' (Kirschenblatt-Gimblett 2003: 27).[16]

The issue of how to enact an official museal memorialisation of 9/11 has been the subject of frequent and ongoing debate. In other outlets, however, the rush to share, to speak and to document was unprecedented. Many websites devoted to discrete and dispersed personal narratives were launched before the 9/11 Memorial Museum began its own endeavour in 2009.[17] This level of activity is symptomatic of the 'highly charged public sphere that formed in response to the event of September 11th' (Message 2006: 10), another useful nod to the idea of the cultural public sphere that has emerged in this book.

The Make History project is articulated as a 'collective map of 9/11 stories' which now houses more than 1,000 photos, 17 videos and 524 stories which have been submitted in text form.[18] It is these narratives that are the subject of this section. Individual stories vary in length from a few lines to 1,000 or more words. Many include the location at which the teller was on 9/11, allowing for stories to be mapped (again via Google Maps) and accessed spatially. Indeed, this is a topographic memory also. As Kirschenblatt-Gimblett (2003) has asserted, the city itself has become a museum for and of 9/11. Stories can also be accessed on a timeline of events, via theme or topic (for example, if one wants to view those that are tagged as messages of hope). Some contributors write in the present tense, although most write in the past tense – perhaps indicating the extent to

15 The archive can be accessed at http://makehistory.national911memorial.org/.

16 She also reflects on museum responses in the immediate aftermath of the tragic events.

17 Such as those at http://www.rememberseptember11.us/, http://voicesofseptember11.org and http://11-sept.org/survivors.html.

18 As at June 2013.

which these narratives are considered, and even rehearsed in performances via other outlets:

'the bus driver calmly announces, "Ladies and gentlemen, you have just witnessed a plane crash into the World Trade Center." … complete pandemonium broke out. Sobbing, praying, frantic questioning, and impromptu rapping all filled the bus to a crescendo of mayhem.' (Chelan David)

'It was the longest day of my life. It was an event that forever changed me.' (Edith Gould)

'When I finally got on the train, I was a sardine.' (John Paul Durazzo)

There is no 'textese' as might be found in other online contributions, although there is evident a familiarity and accepted commonality in the language used and the various abbreviations that are markers demonstrating belonging: 'WTC', 'DC,' 'NJ', even '9/11'. Collectivity and connectivity of experience are also very evident, with a lot of reflection on mediatisation of the 'event' itself, recollections of turning on the television or hearing a song on the radio. The detail is often overwhelming, as we might expect with flashbulb memories.

At the end of each story readers find prompts to share their own story, to click 'I was There too …'; and throughout the site viewers are encouraged to add their own perspective: 'I have photos/video, I have stories, I have both.'

'I added a picture, but I need to tell my story too.' (Teresa Robinson)

In the sample, the 'need' to speak manifests in narrative accounts predominantly in the first person, although there was also a poem, a letter,[19] two diary/blog entries and two contributions which took the form of obituaries.[20] One other takes the form of a definition of Ground Zero, and roundly rejects the use of the term in the case of 9/11. It is common to find the phrase 'My September 11' in the title of narrative entries, demonstrating contributors taking ownership of the memory, and its significance.

The storying process has a number of functions for the contributors, not least the therapeutic:

19 'Dear Grandchildren,
 It is September of 2001 and I don't know you yet, but I am writing to you because I guess I believe you will exist someday. I'm your grandmother Alice. I'm 53 years old and Daniel and Ian are my sons. If all goes well, they will be your fathers.It is hard to think of how to begin. Something terrible has happened …' [Alice Shechter]

20 One for Waleed J. Iskandar, who died aboard American Airlines Flight 11, and another for Edward Carlino, who was on the 98th floor of 1WTC.

'I feel a strange need to dig up all of those feelings and cling to them. It was so horrible, but it all remains so precious.' (Carrie Pitzulo)

'What is my reasoning for writing up my own story of events of that morning? Is it because I am just tired of repeating to friends and family the events of that morning? Yes. Is it because I am a historian (of a minor scale) or because I think it's an event that any "eye witness" should keep his/her memories of? Is it to sort out in my own mind and try to get through it? Yes, it's all of these.' (Robert Dorn)

For the following participant, there is a desire to extend the storytelling process, and to scale up their contribution:

'The rest of my story is in several poems which I would prefer to read and give to you at the memorial site. Please e-mail me so we can arrange an appropriate time for me to come down.' (Craig Fairhurst)

As can be seen, these are flashbulb memories, topographical memories, but also autobiographical. And they raise, more acutely than the previous cases, the spectre of ethics in the digital memory archive.

What to Do with the Accumulated Digital Memory Archive

All three of the projects summarised here seek to open up museums to the voices of their constituents who are seen as being able to contribute a potentially unique and powerful perspective. At face value, they engender active audience participation which is about process as well as product, offering individuals the opportunity to contribute in one-off extraordinary ways to projects that are in themselves extraordinary to the traditional work of the institutions.

The question of in what ways these narrative archives constitute collective memory seems to me to be a central one in this discussion (see Olick et al. 2011). There is, of course, no mutual exclusivity to the ideas of individual and collective memory; a memory does still take place in one's own mind, even at the same time as it might be called forth socially or within particular group arrangements. Memory, although recognised as a personal act 'belonging to a psychological sphere', is simultaneously 'culturally *mediated* through language and convention' (Bennett and Kennedy 2003: 7), The examples above all constitute the bringing together of individual memories, but vary in the extent they might be understood as collective. The frameworks within which they are called forth are indeed social, no more so than in the group workshop process associated with the Culture Shock! digital stories, or the school groups tasked with making films as part of 15 Second Place. In such programmes the making process itself is a large part of the collective

endeavour, giving rise to potentially more potent contributions (see Rodriguez 2001). In such projects, Silberman and Purser note, the technology becomes:

> a digital version of Raphael Samuel's 'theatres of memory' – places, events and opportunities where the community as a whole and the individuals within it can reflect on the past and create an evolving image of themselves (Samuel 1996). (Silberman and Purser 2012: 19)

Make History is perhaps a more complex example of collective memory. We might note the history that is being recounted as being one that was famously collectively experienced (the events of 9/11), but the 'act' of remembering is a solitary one, one where 'individuals interact with software, not each other' (Silberman and Purser 2012: 18). Silberman and Purser propose that there is nothing collective about such online archives other than the sum of individual experiences and, as such, proclaim they fail to 'escape the one-directional frame of the museum panel' (2012: 19). This raises questions about what the use-value of such an archive might, or should, be, and how we expect any audience to respond. Erll (2011:4) notes that 'the Internet has rapidly become a kind of global mega-archive', and one of the consequences might be a sense of archive fever or, worse, archive fatigue. 'Cultural amnesia' might seem as likely an outcome as any lasting democratic intervention, as we invest the technology with the responsibility to remember and store the materials on a hard drive in some obscure location as 'dead knowledge' (Erll 2011: 4). The archive is concretised, but to what end? Moreover, the pace of technological change and sometimes costs of bespoke digital storage systems can render such archival materials inaccessible in a matter of years:

> But how reliable or fool-proof are our digitized archives? Computers are barely 50 years old and already we need 'data archaeologists' to unlock the mysteries of early programming ... Indeed, *the threat of oblivion emerges from the very technology in which we place our hopes for total recall*. (Huyssen 2003b: 25, my italics)

I have noted before that the idea of permanence itself has become myopic, and archives (full of *wholes* yet simultaneously full of *holes*) go against the very notion of memory in the twenty-first century (Kidd 2009b). Yet they persist, and become ubiquitous in museological and other practices, including personal archival practices: for example in social media, blogs and digital photo repositories.

Participatory memory projects are seen as socially and ethically more desirable than those that are not participatory, and digital tools are fast becoming a go-to resource for collecting materials and, later, providing an interface so that audiences can retrieve them. But Silberman and Purser sound a note of caution about such tools: they 'must be used with caution lest they merely enhance the dominance of the authorized, official narratives that have degraded and in many

places replaced the creative power of both individual and collective memory'
(Silberman and Purser 2012: 16–17). Here, the technologies themselves become
imbued with power: to give voice, to facilitate, to archive; but also, potentially, to
silence. Those technologies also become forms of museological power – means
for managing, framing and disciplining. They provide mechanisms for curators,
education staff or marketers (say) to interpret and create additional layers of
meaning through tags, end credits, project descriptions and transcripts that make
connections across the archive, and trying perhaps to render it coherent. Gaynor
Kavanagh's impassioned warning from 2000 still rings true:

> people [are] whole beings, not just ... filing cabinets for oral histories of
> haymaking or the manufacture of Morris Minors, ready and waiting to be
> opened, emptied and shut again. (Kavanagh: 31)

The desire to collect personal narrative memories shows no sign of abating. Quite
conversely, in 2014 the Centenary of World War I, we are seeing a ramping up
of activity in this arena – an increased urgency associated with the slippage of
time, and the (now complete) loss of first-hand witnesses to that 'theatre of war'.
But in each and every instance we should be minded to ask whether a project
is ultimately about process or product, and to honestly account for how such an
archive will be given use-value both now and in the future.

Chapter 5
'Interactives' in the Social Museum

There has been a slow trickle of research disseminated through a variety of channels on the use-value of digital interactives within museum environments and art galleries.[1] Nevertheless, this research has yet to be consolidated into a robust and coherent evidence base for contextualising and considering the continued – not insignificant – investment in such technologies. This is no doubt for a variety of reasons: the case by case (institution by institution) evaluative nature of much of the research; the interdisciplinary scope of the investigation meaning that publication takes place across a number of subject areas, and utilises a mixed lexicon;[2] the variety of approaches to study which can make consolidation or comparison of findings problematic; and the number of technologies that are seen to constitute the field (if we can call it that) of museum interactives.

Alongside this continued, if fragmented, research endeavour, we have seen the technologies on offer to museums change almost beyond recognition: from early kiosk-based computer exhibits (Gammon and Burch 2008) featuring mostly film and audio content, through to the newer generation of multi-touch interfaces currently being introduced through new exhibitions worldwide. Such a change means that the variety of encounters with digital information currently on offer at any one site may be very varied in terms of usability, content and (no doubt) use-value. In the twenty-first century, more advanced forms of mixed interactive systems have been developed, including augmented reality (AR), mixed reality (MR) and tangible user interfaces (TUIs) or 'tangible interactives' (Ullmer and Ishii 2000).[3] According to Eva Hornecker (2008a) the idea of tangible interaction focuses on human control, bodily interaction and creativity rather than simply the representation and transmission of information – a shift which would have significant implications for the role and status of interactives in museum spaces, and the embodied practices of visitation.

Such far-reaching developments make for a rather incoherent knowledge base, and raise serious methodological questions about how such interactions can best

1 See for example Pierroux and Ludvigsen 2013 on interactives in art galleries in particular, also Griffiths 2008.

2 Online databases of conference proceedings like http://www.archimuse.com/index.html, Museum and Heritage Journals, Education Journals, Technology, Information Science and even Engineering outlets.

3 Ullmer and Ishii, from the Tangible Media Group at the MIT Media Lab, define TUIs as devices that give physical form to digital information, employing physical artefacts as representations and controls of the computational data (Ullmer and Ishii 2000).

be 'captured', understood and articulated. Of course, this chapter is unable to reflect the breadth, scope and impact of each of these changes, or to fill that void in understanding comprehensively. Instead it seeks to explore the transition from kiosk-style computer interactives to larger and more open touchscreen interfaces in particular, elucidating the multiple ways interaction with mixed media content becomes simultaneously more accessible and more sociable as a result. It uses a range of empirical studies, including a detailed case study at the Museum of London, to elaborate on these themes.[4]

The distinction between computer interactives and touchscreen interfaces is characterised in a variety of ways in this chapter. Computer interactives are more often than not static, the size of a standard office computer monitor, and navigated by a sole individual (indeed a sole finger or a mouse) providing information on a number of different levels. They are often notable for their kiosk appearance and (necessarily) dark surroundings. Touchscreen interfaces on the other hand may house similar 'content', but are differentiated by the mode and aesthetics of presentation. The interface tends to be a larger touchscreen that can be accessed by a variety of people at any given time. The shift in terminology is thus more than mere semantics. Instead, it implies that there are important changes concerning the utilisation of both hardware and software, the possible inputs and outputs, and hinting at the issues of power and authority that are always ensnared in such interactions.

This chapter explores whether we might at last be entering what Dodsworth has called the 'Era of the Good Interface' (Dodsworth 1999). Is there scope to recommend the new breed of touchscreens as more social, educative, coherent and fluid contributions to the museum narrative? Or do they offer little more than an extension of those activities offered through previous incarnations of the 'computer interactive'.

I accept that 'interactivity' is a broad and sometimes unhelpful term, but use it here knowingly. As Taylor notes: 'There is a widespread tendency to treat digital technologies and the quality of interactivity synonymously … this has helped to foster an excessively uncritical attitude to new technologies – familiarity breeds contempt' (Taylor 2013: 249). The terms of its use in this chapter are very limited, allowing it to signify a particular, and in 2014 very familiar, museological encounter – one where it is evident that 'interactivity has become synonymous with point-and-click digital mediations' (Taylor 2013: 248). It is a term that, in the research recounted in this chapter, we asked audiences themselves to critique, noting the ways in which they gave 'interactivity' meaning within the museum encounter.

What Is 'Known' about Museum Interactives?

Museums' investment in computer interactives, in a number of formats, has been on the increase since the 1990s, and throughout that time there has been a concern

4 Carried out over 2010–11.

to capture and understand visitors' experiences of them. Such technologies are employed for a number of reasons, not least perceived popularity (often seen as attracting visitors to a site such as a science museum)[5] and providing an aid to interpretation. In sum, vom Lehn and Heath conclude: 'They are used to support the interpretation of exhibits and to increase the public appeal of museums' (2005: 12).

Information imparted through a variety of media is seen to engage visitors who might have diverse and contrasting learning styles, and who may be seeking differing levels of complexity in their exploration. Through computer interactives then, all visitors might be able to find a way into the artefactual heritage in a way particular to their needs, at a pace they feel comfortable with (at least in theory).

Of course, there are benefits to institutions also. Computer interactives have been seen as more flexible alternatives to traditional forms of interpretation and labelling precisely due to their basis in digital technologies:

> Such displays have important advantages over conventional labels – content can easily be restructured and changed, text can be accompanied by more complex materials, including pictures and short films, and visitors can be provided with various opportunities to select different information via different media. (vom Lehn and Heath 2005:16)

However, how far has this translated into engagement, experience and increased meaning-making has been open for debate, with little consensus about the behavioural and educative impacts of such devices:

> Which texts do [visitors] understand and in what ways? What does technology add to, or take away from, the meaning-making capacity of the museum? In a media-rich modern museum, in what ways will text be transformed as it is used and enhanced by increasingly powerful devices? The museum ideal is visitor engagement – but this means more than the self-sustained activity of a hamster on a treadmill. (Bradburne 2008: xi)

It emerges as important that visitors are able to 'read' the frames within which an engagement with a computer interactive is being organised. According to Gammon and Burch, '[v]isitors need to understand the purpose and operation ... in order to predict how it will respond to their input' (2008: 42). Visitors need to be able to perceive use-value in the interaction, and to clearly see the means and mechanisms by which it will be carried out. Critically, in Gammon and Burch's

5 According to Gammon and Burch, 'Strong support is found particularly among visitors to science centers and science museums, where digital exhibits have been shown to be immensely popular, with high attracting and holding power ... It has also been found that visitors to science centers and museums expect and demand that contemporary science topics be conveyed using contemporary digital technology' (2008: 38).

study of more than 300 digital exhibits, it was found that visitors were reluctant to use help pages, assuming that such options would be 'lengthy, boring, and complex' (2008: 45).

In an earlier paper (1999), Ben Gammon talks about the conceptual frames of interaction, highlighting the importance of sensitivity to visitors' existing understandings about how such interactions should be organised, and about how particular forms of media behave. Ignorance of these conceptual models can lead to frustrated and stilted engagements of questionable value.

Understanding of the frames of interaction – how they are constituted and understood by visitors – remains crucial because, as Dodsworth (1999) notes: 'Only the very best interfaces can teach you how to use themselves.' Research shows that users tend to spend longer at interactives when they understand their role within a narrative, and when that narrative has a clear point of completion (Ramsay 1998). Likewise, some navigational metaphors can serve to frustrate and confuse users (Ramsay 1998). Simple yet intuitive operations are the gold standard of computer interactivity.

It is important that visitors, beyond making sense of the interactive as a stand-alone interpretive tool, are able to understand that encounter within the overall framework of the museum and their museum visit. It should not be at odds with the aims and mission of the institution or jar with the themes of an exhibition (should it be part of one). As such, an interactive must make sense both within the narrative of the institution and the narrative the visitor is constructing through their visit (see Chapter 1). In terms of the physical positioning of a device, this can prove complicated. Due to their screen-based nature, interactives can often be sidelined to darker corners of exhibitions or galleries, necessarily slightly removed from the narrative being constructed within a particular museal space. As Gammon and Burch have said, a device 'needs to dovetail with the activity of museum visiting' (2008: 42). Perhaps paradoxically, for ultimate use-value, it should be 'available as soon as it is required and [then] unobtrusive when it is not needed' (Gammon and Burch 2008: 42). Positioning is thus fraught with complexities in order to ensure narrative flow for all visitors. This is further frustrated by the lack of continuity in terms of temporal commitment made by visitors to computer interactives. What *is* certain is that this can be hugely varied:

> There is no 'average' time that visitors spend at computer exhibits. Visitors will spend anywhere from 30 seconds to 40 minutes or more on computer exhibits. The time they spend is determined mainly by the quality of the content and screen layout, whether or not seating is provided, and how crowded and uncomfortable the gallery is. (Gammon 1999)

There are thus many complex variables at play in any encounter with a computer interactive on site: comfort, stage in the museum visit, patience, perception of 'pitch', demographic factors and, not least, motivation. Further understanding of these factors is of course crucial, not least if the advocates of interactives wish to

alleviate any enduring concerns that a shift towards creative digital content might facilitate a 'death of the object' (Parry 2007).

Observing 'Interaction' On Site

> So, if you encounter an interactive exhibit that looks suspiciously rectilinear, doesn't know how to communicate with its peers, can't converse with you, can be used by only one person at a time, and which you can sneak up on, then it's on its way to extinction ... and the sooner the better. (Dodsworth 1999)

This section reports preliminary observations of users' encounters with computer interactives carried out at nine museums in England in 2010.[6] The researcher observed more than 100 screen-based interactions in total, including 30 encounters with touchscreen interactives (some of which were multi-touch). The purpose of the observation was to try to establish any shift in terms of the visible components of experience and interaction between traditional kiosk-based interactives and touchscreen interactives, along the trajectories presented by Dodsworth above. Are we witnessing a move toward more dynamic, sociable and aware interactives; and, if so, how do users respond to that proposition?

Experiences of using larger touchscreen interfaces were visibly significantly more social ones than the use with traditional computer interactives. One of the major criticisms of computer interactives in the past has been that they can limit users' social experience of museum environments.[7] To complicate matters further, Gammon notes that sometimes social interaction itself is 'highly detrimental' (2008), not least as those supporting the interaction (such as parents) can give inappropriate or confusing guidance, thus degrading the experience. Nonetheless, it is clear that sociality is a crucial aspect of any museum visit, according to Falk and Dierking (2008), and a key component of any potential learning outcome. It has been noted that the computer screen is not best suited to enabling social interaction;[8] expecting multiple visitors to feel comfortable

6 Observations were carried out at Leeds City Museum, the Royal Armouries Leeds, Eureka Halifax, the National Media Museum, the Museum of London, the Science Museum and Natural History Museum, London (including the Darwin Centre), Jorvik Viking Centre and the National Railway Museum in York. A total of 108 screen-based interactions were observed alongside 137 interactions with mechanical interactives (non-screen). Research trips were also made to the Thackray Museum in Leeds and York Castle Museum, but there was insubstantial activity to observe – which is, of course, also interesting to note.

7 Although it has been noted that interactives more generally are good for sociality (Blud 1990).

8 'Studies have shown, for example, that there is less conversation and other forms of social interaction at kiosk-based computer exhibits' (Gammon and Burch 2008: 47).

using a computer at one time is of course counter to how we interface with computer screens in most aspects of our lives (for now at least).

In the study, people were observed to engage with touchscreen interfaces simultaneously and in groups from all available sides, and often to carry out multiple 'tasks' on the interface at one time. The nature of these encounters of course remains allusive, and establishing a means for gathering information about them continues to present methodological challenges (as will be seen). Such use of the interface does however represent a step towards 'overhearing', 'co-participation' and 'multi-party participation' – activities that vom Lehn and Heath are eager to encourage more readily around computer interactives (2005: 15). Indeed, to noted museum consultant Nina Simon, it is only when individuals and groups communicate with one another around content (not through it) that productive participation and interaction are being facilitated (Simon 2010). It is crucial to the future research agenda that we understand more about the nature of such social encounters, for example, asking questions about whether they are characterised by frustration, enquiry or knowledge exchange, or are completely 'off topic'.

Observation of social encounters thus raised questions about how we might more usefully conceptualise the 'social museum' and understand the relationships between collective and individual engagement, the body and experience, and the group and knowledge construction.[9] Understanding where, how and whether computers interfere with, support or enhance such relationships will be of critical importance going forwards.

It was noted in the use of digital devices of all types that there were different kinds of permissions at play than at other exhibits on the museum floor. For example, whilst children in groups often ran up to touchscreen interfaces and started engaging, they were less likely to do so until they had been given 'permission' when it was a traditional computer interactive. This is perhaps due to the nature of young people's relationships with monitor-based computers at home or school, and perhaps signals the touchscreen as a more dynamic and enticing offering.

It has been recognised in prior literature that computer interactives tend to appeal particularly to children (Ramsay 1998, Gammon 1999), who may not be the target audience for the information but who will commit (at some level) to using the device nonetheless. 'Interactivity' has been central to attempts to engage children and young people within museum spaces for many years, not least because of the roots of that principle in philosophies of experiential learning (Dewey 1938) and constructivism (in the works of, say, Jean Piaget). McLean defines interactive exhibits as 'those in which visitors can conduct activities, gather evidence, select options, form conclusions, test skills, provide input and alter a situation based on input' (1993: 93). Such things are seen as critical to learning 'outcomes'. In

9 We are beginning to see empirical studies emerge in this area: for example, the University of Salford's recent research at Imperial War Museums into 'social interpretation' (2013).

one study, Davidson, Heald and Hein (1991) noted that multisensory interactive installations kept visitors for more time at exhibits, and subsequently increased visitor knowledge. Evaluating how people make sense of the information they find through such means involves further understanding of the types of activity they facilitate: are people browsing, searching, exploring or playing – i.e. is their use purposeful, exploratory or playful (Gammon 1999). Gammon and Burch (2008) note that there is a tendency for users not to look at the top third of an interactive screen. This is an interesting finding that may accord with use of home computing technologies; there has been much work on 'website real estate' with eye tracking software which has demonstrated similar results (reported in Sklar 2009).

For both children and adults who use computer interactives, there is a problem of pacing that needs further attention in research. Being able to move at one's own pace through the exhibit is important, yet computer interactives (and especially those that have been in situ for a number of years) can be slow to respond, with delays causing frustration and faltering confidence on the part of the user; they may be quick to assume they have 'done something wrong'. Some touchscreen interfaces tend to suffer similarly in terms of responsiveness, even though the aesthetics of their presentation might indicate that they are more novel and user-centric.

Designers of touchscreen interfaces must consider the fact that any appeal associated with the 'newness' or innovation of certain technologies can work as either a help or hindrance when it comes to prompting participation. For some visitors innovative technologies might be unfamiliar and daunting; for others, those same devices might seem already outmoded. One notable finding from observing an additional group of university students using touchscreen interfaces was that they often expected them to respond in the manner of smartphones or personal tablet devices to which they are now increasingly accustomed. Consequently, they often found the touchscreens to be lacking in responsiveness and usability. In conversations during the visit they made ready comparisons to the high-resolution retina display and responsive functionality of these other platforms that they are now using on a daily basis (within and beyond education environments also). We see how quickly museum visitors' (or more likely a portion of museum visitors) use of media outstrips the pace at which the institution can reasonably be expected to update.

This problem is unlikely to diminish in coming years unless more is done to embrace the technologies that visitors increasingly come to museums with in their pockets. As we saw in Chapter 1, smartphone cameras, apps, social networks and QR codes are increasingly a part of the equation.

In terms of positionality, there tended to be a far greater flow of people around flat touchscreens than kiosk-style computer interactives. This was due to their design, but also to their positioning within exhibition spaces. They were far more happily integrated into the narrative of the exhibition, and simultaneously often presented as star attractions due to their novelty and size. Thus, a significantly higher proportion of people who entered the gallery spaces tended to use them than

used traditional computer interactives. That said, time commitment to touchscreen interfaces did seem to be slightly more varied than with computer interactives. Although fewer people used the computer screens, they often tended to do so for longer than those who used the touchscreens, even though the latter was a more frequent occurrence. This is perhaps an inevitable outcome of the increase in social interaction associated with them (and less often immersive personal long-term engagement).

Multi-touch and tangible interfaces are designed to be inherently playful, imaginative and immediate. In fact, researchers in Human Computer Interaction Design (HCID) have recently added the goals of enjoyment, emotional engagement, ambiguity and ludic design (Hatala and Wakkary 2005) to their analysis of principles for interaction (alongside usefulness and usability). An understanding of both ergonomic aspects and cognitive psychology developments is perhaps then a desirable basis for designing computer interactives, and unpacking their use in museum spaces.

Of course, all kinds of questions emerge from such encounters, which we cannot hope to answer through observation alone. Was the nature of the encounter meaningful to the individual or group? Would the institution consider it to be meaningful? Was meaning-making being demonstrated? Is it clear what use-value the group anticipated in using the interface? Was the group expressing frustration about aspects of the user experience?[10] Such questions require us to look beyond the quantitative and measurable aspects of experience – for example the route of enquiry through the interface's various offerings or the length of time spent at the interface – toward the qualitative nature of the groups' exchanges: what was actually said, for example, or how the group manoeuvred around and through the space.

Some analysis and research has been carried out into such interfaces (Hornecker 2008b) but mainly as lab-based user studies aiming to investigate interaction techniques;[11] and there have been even fewer studies devoted to touchscreen interfaces as they are defined here (although see the ShareIT project as an example).[12] Such studies often use summative evaluation techniques (quantitative and qualitative), mostly in the use of observations and interviews. However, the

10 Or perhaps, as was noted, these kinds of interfaces become natural gathering sites for parties to re-group before continuing their journey through the museum.

11 Such as the SHAPE project (http://www.shape-dc.org/) and the Finnish Multi-Modal Museum Interfaces (MUMMI) project, which are looking into the development and understanding of mixed reality interfaces, including design issues and accessibility matters. Other studies include work on the 'Tree of Life' interface in the Berlin Museum (Hornecker 2008b); work on the exhibition 'The Fire and the Mountain' in the Civic Museum of Como (Italy); and an evaluation report on visitor responses on the interactives in the Victoria and Albert Museum (McIntyre 2003).

12 The interdisciplinary ShareIT project investigated the benefits of new shareable technologies (the Open University's Department of Computing in collaboration with the Psychology Department at the University of Sussex) from October 2008.

researchers' findings are focused primarily on design aspects, perhaps a result of the principally evaluative nature of much of this study (and not a commitment to a wider research agenda). Many such studies collect and analyse data about usability, that is, user *performance*, yet disregard the knottier issue of user experience, that is, user *satisfaction*, which is a more resource intensive mode of study dealing in human emotion (Bevan 2009).

It is thus vital that we work toward a research approach that understands and positions visitors as protagonists within complex museum narratives, and finds ways of understanding their experiences in more holistic terms.

Case Study: Touchscreen Interfaces at the Museum of London

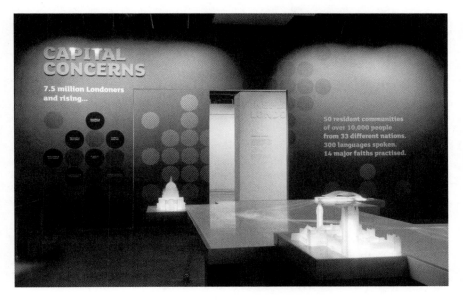

Figure 5.1 Touchscreen interactive in the 'Capital Concerns' exhibition at the Museum of London, Galleries of Modern London. Image courtesy of the Museum of London

With the above in mind, a multi-method research case study was carried out in 2011 into visitors' experiences of touchscreen interfaces at the Museum of London. The results are revealing on a number of levels, not least in relation to the use-value and educative potential of socio-cultural 'interaction' via screen-based media.

The case study at the Museum of London included research at five touchscreen interfaces in the Galleries of Modern London (Figure 5.1), and the findings that follow are extracted from 29 group interviews resulting in approximately 12 hours

of audio recording, plus observations of 93 groups of visitors (from couples and families to larger school groups).

Social Interaction and Social Learning

As anticipated, elements of increased social engagement were evidenced at touchscreen interfaces. This includes discussion *within* the group, but also discussion *beyond* the group (i.e. with other visitors in the gallery). This was noted in observations, but, more crucially, with a number of interviewees in reflection on their experiences with the interactive:

'I guess we've disagreed, bit of a shock.'[13]

'We were discussing like the different options, which would work better and why one option makes sense to the situation that is presented so we definitely like talked about it in the interactive here.'

'She said she lived in Lambeth so we helped her. It is a bit difficult for children because you need to go alphabetically, so we found Lambeth for her and she could do it.' [an example of a social encounter beyond the group]

The exchanges (in the form of discussion) are variously characterised by agreement or disagreement, wonder and enquiry, stemming directly from the interfaces in front of them. These might all be seen as pathways to 'learning' of one sort or another. Many exchanges also reflected individual resonances and responses to the information presented. Visitors appreciated opportunities to find a personal way into the information provided through the interfaces, perhaps locating pictures and information that accords with or sheds further light on their own understanding of the cityscape: its geography, climate, politics and temporality.

'We looked at Islington cause we just walked through it.'

'I work at an energy company and ... we are considering doing ... waste incineration plan and I know lots about it and ... it turns out people consider that you should use less plastic and ... decrease the amount of waste provided which is kind of logical.'

'Well I like that it showed things that people might be thinking about who actually live here ... cause we're here as tourists so we see one little aspect of it which is nice so it's kind of interesting to see what people that live here are thinking about the city.'

13 Quotations in italics come from research respondents. These have been anonymised, and demographic information is given only where it is pertinent to the discussion.

As in the latter of the quotations above, the relationship between the personal and the social also emerged as enlightening for people. In discussion of the Capital Concerns interface, for example (see Figure 5.1),[14] visitors referred back to an integrated polling system which allowed them to see other users' responses to a set of questions as well as adding their own. Users wanted to be able to position and understand their answers in relation to others'. Thus social engagement is not just with those physical beings around them, but also with those 'virtual' visitors who have been before, finding their views to be in synchronicity with, or perhaps counter to, one's own:

'You also realise how much you can synchronise with the people of London by answering the questions.'

'You know what's nice about that you can come to the museum alone and just have you know ... you still can communicate in a way. I know it's a machine, it's a computer but ... otherwise you know in the past I think it was a bit lonely because you were coming you were walking around when you didn't have anybody to talk to them, inside once you have something like this, it makes the whole experience different and also when you come together, then sometimes you talk about it. And it is also fun, just fun.'

'What I thought was not matching what other people thought.'

Visitors engaged more actively and passionately around this particular interface that sought to highlight social issues and debates of contemporary significance in London. Tourists coming from elsewhere in the UK or from other countries felt that the interface offered them a temporary insight into London life, rendering it and its population more familiar as a result. This then is social learning of the sort Falk and Dierking (2008) have identified: experiential, empathetic and consequently fiendishly difficult to measure.

Visitors were more likely to remember information from the interactives that related to and extended their personal interests. Knowledge acquisition was thus (in the short term at least) a process of building upon and consolidating existing concerns and understandings. This was evidently not a purposeful endeavour. Rather, users displayed browsing behaviours – what Gammon (1999) calls exploratory and playful.

When audiences were asked to recall specific information about the subject dealt with by an interactive, the answers were often a mixture of information they gleaned from the interactives and information they have more likely surmised from the museum exhibition in general; as such, they tended to pick up on the

14 The touchscreens work via projection technologies onto two table-tops and onto the floor. There are multiple points of entry around the room.

larger themes of the interfaces, and blend them with the wider display narratives, albeit in relatively superficial ways.

In terms of users' physical-social interaction when using interfaces, the patterns varied. Some of the groups touched the screen together, discussing the information co-operatively and finding a route through it; but mostly it tended to be one member of the group touching the interface and 'leading' the enquiry for that group. Thus, the particular mode of sociality was informed by the wider dynamic of the group, but as much by where people found themselves standing or sitting.

Many visitors were attracted to the interfaces when observing other visitors using them, most explicitly demonstrated in the following reflection:

> 'I noticed the younger girl couldn't make it work, she couldn't catch it at the right time, that's why I used it because I wanted to check whether it was working.'

However, some others did not feel comfortable coming forward and participating when other people were occupying the interactive, and hung back – or, as noted in observation sheets, walked on:

> 'because you know people, kids were sitting there you can't ... move on ... move on guys.'

Visitors were very rarely able to recall which actions they had performed whilst using the interface, which showcases an interesting detachment between the physicality of the experience and any concurrent cognitive processes. Given the comments that follow, this is likely to be because the technology remains very visible in such interactions and, as such, continues to present a barrier between the user and the content.

Usability and Functionality

As predicted, there were issues around usability and functionality that emerged in the group interviews. Many of the discussions people were having in the space, and had afterwards in interviews, were about usability rather than content or the themes being addressed:

> 'That one is difficult to work with your hands. It does not act so well, it takes a lot of time to try and make it work. Technically.'

> 'I didn't know how to work it very well.'

> 'I would like tap the answer really hard but it had to be a light soft touch.'

> 'Fine map but it's moving too quickly, needs to be slowed down. It's difficult to operate that interactive.'

'Yeah, it doesn't say to scroll or it didn't give you more specific instructions, I think, I don't know, my generation ... my daughter is five ... actually would probably figure out a lot quicker.'

'You touch the car nothing, you touch the building nothing ... ok come on let's move. [laughter] ... that's all.'

'Is true, I don't like the technology, it's too sensitive especially if you trying to narrow one ... frustrating to use I think.'

There is some confusion about how to get the screens working in the first instance, with the interfaces' varying functionality difficult to anticipate. Many of the visitors would like to have some further explanation of how to use them. Some of those we spoke to chose not to 'blame' the machine, but rather the way that *they* had used it. In this sense they are taking ownership of issues around functionality that could potentially be disempowering.

Issues around functionality occasionally, however, provide opportunities also; there are a few instances of social interaction arising within and between groups of people about how to make the screens work:

'It was a schoolgirl next to me that I didn't know and we did it together. So I showed her how it worked.'

It was observed that children became really enthusiastic when trying to figure out how to work the interfaces, but did struggle to get any considered use out of them. For larger school groups, where management of numbers was potentially problematic, this led to excited tapping and banging of the screens rather than profound engagement with the content, although we might note that they are unlikely to be the target group for such an interactive.[15]

Many groups were impressed by the graphical elements of the touchscreens and their overall appearance. Visual elements – including the design and the layout of the large interactive in the Capital Concerns gallery space – seem to (positively) overwhelm the majority of the audiences we talked to (see Figure 5.1). For some groups the idea that you might find such interfaces in a museum setting was completely novel, even 'futuristic':

'I've never seen something like it...awesome!'

'This looks like a Star Trek type of thing.'

'Very futuristic type of thing so it's really really good to see.'

15 One teacher was observed shouting at the children: 'It's called a touch screen not a bash screen.'

The presence of such an interface runs counter to the idea of 'the museum' that these visitors are accustomed to, although others had higher expectations:

> 'Well I think in a certain age, getting a map and getting a finger on it and scrolling through is sort of almost the minimum that people expect.'

The link between interactivity and the needs and wants of children percolates right through the interviews, even though, as is acknowledged by some of the interviewees, the content is really not designed for children (as we saw above). It is assumed that children will seek out, understand and respond to interactivity through technology more readily and naturally than older visitors:

> 'I think is for everybody but I can see how ... I don't have children but I have friends with children so I can see how the children find this, you know, a little bit interesting and more of a break and not just staying with Mummy and looking at things.'

> 'I believe that could be useful not for the adults but for kids.'

> 'Yes, I think kids love it, they should love it.'

> 'But I think it is very important to have things like that if you have school classes as well because it helps a lot for children.'

Evident also is a sense that interactives provide a valued 'break' for those who attend museums with children. This perception of interactivity as being an inherently better approach for children is something that has emerged in prior research (e.g. Jackson and Kidd 2008).

This is perhaps linked to another emergent theme around the language people use to describe their actions and experiences of the interfaces. They are *fun*, *toys*, *games* and opportunities to *play*; this is language they categorically do not use to talk about other elements of the museum visit, even when given the opportunity.

Visitors were asked to reflect on the research team's use of the word 'interactives' for such devices, and a nuanced and complex set of answers emerged. Visitors often viewed such interfaces as a genuine medium for dialogue, felt involved in a process and perceived them (as we have seen) as an opportunity to play (all presumably integral to their individual understandings of interactivity):

> 'I think actually it moves up to the next level than just seeing stuff definitely. I think it's really important it does feel like it's natural interaction and you make your choices about where you're going with stuff as well as what you're seeing.'

> 'When you are in the museums where there is a lot of text and a lot of things to look at, it's kind of fun when you have something that you can actually interact

with cause with a lot of stuff you can't touch, you just look at. With this you can actually physically be involved.'

'It's interactive in several ways because it is interactive because the machine reacts to you but it is also interactive because something happens between the people standing in front of it.' [a really interesting response given our interest in social interaction]

'You are involved in the process.'

'They make you think. They direct, like some sort of dialogue.'

That interactivity through such mechanisms might constitute – or contribute to – a new kind of dialogue is worthy of further reflection.

Connecting to the Larger Museum Narrative

In relation to the exhibition narrative the connections that the audience made between the interactives and the galleries were rather superficial. It very much came down to the willingness of the individual to actively pursue those connections; they did not emerge naturalistically. In the majority of cases when the connection was made, it was as a way of describing the interfaces as a spot to 'play' or get a rest from the main business of reading and looking that people associate with exhibitions:

'It gives you a break from just looking and reading, it's something different you know.'

'The explanation is quite short but to the point so you don't have to read this long explanation, it's just a couple of sentences but it really tells.'

The fact that visitors perceived interactives as an escape from reading long descriptions is a little surprising as many interfaces also include significant amounts of text. Perhaps the element of light and movement lends itself to a different perception than the 'simple' text panel.

Others mentioned that these interfaces can support a continuation of the narrative of the exhibition outside of the showcase of just dates and events (a rather traditional interpretation of what a museum exhibition is about):

'It makes it more of a story rather than just you know dates and events.'

'... adds an element of fun and it might be a little bit more simplistic than some of the other panels and stuff like that, it doesn't take away from anything and it kind of ... yeah ... it adds a level of playfulness.'

'... brings history to life'

Evident here again is the fetishisation of the traditional image of 'the museum', principally concerned with dates and facts – dry, static, dead.

Conclusions

It is important that visitors, beyond making sense of an interactive as a stand-alone interpretive tool, are able to understand that encounter within the overall framework of the museum and their museum visit. Current research and evaluation stops short of providing a means of conceptualising or articulating how visitors value their interactions with interactives within the larger narratives constructed by institutions, or within the various social encounters they have around them.

Understanding the contribution of multi-touch interfaces to the museum experience will be crucial in justifying the expenditure that is increasingly being earmarked for them, especially in the face of so many competing technologies and devices, and within a challenging economic landscape. As Falk and Dierking remind us, it is the relationship between 'experience' and 'value' (in learning, but also inevitably in financial terms) that museums have the most invested in:

> It is not enough that new technologies enhance the visitor experience; it needs to be demonstrated that these new technologies enhance the visitor experience better than competing technologies and in ways that are cost-effective. It is not until the field has a strong research base that it will truly be able to both optimize the power of these digital media tools and substantiate their value. (Falk and Dierking 2008: 28)

What emerges from the interviews as important in the interaction is experience itself rather than the content – except where that content allows visitors a personal way into the body of information. We might ask, is that enough? The group exchange (in the moment or with visitors who have gone before), the novelty and feel of the technology itself, and the ready break such interfaces provide from the other 'work' of the museum visit emerge again and again are important in their own right, above and beyond any perceived 'learning' that might be achieved. How to articulate experience and engagement as learning outcomes in and of themselves emerges again as crucial going forward. This chapter might best be read as a plea for a considered and coherent methodology for making sense of such experiences and their evident paradoxes in the future.

Chapter 6
Museum Online Games as Empathetic Encounters

Conventional narratives – books, movies, TV shows – are emotionally engaging, but they involve us as spectators. Games are engaging in a different way. They put us at the center of the action: whatever's going on is not just happening to a character on the page or an actor on the screen; it's happening to us. Combine the emotional impact of stories with the first-person involvement of games and you can create an extremely powerful experience. (Rose 2011: 15)

This chapter explores how, in the moments of engagement afforded by digital media, some of our more challenging, uncomfortable and divisive heritages are activated, using online games as a principal site of study.[1] The video game is a medium with conflict at its core, and so it seems apposite to take stock of how the interpretation of historical conflict is enabled and frustrated in the work of museum games.

Museum online games (as is the case with much other digital heritage content) are frequently framed within discourses of interactivity and education; yet we will see that in truth *many* of these games offer limited interactivity as defined more broadly within game design, and perhaps questionable educational impact. Indeed, with an emphasis on experience and empathy as ways into the story-worlds being created, there are times when such approaches might be deemed lacking in sophistication or consideration.

This chapter seeks to situate and explore online gaming in the museological context, an area that is currently significantly under-researched.[2] It asks questions about how museum games are framed and their purposes articulated; how consciously and fully their makers try to create and contain 'experience' within the games' boundaries; how they contribute to processes of history 'making' for their users; and, crucially, whether there are times when they are patently unhelpful. Such questions might help us understand how games and other associated content – such as augmented reality apps – contribute to a 'gamification' of the cultural realm (to use current parlance);[3] and, more crucially, of people's anticipation of and expectations

1 For more on how we might understand difficult and sensitive heritages, see Kidd 2011b, Kidd et al. 2014.

2 This is also true of games for informal learning more broadly where there is a dearth of understanding (Lin and Gregor 2006).

3 Gamification refers to the growing trend for activities and environments not traditionally understood as video games to take on their mechanics, structures and reward

for the museum encounter (whether virtually or on site). Games are 'increasingly a feature of our culture' (Corliss 2011: 9; see also Shaw 2010, Egenfeldt-Nielsen et al. 2013), blurring work and play, gaming and sense-making, and online and offline; and I contend that we are yet to envisage what that will mean for the museum. This echoes usefully the discussions in Chapter 1 of this book.

An analysis of online museum games is especially pertinent at this time due to the broader – staggering – uptake of casual and social gaming in the last five years. As games have become 'native' across a range of platforms and hardware (as comfortable now on the 3 inch as the 100+ inch screen), they have had widening appeal and broader consumption beyond the traditional video game audience of 10–30-year-old men (Chatfield 2010, Bogost 2011, McGonigal 2011). According to Jane McGonigal, in 2011 'Collectively, the planet [was] spending 3 billion hours a week gaming', and we may yet see a disruption of the 'lingering cultural bias' toward gamers (McGonigal 2011). Casual games in particular – deemed 'hyperaddictive, time-sucking, relationship-busting, mind-crushing ... silly digital games' in the *New York Times Magazine* (Anderson 2012) – will, according to Tom Chatfield (2010), soon be 'universal'.[4] This is a category within which the museums' online games discussed in this chapter might most readily be understood: their aesthetic, their usability and the commitment required by users specifically being reminiscent of the broader suite of casual games on offer in 2014.[5]

Throughout this chapter I explore the efficacy of games theory – especially related to empathetic engagement – as a way of enhancing existing discussions about the mediated museum (see for example Henning 2006, Parry 2007 and Simon 2010).

systems (see Rayner 2011, Deterding et al. 2011, Werbach and Hunter 2012, Jagoda 2013, Silva et al. 2013). This is in recognition that 'pecuniary (e.g. money, gifts) and instrumental (e.g. information seeking) motivations are not the only ones worth talking about' (Antin 2012). Recently, we have seen more cultural institutions and practitioners turning toward games-makers for inspiration on how to engage, and maintain, communities of interest: see for example Simon 2013 and the reporting of the V&A's appointment of their first 'game designer in residence' in the *Independent* (Clark 2013).

4 This trend has been amplified by the popularity of consoles such as the Nintendo Wii which, due to its motion control, allowed for selling as a family (and even a fitness) unit. Games such as *SingStar*, *Guitar Hero* and *GarageBand* have also facilitated a widening of the market for social and casual games.

5 Particularly well-known examples of 'casual' games include the *Angry Birds* franchise (Rovio Entertainment from 2009), *Words with Friends* (Zynga 2009), *Draw Something* (Omgpop 2012) and *Candy Crush Saga* (King 2012). As many of these casual games (but by no means all) are paid downloads, this surge in interest has meant a welcome injection of finances and energy into a market that had seen closures during the recession (in the UK at least), and led to new tax reliefs for the games industry. Many of them can be marked also by the facilitation of social play (e.g. *Draw Something*) rather than individual play.

The Analysis

The chapter is based on an analysis of 30 online museum games (15 UK and 15 international) which have been comprehensively coded and analysed.[6] Examples from the analysis include *High Tea* (Wellcome Trust, UK); *Dressed to Kill* (Tower of London, UK); *Great Fire of London* (Museum of London, UK); *The Beatle's Game* (National Museums Liverpool, UK); *Before the Boycott: Riding the Bus* (National Civil Rights Museum, USA); *Gold Rush* (National Museum of Australia); *Virtual Knee Surgery* (Center of Science and Industry, USA); and those discussed later in this chapter.

Given the digital nature of the subject matter, games could be located using an online search and a purposive sampling approach. It is necessarily a non-proportional sample as the overall size of the international museum online gaming market is difficult to ascertain (principally because of language barriers and differing conceptions of 'the museum' and 'the game'). The majority of the games in the study were single-player games articulated within education and learning frames, and could be completed within 15 minutes (a small minority took longer). In such games, the narrative contained within the 'game-world' is easily understood as a single unit of analysis, with a beginning, middle and end – making them unlike pervasive or augmented reality games (which are beginning to gain ground in the museological context). Although many video games can be understood as intertextual, most museum online games are fairly self-contained, with the exception of the inclusion of archival materials from the institution in a small number of cases.

In order to inform this analysis, Eric Zimmerman's unpacking of the term 'game-story' was used to add texture and rigour. Zimmerman is a game design practitioner-academic from the US who has written much about game culture and the ways in which game-stories might be constructed and understood. He focuses on four elements in game design which, of course, overlap: narrative, interactivity, play and games – making a convincing argument for the value of play, *especially* in educational games (Zimmerman 2004). Interactivity within narratives, in Zimmerman's theory, includes four potential elements: cognitive, functional, explicit and cultural. It is worth reviewing these in some detail. Cognitive interaction refers to processes of interpretation within the game-world, processes of 'decoding' (to reference Hall 1980) and the semiotic unfurling of meaning. Functional interaction references the utilitarian functionality of games, their textual apparatus (this might refer to design elements and framing mechanisms). Explicit interactivity is characterised by pre-designed and pre-programmed choices and procedures, thus offering limited capacity for changing in dramatic ways the outcome of the game. This is perhaps the most familiar use of the term interactivity to us in our other daily activities (pushing the red button

6 The methodology was informed by Consalvo and Dutton (2006). Their use of interaction maps and game-play logs was especially insightful.

or choosing our own ending for example). Cultural interactivity references the possibility for more dynamic participation, where the game's boundaries are rendered more porous – being open to appropriation or deconstruction, sociality or, indeed, bleeding into other online content. This kind of 'meta-interactivity' is more allusive, alluding perhaps to the kinds of activities familiar within the open source and open data movements (see Chapter 7) (Zimmerman 2004).

The analysis of 30 games asked questions about: how explicit the narrative elements of each game-story were, and how they related to real-world historical events and encounters; which 'characters' (whose narratives) were prioritised; what kinds of interactivity were promised and delivered; how (indeed whether) the rules of the game were articulated; whether there was any dramatic conflict in-built in the game; whether there were opportunities for free-form play (or indeed mischief) within the structure of the game (meta-interactivity); where the game was hosted; and how it related to the museum's website and associated tangible/ intangible heritage. It also explored the extent to which each game's framing was explicitly educational.

In the following section, I briefly present some headline findings from the study, before going on to explore one area of particular significance using three case studies. This is ultimately a chapter about two things: firstly, the struggle for autonomy within video games, ably articulated by Frank Rose:

> In-game narratives introduce a familiar tension between author and audience. As with any participatory narrative, the issue is control. The designer creates the game, but the player holds the controller – so who's telling the story? (Rose 2011: 1)

Secondly, it is about questioning the extent to which museums understand their online games *as* games.[7]

The State of Things: Findings from the Analysis

Museum online games are created for both entertainment and educative purposes, with a view to providing motivation for further exploration of a museum's resources and the topic at hand. They are principally freely available online, for use in informal, lifelong learning situations or within structured learning environments like classrooms. It is hoped that 'serious games' (Bogost 2011, Egenfeldt-Nielsen et al. 2013) can create worlds within which exciting new learning opportunities can be presented and potential new audience relationships forged. Games are thus

7 Henson and Birchall say in their 2011 conference paper on games at the Wellcome Collection: 'We think that gameplay is important in its own right' and 'Good gameplay is crucial to successful games'; but how this is being discussed and made sense of at the level of game design is less clear, and has been the subject of no prior research.

tasked with a seduction of sorts – opening up institutions and their collections in ways that run counter to the traditional, staid, dry image of 'the museum'. According to Lin and Gregor, 'these functions can motivate and increase learners' participations and attentions' (2006); and Herminia Din goes as far as saying 'the more you play, the more you learn' (2006). Of course, these are not inevitabilities, and there has been no large-scale user testing or audience research to support such causal links in relation to museum online games.

The games under analysis allude to a vast breadth of issues, heritages and time periods, yet with significant clustering around twentieth-century conflict and around science and technology. The latter is unsurprising: science centres and museums are dedicated to the procedural and technological, and invariably emphasise interactivity, making it reasonable to assume the content would lend itself well to such a format. But the former clustering is more difficult to rationalise, and worthy of closer consideration in the next section.

Each of the games demands very different kinds of investment by users in terms of time commitment, intellectual and emotional energy, and additional work with resources such as a museum's online collections. Achievements and goals don't always conform to the usual parameters video games set for success, being in many cases less specific and more ambiguous, with limited opportunities to compare performance against other players. This is significant given Jane McGonigal's definition of games as comprising goals, rules and feedback systems alongside voluntary participation (2011). Feedback systems are those in-built mechanisms that give players a sense of how they are progressing toward the game's goal and allow them to compare their progress with others (how many points they have, for example, or levels they have completed). Without such mechanisms, a game is not really a game at all. Bernard Suits has called game playing 'the voluntary attempt to overcome unnecessary obstacles', but maintains that we must be aware of what those obstacles and rules are as we play. Only with such awareness can players assume the 'lusory attitude' necessary for success (Suits 2005: 54–5).

The games in the study universally make broad assumptions about audience and prior experience of game-play, more often than not being – subtly or otherwise – targeted at children. There is an implicit assumption in the way these games are framed and where they are located on museum websites that younger, more technologically savvy website users will respond to gaming activities more positively than they might to other manifestations of the online museum. In the main they use Flash plug-ins and require consistent and reasonably fast internet connections, meaning their potential use-value could be undermined in certain contexts – not least, on occasion, schools (or museums themselves).

'Quality', variously defined, as with all game-based learning, remains a real issue – especially in light of the assertion by Brenda Laurel (renowned thinker in the field of human-computer interaction) that all educational games are 'crap' (quoted in Fortugno and Zimmerman 2010). It has been suggested that in such games the experience of learning can be subordinated to the experience of playing (Egenfeldt-Nielsen et al. 2013). This is not helped when additional educational

materials and resources are completely separate from the video game (as is sometimes the case with museum games). As Egenfeldt-Nielsen et al. note:

> The simple structure of video games limits the amount of material one can include and this material must be integrated into the core game activities. Otherwise, the player risks learning only one thing, namely how to play the game. (Egenfeldt-Nielsen et al. 2013: 235)

Audience reflections on quality and use-value are something we know little about in relation to museum online games, and are of course a logical site for continued study in this area. Dondi and Moretti have said that 'Any digital resources that are employed in learning and teaching processes should meet quality criteria related to … context, content and technical areas' (2007: 511). In this helpful model for assessment, museum online games tend to do fairly well on content criteria, reasonably well on technical criteria, but often completely lack appropriate context criteria. It is very possible to play many of these games without any recognition of their museological underpinnings, or even the wider historical context within which any learning might be best situated.

To re-visit Zimmerman's categorisations of interactivity, we might note that there were no opportunities identified for cultural interactivity in the analysis – free-form play or mischief within the structure of the games. Interactivity was wholly pre-programmed, explicit throughout. This means there are currently limited prospects for sociality, user-creativity or, often, cross-reference to other museum content. These games' proprietary nature perhaps offers a useful nod to the architectures of veridicality and authenticity that museums have constructed and maintain, potentially even to their cost.

The Awkward Silence: Museum Online Games and Empathy[8]

It emerged in the research that empathetic engagement was being used as a narrative mechanism in a number of the cases as a means for securing 'buy in' from game-players, especially in those cases where difficult and sensitive topics were being handled. This was true in a third of total cases (10 games). Assuming a character or participating in a role-play is of course common in video games, but the extent to which emotional engagement with another was used as a quality of the game-story was unanticipated, and noteworthy for a number of reasons.

8 This emphasis stems in part from issues raised in the work of the Challenging History network (www.challenginghistorynetwork.wordpress.com), of which I am a founding member, and the Arts and Humanities Research Council (AHRC)-funded network Silence, Memory and Empathy (www.silencememoryempathy.wordpress.com). For more on these themes see Kidd 2011a and 2013.

As one of the principles of psychology, empathy has been understood as when a person 'feels her/himself into the consciousness of another person' (Wispé 1987). It is an other-oriented feeling, a social interaction that can lead to a number of outcomes, not least a motivation to respond with care or with action. But what is its use-value in this kind of context? And what are the responsibilities of the museum to hold people safe during such encounters?[9]

Empathetic feelings are not necessarily confined to interactions we have in the here and now – they can be dislocated by time and space, allowing us to have such feelings for those 'in the past'. Marianne Hirsch's theory of 'postmemory' (1997) is one way of beginning to understand this. Postmemory is the experience of those who carry memory even after primary witnesses to events are gone. It is an inheritance of past events that are still being worked through, and thus experienced. If I hear about traumas experienced by a community or social group that I belong to, they may become in some way my memory, as a person 'born after'; but the memory is 'delayed, indirect, secondary' (Hirsch 1997). Empathy is a big part of many people's relationships with their 'past' as played out in museum spaces and historic sites.[10]

Empathy is also understood as being key to our learning potentials. According to a review of the literature by Feshbach and Feshbach (2009), it can increase our social understanding, lessen social conflict, limit aggression, increase compassion and caring, lessen prejudice, increase emotional competence and motivate pro-social behaviour (that is, moral behaviours and altruism). All of these can lead to better classroom learning and, in more than one study, higher grades.

But empathy is of course not inevitably or universally a positive experience; and neither is it without its limitations. More will be said about these after introducing three case studies using calls to empathy as key devices in the game-story.

Case 1. What Time Is It? Jewish Museum, Berlin[11]

What Time Is It? is described on the Jewish Museum Berlin website as a game that will give you (the player) 'an inkling of how it felt' to live daily life against the 'manifold discriminations and limitations' associated with being a Jew in Germany under the Nazi regime. It comes under the banner of the museum's 'Kids, Students,

9 Such questions are not easy ones for museums more broadly. The Silence, Memory and Empathy project (2012–14) is looking specifically at how empathetic engagement might better be understood within the museums context, and how it might be more ethically 'practised'.

10 2007 research around the bicentenary of the Abolition of the Slave Trade Act in the UK revealed a lot of this in evidence – people feeling empathy for and continuing to work through the issues that were raised by the very fact of the journeys and experiences of their ancestors (Kidd 2012).

11 Available at http://www.jmberlin.de/ksl/spiel/ns/spielstart_ns_EN.html.

Teachers' provision, so is very much articulated within an educational framework. The topic here is of course a toweringly difficult one, with complex legacies.

On launching the game, players are greeted with a number of familiar game devices: a map in the background and a clock in the foreground. The hands of the clock are spinning, indicating urgency or perhaps some countdown to a final judgement. The player is urged to stop the clock, and to select a language (English or German) before the implications of the time 'choice' you made become apparent. I stop the clock at 1.31pm and find out that 'the shopping period for Jews would have begun in 2 hours and 29 minutes'. I am given some further details about this order from 1940 which restricted shopping times to between 4 and 5pm for Jews, and am offered the reference to the police register from which it came. In fact all times at which it is possible to stop pivot around this particular fact. At 7.03pm the shopping period would have ended 3 hours 3 minutes ago, and at 4.05pm the shopping period for Jews would have begun 5 minutes ago. The chief function of this opening screen is ultimately to enable users to choose a language, and to entice them into the fuller game.

On clicking onto the next screen, a fuller map of the city emerges, and a range of locations are listed on the right: School, Sports Club, Cinema and Employment Office for example. The user clicks on one, and a portion of the map becomes highlighted, overlaid with archival material and bits of information. Users can click further into some of this material, but invariably find that Jews were disallowed from entering many of the spaces, again being given information from the records about when the order was issued. Each realisation of the limitations and their associated disempowerment is met with an alarmingly loud buzzer, indicating prohibition is in play.

There are a number of things we might note about this example as it relates to empathy, and to game-play.

Firstly, although there is an indication that the user is going to be required to 'feel' during the course of the game, there is no attempt to immerse them in character as the faceless Jew who is being discriminated against and whose ultimate potential fate looms large even though it remains silenced. This is no doubt a conscious decision; to 'become' the Jew in Nazi Germany is a step too far perhaps. Ultimately then, it is sympathy and not empathy that is being encouraged here. Perhaps alarmingly, the unintended consequence of this decision is that 'the Jew' remains Othered, different and potentially dehumanised, even as the game attempts to increase understanding and identification.

Secondly, this 'game' is problematic in terms of play. Although characterised as a game from the outset, like many of the other games in the sample, it is virtually unrecognisable in comparison to the broader suite of casual games that we are becoming accustomed to. This may or may not be problematic, but there are missed opportunities here to develop a story-world that users might buy into more exhaustively. To re-visit McGonigal's definition of a game here, there may be voluntary participation and implicit rules, but there are no feedback mechanisms in play. Indeed, what is the overarching goal of

the game? The goal for the museum might be clear, but the goal for the player is more ambiguous.

Case 2. Ngā Mōrehu – The Survivors, Te Papa Museum, New Zealand[12]

Ngā Mōrehu puts players in the position of a Māori child in the early twentieth century. This is similarly a challenging and sensitive topic, the politics of which the Te Papa Museum is very much invested and involved in (see Message 2006). Players are tasked with making decisions in role, and responding as the consequences of those decisions unfold. The game uses Flash and is image-heavy, so comes with a warning that it may take up to 10 minutes for each 'scene' to load. The game can be played in Māori or English, is referred to as both a 'game' and an 'interactive' and is framed with the cautionary note: 'Life in early 20th century New Zealand can be tough, and not always fair – especially if you're Māori. Have you got what it takes to survive?' This game is hosted on the museum's website, quite deeply embedded within the Exhibitions pages.

The first interaction the player has is deciding whether to play as a nine-year-old Māori girl or boy. There are 10 scenes for the player to work through, all of which include a decision to be made by the player: What name will you be known by? Will you live on the land or in the city? In a hostel or a house? Players are given a limited number of routes through the narrative, but will encounter prejudice, tragedy and poverty whichever they choose.

The game has a number of pre-programmed counter-strikes overturning decisions that would have been met with prejudice or discrimination at that time. For example, your response to the question of whether to be known by your Māori or English name in school matters little because your teacher will call you by your English name anyway. Any sense of empowerment is ultimately quashed, but in an exercise that has the potential to reveal much about futility, injustice and the legacies of discrimination.

Case 3. Over the Top, Canadian War Museum[13]

War games are increasingly common as a means of training soldiers, and our experiences of military conflict, according to Alec Charles, become more game-like all the time: 'the video game of the war and the war of the video game have significantly blurred' (Charles 2012: 64). It is perhaps a natural extension of such a trend that museums concerned with educating people about military action might follow suit.

Over the Top is an 'interactive adventure' set in the First World War which seeks to provide players with an opportunity to 'experience life in the trenches

12 At http://www.tepapa.govt.nz/whatson/exhibitions/sliceofheaven/interact/Pages/
Interact.aspx.

13 At http://www.warmuseum.ca/cwm/games/overtop/index_e.shtml.

... part history and part adventure story'. It is also a Flash game. At times, the narrative is linear, unfolding sequentially as the player clicks on; but then it stops and there are decisions to be made. The player assumes the role of a soldier, giving their own name, the name of a friend and the name of their hometown. These details are then written into the narrative: the friend is injured and (depending on the choices you make) may die, leaving the 'odour of burnt flesh' that stops short of making you throw up. In all scenarios encountered in the research, the player eventually dies, prompting a telegram to their parents informing them that their child has been killed in duty – which does, of course, use the player's actual name as it has been volunteered:

> To Mr and Mrs Kidd,
> Deeply regret to inform you that private Jen Kidd was officially reported killed in action November 9th (Canadian War Museum)

This is an immersive role-play of sorts, one where you encounter gas attacks, the gore of war and are rewarded for killing German soldiers. But is this akin to empathy, and ultimately comprehension? This might be a sobering exercise in the futility of war, but there is something squeamish in the exegesis of the empathetic engagement.

In this game especially, as one replays scenes hoping desperately for a route that might mean survival (if not for your friend, then for you), it is difficult to escape the 'revelation that one's feeling of self-determination [were] only ever an illusion' (Charles 2012: 68). The pre-programmed linearity of the game again means that agency is an impossibility.

Video Games and Empathy

Belman and Flanagan's research into designing video games for empathy reveals some interesting findings that might be helpful here. Firstly, they note that:

> Players are likely to empathize only when they make an intentional effort to do so as the game begins ... without some kind of effective empathy induction at the outset, most people will play 'unempathetically'. (2010: 9)

Two of the above examples make that call to empathy in the assumption of a role or character. Yet it is only in the example where this does *not* happen (case 1) that it is made explicit in the game's framing devices that the player is going to be required to 'feel'.

Secondly, Belman and Flanagan found that '[i]nducing empathy without providing a "way out" of empathetic pain through helping may have negative consequences' (2010: 10). In all three instances above, the outcomes are pre-scripted so as *not* to provide for that way out or further agency; our ability to 'help'

is inhibited by the game-play itself. Any agency users do feel is entirely fictive. The consequences of this, for Belman and Flanagan, are profound: 'people could guard themselves against feeling empathy in the future to avoid similarly unpleasant experiences' (2010: 10). The 'illusion of agency' (Charles 2012: 68), which in video games effectively places the player at the centre of the universe, is incongruent with the real-world scenarios in which our protagonists above find themselves – in worlds where they are powerless. Indeed, we might ask, what is the use-value in simulating a reality where the outcomes for many of the characters – our soldiers, our Māori children and of course Jews in Nazi Germany – are (to put it crudely) a matter of historical record, even though their legacies might be ever-present? Is it ethically dubious to teach children that individuals might have been able to influence those outcomes by making different or 'better' decisions? Or is the use-value of that disempowerment in itself an instructive enough learning outcome?

Ian Bogost notes that '[o]ne of the unique properties of videogames is their ability to put us in someone else's shoes'. But he goes on to say that 'most of the time those shoes are bigger than our own' (Bogost 2011: 18). In the majority of video games we carry out power fantasies, dress up, wield deadly weapons, wage war, create and destroy. But what, he asks, might be the consequences when 'weakness is all the player ever gets'? When 'strength adequate to survive is simply inaccessible'? (Bogost 2011: 19)[14] Such operationalised weakness might be an incredibly powerful learning mechanism; but what emerges from the literature, and the game-stories above, is that how you frame such an encounter is of critical importance. Without such thought games designers run the risk of *over-exposing* players to representations of trauma that can result in 'empty empathy' (Kaplan 2011), or create an 'empathy paradox' where the empathy process results in narrowing our understanding of a past – providing a monocular and incredibly partial reading of events (Jackson and Kidd 2008). Games designers can only partly direct the experiential elements of a game; they can design the rules of play, dictate the formal structure, but they cannot control how the game will be inhabited and 'felt' (Salen and Zimmerman 2004). We need to think more about the relationship between a game's formal system and how it transforms into an experiential one if we wish to understand how and in what ways experiences of a game will be meaningful.

Perhaps the best we can hope for is that a game's framing encourages forms of 'empathic unsettlement' through game-stories. LaCapra uses this term in *Writing History, Writing Trauma* (2001) to highlight the disruption and disturbance that can be found in empathic engagement with people/events from the past. Here, the unsettling nature of empathy itself highlights the very limits of understanding (Williams et al. 2010), raising questions about what can and can't be known, learnt, felt and made sense of. Such an approach prevents over-identification and/or harmonising narratives, and acknowledges that our understanding of the Other can

14 Bogost uses the example of *Darfur is Dying* (http://www.darfurisdying.com) to discuss the place of 'weakness'.

never be complete. It acknowledges the limits of empathy: that empathic accuracy might never be achieved; that it might be akin to manipulation; and that in the final analysis our capacity for self-orientation might exceed that for other-orientation. But it raises other questions also. In the museums sector, is the end point of empathy knowledge or action? What is the relationship between experience and comprehension? As Juliet Steyn has so eloquently asserted, 'Understanding and comprehension come slowly. Their efforts cannot be short-circuited' (2014).

Perhaps the only problematic that is emerging here is the use of the term 'game' to describe such online activities. Nick Fortugno and Eric Zimmerman (2010) contend that we should not be content to 'transfer the *style* of games onto educational tasks without understanding the *substance* of what makes a game work', else the feeling of 'play' will remain allusive. Henson and Birchall note that 'the online games market is very crowded and gamers won't seek out or recommend your game based on its learning outcomes' (2011). The feeling of play is engendered in the 'magic circle', a temporary game-space within which the player buys into the reality of the game's conflict, but all the while knowing that it is artificial. Such a suspension of disbelief is only possible if the player can read the range of signs that indicate that a game is 'on' (Salen and Zimmerman 2004: 94). I don't wish to argue that players of museum online games are unable to enter that magic circle, even if their engagement with such games might only be one-off and brief. I claim not that they are unable to ascertain what is real and what is fictive, or that they are unable to leave that game space. Rather, I wish to question the extent to which empathy, and its manipulation, is being given use-value in that space. It is this magic circle also that creates the feeling of 'safety' that is so important to players of video games. It is 'remarkably fragile … requiring constant maintenance to keep it intact' (Salen and Zimmerman 2004: 98). If games are experiential systems, if they are lived, then this is a responsibility museums should be live to also. Empathy, but to what end?

Conclusions

There is a growing body of literature that explores the value of games to learning processes (see for example Gee 2007), and which documents the rise of 'serious games' since the 1950s (Egenfeldt-Nielsen et al. 2013). There is also a growing literature on the role of empathy in gaming processes also (see Belman and Flanagan 2010, Bogost 2011), but we need to know more about how these collide in the case of the museum. Museum online games *may* be a powerful aid to learning, 'cognitive technologies', but the ways in which they are designed to make us 'feel' demand more reflection. Museum professionals are acutely aware of their responsibilities in this regard in other aspects of their work, in education programmes and on site – almost to the point of paralysis at times; but they are often less sophisticated in their consideration of these things in the online environment.

It is also timely to question how we articulate 'achievement' and 'goals' in games where protagonists might be overwhelmed by their own weaknesses, rendered powerless in the face of grave acts and discrimination or in the face of the historical record. 'Winning', 'success', even 'surviving' may be an impossibility from the outset, a useful learning experience perhaps, but counter to the feelings of safety that are traditionally written into the magic circles game-stories work so hard to construct. This raises questions not only about how adequately museums account for and justify empathy as an e-learning outcome, and the extent to which discussions take place with the games designers on these themes during construction.

Some wider questions are raised with regard to the ethics of museum practice in the digital environment. Should such encounters always and inevitably make links to the institutions that pay for them, and to their collections? Or are such links an unnecessary nod to traditional authorial voice and ownership? Might there be opportunities here to move toward more cultural interaction – away from the programmed and rather linear interactivity we have seen here – with a view to widening our understandings of relationships, values and other cultures through (for example) social games or open-source endeavours? Is there scope for museum games that learn from us as we play? Frank Rose has written about creative and insightful uses of existing games that seek to push the narrative into new realms, such as the use of *The Sims* to tell stories about homelessness (Rose 2011: 136).

In the final analysis, it is worth noting again how little we know about how museums' increasingly varied 'ecosystems of games' (Ridge 2012) contribute to processes of historical understanding for their users. More research needs to be done in this area. Yet we also know very little about how those working on their design and construction (both within the museum and externally as designers) reflect on or conceive of the games as history 'makers', as parts of museum narratives that are centuries in the making, and as similarly implicated in the processes and politics of representation. Given that these games are freely available online, and their potential for reach boundless, it is time we cared more about how their game-stories intersect with, conflict with and cross-fertilise the other narratives that make up the museum text.

Chapter 7
Mashup the Museum

In this book has been noted the conflicted and occasionally irreconcilable spectre of the museum in the new mediascape: a site where innovation meets tradition; authorship meets plurality; and, crucially, professional history 'makers' meet the public. In this final chapter I propose that, at its most radical extension, this mediascape reinvents the museum as a mashup, a site of active consumption, micro-creation, co-creativity and remix. It is this notion of 'remix' that will be at the heart of the discussion and case studies presented in this chapter, which recognises the demanding landscape within which heritage institutions operate, but seeks to position and respond to the more accommodating, adventurous and playful spirit which is found at the heart of an increasing proportion of museum practice. Indeed, it notes the move toward a set of emergent museum norms for the twenty-first century that have experimentation and collaboration at their core.

The museum is an intriguing site for reviewing the affordances of remix culture for a number of reasons. Firstly, we might recognise that notions of authorship and ownership are already problematised in such sites. A museum or art gallery might be in possession of an artefact or artwork, but it does not inevitably follow that it owns the copyright. To further complicate this scenario we might note that 'orphan' works are actually incredibly common in such contexts – that is, works whose origins are unknown and whose ownership is impossible to determine. Secondly, and increasingly, visiting, viewing or gazing at cultural goods is being recognised as an active site of interpretation rather than assumed to be a passive and rather underwhelming site of 'consumption'. Roland Barthes 'death of the author' (1977) for example sought to reposition the 'reader' as having mastery over a text, undermining the extent to which such texts might be perceived as conveying singularity of meaning as directed by an 'author':

> a text is made up of multiple writings, drawn from many cultures and entering into mutual relations of dialogue, parody, contestation, but there is one place where this multiplicity is focused and that place is the reader, not, as was hitherto said, the author. (Barthes 1977: 148)

> As such, '[t]he author's "death" provides an opening for multiple interpretations and possibilities' (Chris and Gerstner 2013: 8).

Thirdly, museums have, in their move toward digital, embraced computation as a means of documenting, preserving and allowing access to cultural heritage.

This commitment has meant a wealth of digital content available online and, concurrently, ensured that museums have been at the heart of debates within digital humanities and elsewhere about the ethics, ownership and use of digital collections. These three observations are at the heart of this chapter, and indeed this book as a whole.

The chapter begins with an overview of literature that can help us think through the issues inherent to remix: that is, the bringing together in combination of a number of discrete existent forms of creative output or artefacts in one new derivative work – one that echoes the original works but seeks to be more than, or at least in some meaningful way different to, those works. In this sense, mashups are 'additive and accumulative' (Sonvilla-Weiss 2010: 9). As Lankshear and Knobel note, what is significant here is 'the practice of taking cultural artefacts and combining and manipulating them into a new kind of creative blend' (2007: 1). The chapter then goes on to explore a number of case studies that variously elucidate upon the affordances of such practice. The conceptual framework is provided in an appraisal of Lawrence Lessig's notion of remix, Walter Benjamin's work on aura and Claude Lévi-Strauss' concept of bricolage.[1] These are a now familiar set of works within which to appraise and understand such practices and debate their implications.

Understanding Remix

The most renowned intellectual and discursive underpinning is provided by Lawrence Lessig in his 2008 text *Remix: Making Art and Commerce Thrive in the Hybrid Economy*. Indeed, *Remix* has become something of a manifesto for 'mashup' culture and micro-creation more broadly.[2] A Law Professor at Harvard University, Lessig is one of the founding members of the Creative Commons:[3] a collective re-imagination of licensing of creative works that has gone some way to transforming the discourse about ownership and copyright in many content arenas such as self-publishing, open access publishing, the flickr commons; or the work of Communia in its Public Domain Manifesto for example.[4]

1 This chapter foregrounds public forms of user creativity and remix rather than another set of activities that are commonly referred to as mashups – data mashups. These bring together different data formats using an application program interface (API) and display them via a single graphical interface (Constantinides 2012). At this time, such mashups raise fewer of the issues that will be outlined here.

2 See also Kirby Ferguson's series on remix at http://everythingisaremix.info/watch-the-series/ [Last accessed October 2013]. This provides a good history of practice and an overview of the issues. See also Leadbeater and Miller 2004.

3 http://creativecommons.org.

4 See www.communia-project.eu and www.publicdomainmanifesto.org.

Broadly, according to Lessig, remix indicates the embrace of a shift from a Read-Only culture to a Read/Write culture.

A Read-Only culture is one based on the idea that creativity is something only talented and artistic individuals do and have. In this conception of culture authorship and ownership are clearly located and articulated, and the majority of people get their only interaction with that culture through acts of consumption such as watching a film or going to a museum. This of course has been understood as the prevailing model for broadcasting, cinema and publishing; indeed, it was the dominant model of the twentieth century for engaging with cultural content. We might consider that this has been the dominant model in the museum also, impacting upon organisational structures, architectures and the visitor performance.[5]

Read/Write culture differs in that it allows for, and often encourages, practices of remixing where people 'add to the culture they read by creating and re-creating the culture around them' (Lessig 2008: 28). Rather than simply watching or consuming a film, this model might see audience members writing a spin-off to include the characters (as Harry Potter fans have done in Pottermore);[6] extending the narrative world (taking characters onto Twitter for example, and posting content from their perspectives); parodying the story (as in the many Hitler Downfall parodies);[7] or starting a wiki (as in Wookieepedia).[8] Lessig is convinced that, for a whole generation of young people, this has become not only a pastime but also a new way to 'write'. For Lev Manovich, the term 'remix' is apt because 'it suggests a systematic reworking of a source' (Manovich 2007) rather than activity characterised by aimlessness or chaos. It is thus a more participatory culture, with users having more options to produce and influence cultural outputs – not necessarily for financial reward, as Lobato et al. say: 'The absence of formal economies does not mean that there is no economy at all; it just means that the mechanisms of exchange lie outside the formal' (Lobato et al. 2014: 13). There is demonstrably a different kind of currency being exchanged in remix culture. most notably peer recognition and 'likes'. Indeed, to Manovich, this is perhaps where the real challenge and opportunity presented by such activity is presented: in the 'innovation, energy and unpredictability' of the networks that are forged as a result (Manovich 2009).

Read/Write is a culture that is not synonymous with the digital, however, and nor has it been enabled by it; remix is categorically *not* born digital. In fact, according to Lessig, such culture preceded the dominant twentieth-century model (Read-Only), and might be seen as normative. As Lankshear and Knobel boldly assert, 'remix is the general condition of cultures: no remix, no culture' (2007: 2). In addition, they say: 'We remix language every time we draw on it,

5 Although, as is noted already in this chapter, this idea of passivity in museum visitation is open to criticism.

6 https://www.pottermore.com.

7 Collated at http://www.youtube.com/user/hitlerrantsparodies [Last accessed October 2013].

8 http://starwars.wikia.com/wiki/Main_Page [Last accessed October 2013].

and we remix meanings every time we take an idea or an artefact or a word and integrate it into what we are saying and doing at the time' (2007: 2). Shields goes as far as asserting that 'collage' in its broadest sense, 'the art of reassembling fragments of pre-existing images in such a way as to form a new image, was the most important innovation in the art of the twentieth century' (Shields 2010: 19), and again pre-dates the digital. Digital technology however, as has been noted elsewhere in this book, does herald a revival of that culture on a scale unprecedented, and which is demanding attention – not least from the legal authorities for reasons outlined in this chapter. On its revitalisation in recent years, Lev Manovich has surmised that 'If post-modernism defined 1980s, remix definitely dominates 2000s, and it will probably continue to rule the next decade as well' (Manovich 2007).

Voigts and Nicklas suggest we might like to be more cynical of such practices and the extent to which they can be understood as 'politically, aesthetically and culturally valid' activities (Voigts and Nicklas 2013: 139). 'How transgressive is mashup culture?' they ask. 'Are these the free and creative variations of "cultural jazz" or merely a playground fostered by Big Bad Media to better situate and flog the products of corporate intertextuality?' (Voigts and Nicklas 2013: 139).

We might, momentarily at least, sidestep issues of such corporate intervention by noting that at the heart of remix culture and user creativity are various unpredictable and often unfathomable practices of fandom. In recent decades, Read/Write culture in the online space has been fuelled in large part by the endeavours of fans (most notably perhaps *Star Wars* and music fans); indeed, Henry Jenkins wrote about the practices of 'textual poachers' in the early 1990s (Jenkins 1992). The centrality of 'poaching' and 'the copy' at the heart of such activity have of course implicated copyright and ownership as central tensions within this landscape. Other practices however have been fuelled by politics, activism and the will to change. We can see this in evidence if we take the examples of parodies of political leaders' speeches and the various interventions known as culture jamming (see for example Lasn 2000). Clamping down on such approaches runs a precarious line characterised by futility and censorship. For all of these reasons remix might be considered politically and institutionally sensitive for museums.

If copying and poaching are central to such practices,[9] so too is a reappraisal of the auratic function of cultural texts, a problematic nowhere more evident than in the museum or art gallery. Walter Benjamin's *The Work of Art in the Age of Mechanical Reproduction* is of course a central text on this theme. In Benjamin's appraisal of the significance of photography in particular on our interpretation of aesthetics, he noted that mass reproducibility inevitably disrupted the relationship between the 'original' and its 'aura'. The consequences of such a distinction are, for Benjamin, notable for their potential to affect 'artistic invention itself and perhaps even bring about an amazing change in our very notion of art' (Paul Valéry, in Benjamin 1955: 211).

9 No better exemplified than in practices of sampling and mixing in the music industry, which took off in the late twentieth century.

Indeed, according to Bella Dicks, this 'opens up new horizons of social and political understanding' (Dicks 2003: 19).

In the museum, the potential consequences of this split between original and aura are profound; according to Silverstone, it is precisely 'aura' which is at the heart of what museums do:

> Museums display real objects, genuine objects, objects that have a history of use or an attachment to a place, objects which have an unambiguous authenticity, which in its reproduction would be destroyed (Benjamin 1970). Museums display and classify objects in ways which preserve their 'aura'. (Silverstone 1988: 233)

Silverstone goes on to explore the almost mythic quality – or perhaps even the fetishisation[10] – of aura in the museum, which in actuality runs counter to many of the experiences museum visitors have become used to in recent years; simulations and the unreal are of course a fact of museum visitation also. Here, the museum emerges as already:

> an agent not of innocent and unmediated display, but as an agent of artful and sophisticated creative representation, in which the claims to be presenting the real are simply that; claims, whose success or otherwise depends on the contextualisation and 'textualisation' of the exhibition as a whole, and the continuing acceptance of the Museum's authority as a purveyor of truth. (Silverstone 1988: 233–4)

It is of course not possible to assert the extent to which visitors are aware of the constructed nature of the museum experience, and the partiality and politics of display (see Introduction for more on this), but this has certainly been a rising concern for many museum professionals engaged in increased reflexivity of practice. That said, recognition of such a politics of representation has been less of a preoccupation of literature pertaining to the online museum in particular.

In the online environment, it might be said that practices of poaching, simulation and bricolage have become normative. As Deuze asserts:

> the manifold scrambled, manipulated and converged ways in which we produce and consume information worldwide are gradually changing the way people interact and give meaning to their lives. (Deuze 2006: 66)

Indeed to Paul, the 'immaterial systems supported by the digital medium and its network capabilities have opened up new spaces for cultural production and DIY culture' (Paul 2006: 3). This is something more and more 'autonomous producers'

10 In, say, guidelines discouraging or forbidding photography of museum and art gallery collections, although such rules are now on the wane (see Miranda 2013 for example).

(Paul 2006: 9) are taking advantage of across the realms of cultural, social and political production; one only has to look at YouTube to see that in daily evidence.

A key component of such production is the practice of bricolage, first conceived by Claude Lévi-Strauss in 1962 in relation to forms of labour that were premised on reuse, specifically workers mending and maintaining machinery by reusing and appropriating objects and elements from elsewhere: 'His [the bricoleur's] universe of instruments is closed and the rules of his game are always to make do with "whatever is at hand"' (Lévi-Strauss 1962: 17). This was extended to the realm of ideas and myth, which were seen as drawing also from a wide range of available resources. Practices of remix have also been understood as bricolage, best exemplified in the work of those seeking to challenge mainstream or dominant cultures by making use of and subverting the products of those cultures. They represent 'the highly personalized, continuous and more or less autonomous assembly, disassembly and re-assembly of mediated reality' (Deuze 2006: 66). John Hartley defines such practices as 'the creation of objects with materials to hand, re-using existing artefacts and incorporating bits and pieces' (2002: 22).

We will see that practices of remix and bricolage are rife in the cultural sector also: firstly within recognised professional artistic practice; secondly through 'amateur' participatory practices sanctioned by institutions themselves; and thirdly in spaces and places not legitimised by institutions, or that actively challenge their authority and ownership. It might also be noted that these issues are amplified in what I have termed from the outset the transmedia museum: the granularity and co-location of digital artefacts allowing for their easy use beyond the museum context (see Chapter 1). In short, both officially and unofficially, remix is an emergent museological practice.

Remix As Professional Artistic Practice

As has been noted, many practices of remix are far from benign, raising questions for the museum about ownership, rights and authenticity. But there are clear examples where, in boundaries recognised (and often set) by institutions, practices of remix have been embraced and encouraged. I will review one such example here with a short case study of Michael Landy's 2013 *Saints Alive* exhibition at the National Gallery in London.

Michael Landy's two-year term as the National Gallery's eighth Associate Artist culminated in 2013 with the *Saints Alive* exhibition in the Sunley Room, a temporary exhibition space on the second floor. Landy's tenure was marked by an interest in exploring the saints that pervade much of the Christian art in the gallery, a desire made material in the startling exhibits on show in this final exhibition. Landy's interest in the saints had emerged from his own 'self-flagellation' about what in fact he would *do* during his tenure, the brief being such an open one: 'What am I doing here?' he asked as he traversed the gallery's

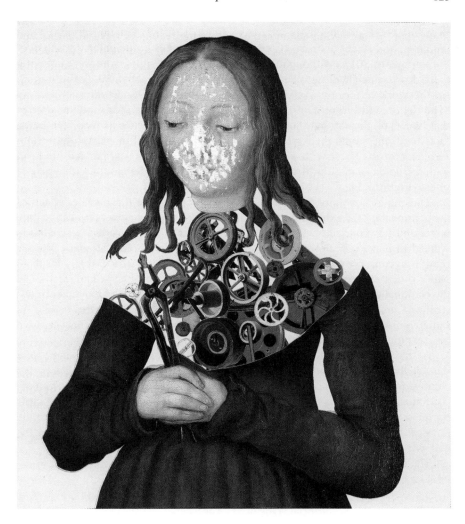

Figure 7.1 **Michael Landy, *Saint Apollonia (de-faced)* 2013, photographic paper, catalogue pages on paper. 50.2 × 44.7 cm (19¾ × 17⅝ in). Framed. (TDA03495). Courtesy of the artist and the Thomas Dane Gallery, London**

various spaces (BBC 2013). In answer, Landy began to make copies of artworks from the collection, and then to cut things out. As the National Gallery's Nicholas Penny notes in the exhibition catalogue, 'these cuttings combined and multiplied and grew, eventually into three dimensions; and then they began to move' (National Gallery 2013: 7).

Saints Alive presented six very large (up to 12ft tall) kinetic sculptures that violently, and rather alarmingly, destroyed themselves in the gallery space over the summer of 2013 – although in fact it was we, the visitors, who were breaking them down. Each sculpture had a foot pedal that, once activated by the viewer, set the work in motion. As such, to borrow from Charles Leadbeater's essay 'The Art of With' from 2009, 'It [was] not just the artist's ideas and knowledge that [were] on display but those of the participating audience as well.' On being 'activated' the saints then succumbed to their own brand of martyrdom: Saint Jerome beat his chest with a boulder; Saint Francis of Assisi banged his head with a crucifix; and Saint Apollonia smashed herself in the mouth with a pair of pliers (Figure 7.1).

These grotesque, noisy and unsettling characters were the focus of much of the commentary the exhibition received, unsurprising given how provocative they were, and how intricately assembled. Landy said of these works: 'I've always wanted to make a sculpture that defaces itself … the whole National Gallery's remit is to conserve and protect artworks. That's not mine' (BBC 2013). This then, was a direct attempt to disrupt, intervene and to mashup. Landy had 'arrived at the National Gallery and destroyed countless paintings, slicing through centuries' worth of imagery with a sharp-edged scalpel' (National Gallery 2013: 33). As Landy himself said in the exhibition catalogue, 'destruction can also be a creative act' (National Gallery 2013: 36).

At the other end of the gallery space a collection of quieter, yet no less mischievous, works adorned the walls: a number of collages bringing together cuttings from exhibition catalogues and high-resolution prints of paintings from the collection, with Landy's drawings. These fragments scope out and extend the ideas for the sculptures beyond the possibilities of the kinetic pieces and the order of the physical world. The works were a bricolage of source materials available in the galleries (Figure 7.1).

The exhibition catalogue notes Landy's use of these 'fragments' as akin to the broader museum project as itself a remix:

> Given that the National Gallery is itself a collection of fragments of broken-up paintings that have been rearranged to function as works of art, rather than being allowed to fulfil their original purpose as aids to religious contemplation, it might be thought that Landy's apparently whimsical use of the old painting is a critique of the culture of Old Master galleries. (National Gallery 2013: 33)

It might seem radical for the National Gallery to allow Landy to re-imagine the collection in the ways outlined above (although it's not unprecedented elsewhere, as in Banksy's high-profile installation at the Bristol Museum and Gallery, UK, in 2009); but it raises the question of what *might* have been possible should the right to remix, and the legitimisation of that mode of artistic enquiry, have been extended by the National Gallery to the visitor also. The point of the exhibition seems to have been to 'give new life to parts of the collection [visitors] have previously ignored'

Figure 7.2 'Leda and the Marsyas'. Reproduced courtesy of the artist, Jonathan Monaghan

(Penny, in National Gallery 2013: 7), not explicitly to engage them too in that spirit of play. Indeed, as Landy's pieces became new derivative works in their own right they also became protected by the same legal affordances of the originals. Only with the gallery's permission could Landy rip, distort and reconfigure in the ways he did; and if I want to do the same, I am going to have a fight on my hands.

Playful interactives on site, or in the online exhibition portal, might have encouraged visitors or website users to do the same: to engage creatively and critically with Landy's processes, and with the larger collection. There were a few nods to this endeavour: the gallery ran a workshop for families which encouraged them to 'cut, collage and create'; and the shop sold a colour-in version of one of Landy's recreations so visitors could 're-produce an iconic Landy image … in their own way'. Nice touches perhaps, but hardly radical.

The point of this case study is not that museums should open up the entirety of their collections to creative reuse and 'destruction'. Rather, it is to note how, in more subtle ways, professional practices we might define as remix are being encouraged.

Another brief example is the increased experimentation with 3D mashups at the Metropolitan Museum of Art in the United States.[11] Using MeshMixer and a 3D

11 See http://www.metmuseum.org/about-the-museum/museum-departments/office-of-the-director/digital-media-department/digital-underground/posts/2013/3d-printing.

printer, the museum has created a fusion of two different sculptures – *Leda and the Swan* and *Marsyas* – to produce 'Leda and the Marsyas' (Figure 7.2) (Undeen 2013). The piece caused some controversy upon its unveiling, sparking a discussion on Twitter about the use-value of technological interventions in museums and galleries, and numerous reappraisals of authenticity in 140 characters. The work was seen as a 'travesty' of the original, and demonstrative of the wider 'trouble with tech' (@CultureGrrl). But, as Suse Cairns posits in her Museum Geek blog, we might equally see this as an extension of artistic practice more generally, and the kind of questioning that it should elicit. Cairns goes on to ponder the extent to which it matters to our response whether an artist is making the work (as in Landy's practice above), or a museum technologist or programmer. Cairns concludes that the crux of the issue may actually be 'about the shift in the balance of power as traditional artforms and positions are interrogated' (Cairns 2013). Who gets to be a part of the practice, and the discussions that inevitably emerge around that practice, are, to Cairns, of critical importance.

The next sections will focus on current (often rather tentative) extensions of remix as a participatory practice to visitors and users in museum online and offline contexts. The examples operate within and variously frustrate two co-existent frames for our understanding of remix: remix as creativity and as criminality.

Remix As Creativity

> I don't feel any of the guilt normally attached to 'plagiarism,' which seems to be organically connected to creativity itself. (Shields 2010: 38)

There have been many examples of museum projects explicitly and directly embracing 'remix' in all its forms. Early examples include the collaborative *Franklin Remixed* project (see Fisher and Twiss-Garrity 2007);[12] the 2009 Brooklyn Museum musical remix project that accompanied the Who Shot Rock and Roll exhibition;[13] and the Auckland War Memorial Museum's annual competition (since 2010) called *I AM Making Movies*, which encourages young people to make movies based on source materials and stories from the museum's collections (see Swift 2011). More recently, we might observe various events that come under the banner of the ongoing Seattle Art Museum's remix initiative, including a number of creative activities

12 From the Benjamin Franklin tercentenary, the Rosenbach Museum and Library, the University of the Arts and Night Kitchen Interactive, Philadelphia.

13 Using SoundCloud, this project encouraged users to download a number of tracks, remix them and then enter them into a competition. Still available at http://www.brooklynmuseum.org/exhibitions/rock_and_roll/remix.php [Accessed October 2013]. There were strict guidelines in this project relating to the use of additional copyrighted materials.

inspired by and utilising the collections and 'highly opinionated' tours;[14] also, archives such as the Welsh Experience of World War One digitisation project which will distribute high-resolution source materials freely to reuse for non-commercial purposes.[15] Other high-profile examples include the Rijksmuseum, which has more than 125,000 high-resolution images available for download and reuse (see Chapter 3), and the British Library's YouTube clips, also available for download and reuse. The Getty Museum's Open Content Program is another example of images in the public domain being distributed, but for any purpose.[16]

Such openness is also exemplified in projects such as Europeana[17] and the Google Art Project, where even if images cannot be claimed as public domain, there is at least a commitment to make copyright information clear and upfront.

Perhaps the most notable and committed effort to embrace remix in the 'GLAM' sector[18] has been through the flickr commons: an attempt to bring together public photography collections in a way that is accessible and breeds reuse and further knowledge production.[19] As of October 2013 there are 73 institutions represented in the commons, sharing materials that have 'no known copyright restrictions' and thus public domain licences.[20] There is an encouragement for members of the public to add tags and comments to images, which provides helpful additional metadata and interpretation for museums – a kind of 'digital constructivism' (Fisher and Twiss-Garrity 2007). We also see within such an initiative a hope that being in the commons will increase exposure for the institutions and their collections.

But the idea of the commons is by no means a straightforward one, or one that is easily and readily understood by museums' communities of users. Edson and Cherry (2010) ask:

> But what exactly is a commons? What are its characteristics? What makes a commons different than just a good on-line collections Web site? Why are these differences important to our organizations and audiences?

The *value* of a commons is found precisely in the free sharing of information and resources; but of course that value is understood and assessed differently depending on an individual's personal and professional affiliations. Edson and Cherry settle on a list of themes and attributes that can be found in various 'museum commons'.

14 See https://www.seattleartmuseum.org/visit/calendar/Events?EventID=28200; also events at the Olympic Sculpture Park, http://www.seattleartmuseum.org/calendar/eventDetail.asp?eventID=21777. These have been running since 2010.

15 National Library of Wales, http://cymruww1.llgc.org.uk.

16 http://www.getty.edu/about/opencontent.html.

17 http://www.europeana.eu/.

18 A shorthand for Galleries, Libraries, Archives and Museums often used by such organisations.

19 As with Wikimedia commons, http://commons.wikimedia.org/wiki/Main_Page.

20 http://www.flickr.com/commons/institutions/.

In these spaces, they note, resources tend to be federated, findable, shareable, reusable, free, high resolution, machine readable, and designed and presented with users in mind (Edson and Cherry 2010). They also, crucially, exist within and advance the idea of the public domain.[21] This is not to say that all museum collections exist within the public domain; far from it. Even though the public support, and in supporting purchase, conserve and store collections materials, there are of course a great number of them that remain inaccessible via these formats. Nevertheless, there is an increased trend toward openness, sharing, reuse (for non-commercial purposes) and joint knowledge creation within the rhetoric, and a recognition that 'each remix in principle expands the possibilities for further remix' (Lankshear and Knobel 2007: 10).[22]

In these examples, the desire to download and adapt is understood as creativity, and any legal barriers are seen as potentially limiting to that pursuit:

> To cut short the creative exchanges that digital-media technology set in motion,
> in other words, is to bring to a standstill aesthetic and intellectual transformation.
> (Chris and Gerstner 2013: 10)

In this view also, objects and their likenesses are inscribed again with a use-value rather than being purely illustrative. These initiatives, where (we might note) museums are very much in the driving seat, see Read/Write as a philosophy to be embraced and guarded. They are of course, however, not universal, as Kristin Kelly notes:

> Some museums would like to implement open access to images in their
> collections, but lack the technological, financial, or human resources to do so.
> Other museums are waiting until more museums have adopted open access to
> learn from their experiences. (Kelly 2013: 7)

There are then still barriers in place which act as very real – or at least perceived – limiting forces for museums in the embrace of remix.

21 For the full list as set out by the authors, see Edson and Cherry (2010).

22 Notably, many of the examples used here are opening up image archives for users to remix, and this is not simply a quirk of this landscape. It has been noted that work with images and 'Photoshopping' (as a verb) have become core to the practice of remix within the digital landscape (Lankshear and Knobel 2007). Indeed, programs like Instagram and iPhoto have made them nigh on ubiquitous. Such processing and editing, indeed manipulation – especially when it is highlighted by the mainstream media, say, in advertising – is often seen as analogous to lying, as if photographs were ever 'pure' or objective in the first instance (Gripsrud 2006). In these instances, the use is deemed to be rather *too* creative, with inauthenticity and inaccessibility being likely consequences. The 'aura' of the original has seemingly been violated, with lack of transparency being a complicating factor.

Remix As Criminality

> [D]igital remixing has been the object of high profile and punitive legal action
> based on copyright law. The legal backlash against popular practices of remix has
> helped fuel an organized oppositional response to what is seen as unacceptable
> levels of constraint against the public use of cultural material. (Lankshear and
> Knobel 2007: 1)

One fact that becomes impossible to overlook in this debate is that every single act
of remix creates a 'copy', even as it might be a part of a new 'derivative work'. A
new expressive creation is produced, but one that often includes elements that are
copyright-protected in other work. This creates great challenges: how to set policy
that accounts for different uses of content; whether and how far the rights of creators
should be protected; and how to deal with those who actively and persistently flout
the law in relation to these matters. Policy in this arena needs to manage, contain,
encourage, facilitate and regulate all at the same time. It is thus easy to see how
museums can find themselves at a point of paralysis in response.

There are clear reasons why museums might wish to assert and protect
copyright over particular works, not least a concern that particularly sensitive
collections or cultural properties should not be misused or disrespected; nor those
with 'ethical entanglements' (Eschenfelder and Caswell 2010). To Eschenfelder
and Caswell this remains a distinct possibility:

> Reuse also increases risk of disrespectful or defamatory framing of a work.
> Third party re–representations may present works, their source communities,
> or people pictured in the works as illegitimate, absurd, laughable or objects of
> hatred. This is particularly troublesome if the source community is a historically
> disadvantaged or misrepresented group and/or the digital work in question is
> considered a traditional cultural expression (TCE). CI professionals may feel a
> 'duty' to ensure respectful uses (Tanner 2004). (Eschenfelder and Caswell 2010)

In the face of a mixed copyright landscape – where some works are in the public
domain, some clearly not and others more complex to deduce ownership for – it can
seem an attractive option simply to 'post copyright claims that control reuse over
digital works regardless of their copyright status' (Eschenfelder and Caswell 2010).
Such a default is perhaps more straightforward to operationalise. Hamma is damning
in his appraisal of such blanket policy and its suitability to the larger museum project
as a public good (particularly in his case, in consideration of artworks):

> Resistance to free and unfettered access may well result from a seemingly well-
> grounded concern: many museums assume that an important part of their core
> business is the acquisition and management of rights in art works to maximum
> return on investment. That might be true in the case of the recording industry,

but it should not be true for nonprofit institutions holding public domain art works; it is not even their secondary business. (Hamma 2005)

In this view, any predisposition to assume all rights should be reserved in all instances, or at least licences purchased, is to fundamentally misread or even purposefully undermine the primary functions of such institutions.

In 2010, Eschenfelder and Caswell studied the access US archives, libraries and museums offered to their collections, and concluded that most did try to maintain some level of control with 54 per cent controlling a moderate to large amount. They found that it was more often than not historical photographs that were offered up for reuse (as is also the case if one looks at the flickr commons). They also concluded that most museums were motivated by a concern that object description and repository identification would not be appropriate or correct (71 per cent of respondents) or that it would be misused or misrepresented (66 per cent). They thus exhibited an incredible mistrust of the very publics for whom they are said to operate. Demonstrably then there are those who, according to Ross Parry, view the web medium as inherently problematic for the museum: a space where 'some essential principles for the museum related to trust, accuracy and artifice, all remain difficult to fix' (Parry 2013a: 18). In this view, the affordances of the new mediascape remain difficult to reconcile with museological traditions, being both 'lawless' and 'normless', and potentially 'trustless'.

But we might note that it is not always the museum that occupies the legal (if not moral) high ground in this debate. There are times when museums themselves can fall foul of the law also. In 2013 Naomi Korn (noted copyright specialist working with public bodies, including the museums sector) reflected that such content had the potential to criminalise the institutions also (Korn 2013a). For example, museums enthusiastically endorsing user-created contributions that could well prove to have originated elsewhere – and thus still be copyright protected; or being unaware of copyright-protected works that have been posted by users within social network spaces they host (Korn 2013a). This may be complicated by the degree to which, 'Rather than trying to control social media, most copyright owners have realised they will be better off embracing it as a marketing and promotional tool' (Olson 2013: 84).

There are also very real examples of museums being criminalised for their own uses of copyrighted works. We might note two cases. The first is the Monroe County Heritage Museum in Alabama, US, which in September 2013 was locked in a legal battle with Harper Lee, author of *To Kill A Mockingbird* – the text to which the museum's very existence is dedicated (indeed, its website can be found at http://www.tokillamockingbird.com). The museum's merchandise in particular was seen to be trading on the name of the book, and its relationship with that place (Reuters 2013a 2013b). The legal proceedings for this case are still unfolding, but have resulted in much local and international debate about what an author's responsibility is to any place they call forth in such a text, and

what that place's responsibilities are to the author also: are they preserving and promoting that work or exploiting and profiteering from it?

The second case involves the Gagosian Gallery in New York, which, in 2011, was taken to court as part of a dispute between two artists, Patrick Cariou and Richard Prince. The case originated with an exhibition in 2008 featuring 22 of Prince's remixes of Cariou's original works – photographs from his book *Yes, Rasta* that had been adapted, displayed and some later sold for millions of dollars. In the final ruling, which found in favour of Cariou, 'Prince and the Gagosian [were] ordered to destroy all the paintings and exhibition catalogues … and to tell buyers that the paintings were not lawfully made and cannot lawfully be displayed' (Bates 2011). Prince is characterised by *Artnet* magazine as 'an artist who routinely flouts the law' (Corbett 2011), a fact that only makes his artworks more tempting to collectors and galleries. The verdict, which is under appeal, has been largely decried by cultural commentators, artists and galleries who see that it might 'have a "chilling effect" on appropriation-based practices' and a negative impact on creativity more broadly (Harrison 2013: 56).

Such examples show that although the legal position might be clear (even if unknown), the moral and ethical positions can remain ambiguous; who is doing good/right and who is doing bad or 'wrong' depends very much on where you are standing. They also raise very pertinent questions about who bears responsibility in cases of misuse, non-accreditation and blatant naivety, and what might constitute reasonable repercussions.

As I write in 2013, there is a lively debate occurring within the United Kingdom about whether a number of exceptions to copyright should be legitimised in the legislative framework, a modernisation of law that would see an extension of fair dealing that might aid the practices reviewed in this chapter (see Korn 2013b and Hargreaves 2011 for example).[23] The 2011 Hargreaves report in particular makes a number of recommendations with a view to 'supporting innovation and promoting economic growth in the digital age' (Hargreaves 2011: 7). These include: making all orphan works licensed for public use; resisting the over-regulation of activities that do not impinge authors' incentives to create – including parody, non-commercial research and 'format shifting' (2011: 8); and creating exceptions that allow for text and data analytics. These recommendations were broadly accepted and incorporated into the UK Government's response (HM Government 2011). In 2014 we will find out whether a bill can be passed to give copyright law in the UK the most radical overhaul it has undergone in centuries.

23 For a more general text that overviews these problematics in some detail, see Olson 2013, who says: 'traditional copyright rules, which emphasize exclusive authorship and ownership, are not well suited to fostering a system based on collaborative and interactive creation' (Olson 2013: 93–4; see also Kawashima 2010 and various chapters in Hunter et al. 2014).

Conclusion

> We have become so inured to the proprietary model, so dazzled and intimidated by its cultural and political power, that any commonsense challenge to its assumptions and tenets seems radical, idealistic, or dangerous. But in recent years the practical advantages of the 'open source' model of creativity and commerce have become clear. (Vaidhyanathan 2012: 24)

The above quote, from Siva Vaidhyanathan's essay 'Open Source as Culture/ Culture as Open Source', is a precursor for a later assertion that open source is a workable model for culture far beyond the world of software ('extra-software' 2005: 29), and that a new set of defaults need to be set in place. This is of course not a universally held set of beliefs, as has been noted in this chapter. In the closing paragraph, Vaidhyanathan calls for common sense to be added to the toolboxes of those who argue from polarised positionality on this subject.

In their research, Eschenfelder and Caswell identified three attitudes amongst museum professionals toward digital collections. Firstly, 'the virtual display case' view holds that content should be as visible as possible, but that it should be protected or shielded by the institution itself from potentially disruptive and harmful uses (perhaps including remix). Secondly, the 'cultural property approach' holds that the institution has a duty of care to content source groups to ensure that they are not disrespected, exploited or diluted through overuse (see also Bowrey and Anderson 2009, Spock 2009). There are thus ethical considerations at play in any discussion about cultural content, and it is worth noting that these do not always map readily onto the legal considerations. Neither is the distinction between ethical and unethical behaviour dichotomous. Thirdly, the 'cultural remix' approach contends that cultural content should be open to reuse and redistribution in the pursuit of knowledge (Eschenfelder and Caswell 2010).

Proponents of this 'cultural remix' approach see it as fast becoming a default position for users of the web whose browsing patterns and consumption of content are often strategic and utilitarian. As Kristin Kelly notes, 'Users of these images, whether academics or the general public, are accustomed to working at Internet speed and expect the images to be delivered at that speed as well (Kelly 2013: 3). They expect to be able to access museums' content at the same speed, in similar formats, and to find them as malleable as other content they consume online. The longer-term implications of that change in expectation of course remain unclear.

Lev Manovich, one of the most influential scholars of the 'new' media, was quick to ask (in 2007) 'What comes after remix?' Noting that remix fundamentally shifts the ground upon which creativity is performed, he ponders:

> Will we get eventually tired of cultural objects – be they dresses by Alexander McQueen, motion graphics by MK12 or songs by Aphex Twin – made from samples which come from already existing database of culture? And if we do,

will it be still psychologically possible to create a new aesthetics that does not
rely on excessive sampling? (Manovich 2007)

Remix is so much a part of the cultural logic that it has become difficult, if not
impossible, to challenge (Manovich 2007).[24] This has been less true in the museum,
however, where the possibilities of remix – where it is noticed and noted – still
represent a significant re-fashioning of museological practice, and simultaneously
re-fashion contemporary museology also.

There are also those who seek to stress the limitations of the remix approach
to culture. Christen reminds us that the technologies themselves are not neutral
(as was noted in the Introduction), and that their use happens within certain
kinds of 'knowledge practices' and 'economic structures' that are themselves
also pre-loaded (Christen 2005: 333). She notes also that issues of access remain
problematic; race, gender and class in particular remain barriers to individuals'
participation in the 'commons':

> the cultural commons solution buys into a mutated colonial logic that once
> produced the museum of mankind ideal of cultural collection; innovation and
> preservation for some, erasure for others. Instead of reproducing this either-
> or debate (public/private, commons/enclosure, pirates/purchasers), we should
> ask where the lines of this commons are drawn and by whom. (Christen 2005:
> 333–4)

Raymond Williams' assertion that 'Any restriction on the freedom of individual
contribution is actually a restriction of the resource of the society' (Williams 1976:
124–5) can thus be read in two ways: as an argument *for* unrestricted remix; and as
a reminder of its inadequacies and limitations for those without the requisite social
or cultural capital – or indeed, digital literacy.

Christen believes that reviewing and updating legal structures – in the ways
I have outlined above – is naive in that it serves only to assert, and maintain,
Western 'versions of property and progress as universal' (Christen 2005:
334). Moreover, remix, according to Eduardo Navas (2012), is linked to 'the
domestication of noise' (here he borrows from Jacques Attali), and as such
becomes a means of normalising certain kinds of behaviours and resistance. In
the case of remix, that domestication results in a moderate and containable form
of activism and art, whose parameters are now easily understood and increasingly
devoid of their perceived radical origins: 'Remix is parasitical. Remix is meta –
always unoriginal' (Navas 2012: 4).

With specificity to the museums context in mind, we might also question the
implications for contemporary museological practice. Is there not a chance that

24 Although, as Manovich notes elsewhere (2009), it is a practice that is carried out
by a tiny minority of internet users and should not be overstated within the landscape of
participatory media more broadly.

the institution gets lost in this kind of culture? Are we comfortable with the idea of the museum archive as pure source material? Is the ultimate success story of the museum in this landscape one that renders itself invisible? Such questions raise real and urgent questions about where and how we locate value in our cultural institutions. Another question raised in this discussion is whether we know enough about how remix can facilitate and constitute learning. As in Chapter 6, questions about how museums articulate and understand e-learning outcomes come again to the fore.

In the face of such questions, we might note the incorporation of these activities in museums (in the manner outlined earlier in this chapter) as a rather cynical process of containment or even 'domestication' of the noisy communications we see happening 'elsewhere'. If museums and galleries want to genuinely embrace the affordances of remix, they would do well to relax their understanding of their own authority, and their assessments of who and what constitutes creativity:

> Museums must recognize the fact that in this digital environment it's likely visitors and students will use museum collections in ways which may surprise, delight or even worry them a little bit. (Swift 2011)

The larger narrative that has emerged in this book, and that emerges again in this closing chapter, is one that moves between museums' simultaneous tendencies toward internalism and externalism. Internalism references museums' desire for institutional purpose, policy and voice, and to feel a part of a wider sector that recognises and legitimises their practice. Externalism highlights museums' concurrent wish to look outward, to throw off their authorial voice, even momentarily, and to drive their narratives and content into new and perhaps difficult spaces, such as the digital media. This conflicted mode of being ably demonstrates our still emerging understanding of 'Internet logic' (Freedman 2012: 73) and its possibilities for the museum.

Bibliography

Abell, S.K. and Lederman, G.N., 2007, *Handbook of Research on Science Education*. Mahwah, NJ: Lawrence Erlbaum.

Adair, Bill, Filene, Benjamin and Koloski, Laura, 2011, *Letting Go? Sharing Historical Authority in a User-generated World*. Philadelphia: Pew Center for Arts and Heritage.

Allah Nikkhah, Hedayat and Redzuan, Ma'rof, 2009, 'Participation as a medium of empowerment in community development' in *European Journal of Social Sciences* 11(1): 170–76.

Allen, Michael Thad and Hecht, Gabrielle (eds), 2001, *Technologies of Power*. Cambridge and London: MIT Press.

Allen S. and Gutwill, J., 2010, 'Designing with multiple interactives: five common pitfalls' in *Curator: The Museum Journal* 47(2): 199–212.

Ambrosi, A. and Thede, N., 1991, *Video the Changing World*. New York: Black Rose.

Amelunxen, H., Iglhaut, S. and Rötzer, F. (eds), 1996, *Photography after Photography: Memory and Representation in the Digital Age*. Amsterdam: G+B Arts.

Ames, M.A., 2005. 'Museology interrupted' in *Museum International* 57(3): 44–51.

Amgueddfa Cymru, 2012, 'Welsh Language Scheme'. Available at http://www.museumwales.ac.uk/en/47/ [Accessed 20 August 2013].

Anderson, Sam, 2012, 'Just one more game … Angry Birds, Farmville and other hyperaddictive "stupid games"' in *New York Times Magazine*. Available at http://www.nytimes.com/2012/04/08/magazine/angry-birds-farmville-and-other-hyperaddictive-stupid-games.html?pagewanted=alland_r=0 [Accessed 23 October 2012].

Anderson, David and Cornfield, Michael (eds), 2003, *The Civic Web: Online Politics and Democratic Values*. Oxford: Rowman and Littlefield.

Antin, Judd, 2012, 'Gamification is not a dirty word' in *Interactions* (July–August): 14–16. Available at http://mags.acm.org/interactions/20120708/?pg=16#pg16.

Appadurai, Arjun, 1996. *Modernity at Large: Cultural Dimensions in Globalization*. Minneapolis: University of Minnesota Press.

Arts and Business, 2013, 'The Latest Private Investment in Culture Survey 2011/12'. Available at http://artsandbusiness.bitc.org.uk/research/latest-private-investment-culture-survey-201112 [Accessed November 2013].

Arts Council England, 2013, 'Taking Part: The National Survey of Culture, Leisure and Sport Adult and Child Report 2011/12'. Available at https://www.gov.uk/

government/publications/taking-part-the-national-survey-of-culture-leisure-and-sport-adult-and-child-report-2011-12 [Accessed October 2013].

Assunção, Paula and Primo, Judite (eds), 2013 (2nd edn), *To Understand New Museology in the XXI Century*. Lisbon: Universidade Lusófona de Humanidades e Tecnologias.

Atton, Chris, 2002, *Alternative Media*. London: Sage.

Bal, M., Crewe, J. and Spitzer, L. (eds), 1999, *Acts of Memory: Cultural Recall in the Present*. Hanover, NH and London: University Press of New England.

Baldwin, Timothy and Kuriakose, Lejoe Thomas, 2009, 'Cheap Accurate RFID Tracking of Museum Visitors for Personalized Content Delivery'. Available at http://conference.archimuse.com/biblio/cheap_accurate_rfid_tracking_museum_visitors_personal.

Ballantyne, Roy and Uzzell, David, 2011, 'Looking back and looking forward: the rise of the visitor-centred museum' in *Curator: The Museum Journal* 54(1): 85–92.

Bates, Stephen, 2011, 'Richard Prince ordered to destroy lucrative artwork in copyright breach'. Available at http://www.theguardian.com/world/2011/mar/23/richard-prince-artwork-copyright-breach [Accessed 13 October 2013].

Batson, C. Daniel, 2009, 'These Things Called Empathy: Eight Related but Distinct Phenomena' in Decety, J. and Ickes, W. (eds), *The Social Neuroscience of Empathy*. Cambridge, MA: MIT Press.

Baudrillard Jean, 1983, *Simulations*. New York: Semiotext(e).

Baudrillard Jean, 1981 (1994 edn), *Simulacra and Simulation*. Ann Arbor: University of Michigan Press.

Baym, Nancy K. 2010. *Personal Connections in the Digital Age*. Cambridge, MA: Polity Press.

BBC, 2013, *Front Row*. Wednesday 22 May 2013, 7.15pm. Available at http://www.bbc.co.uk/programmes/b01sjj7x.

Belman, J. and Flanagan, M., 2010, 'Designing games to foster empathy' in *Cognitive Technology* 14(2): 11–22.

Benjamin, Walter, 1955 (1992 edn), *Illuminations*. Ed. Hannah Arendt; trans. Harry Zohn. London: Fontana.

Bennett, J. and Kennedy, R., 2003, *World Memory: Personal Trajectories in Global Time*. Basingstoke: Palgrave Macmillan.

Bennett, Tony. 1995. *The Birth of the Museum: History Theory Politics*. London: Routledge.

Bennett, Tony, Savage, Mike, Silva, Elizabeth, Warde, Alan, Gayo-Cal, Modesto and Wright, David, 2009, *Culture, Class, Distinction*. London: Routledge.

Bergstrom, Kelly, 2011, '"Don't feed the troll": shutting down debate about community expectations on Reddit.com' in *First Monday* 16(8). Available at http://firstmonday.org/ojs/index.php/fm/article/view/3498/3029.

Berlin, 2003, 'The Berlin Declaration on Open Access to Knowledge in the Science and Humanities'. Available at http://openaccess.mpg.de/3515/Berliner_Erklaerung [Accessed 24 April 2014].

Berry, D.M. (ed.), 2012, *Understanding Digital Humanities*. Basingstoke: Palgrave Macmillan.

Bevan, N. (2009). *What is the Difference between the Purpose of Usability and User Experience Evaluation Method?* London: Professional Usability Services. Available at http://nigelbevan.com/papers/What_is_the_difference_between_usability_and_user_experience_evaluation_methods.pdf.

Bidwell, Nicola J. and Winschiers-Theophilus, Heike, 2012, 'Extending Connections between Land and People Digitally' in Giaccardi, Elisa (ed.), *Heritage and Social Media*. London and New York: Routledge.

Bishop, Claire, 2012, *Artificial Hells: Participatory Art and the Politics of Spectatorship*. London and New York: Verso.

Bishop, Claire (ed.), 2006, *Participation*. London: Whitechapel.

Black, Graham, 2012, *Transforming Museums in the Twenty-first Century*. London and New York: Routledge.

Black, Graham, 2005, *The Engaging Museum: Developing Museums for Visitor Involvement*. London and New York: Routledge.

Black, Sue, Bowen, Jonathan P. and Griffin, Kelsey, 2010, 'Can Twitter Save Bletchley Park?' Paper presented at Museums and the Web 2010, Colorado. Available at http://www.museumsandtheweb.com/mw2010/papers/black/black.html [Accessed 24 April 2014].

Blud, L.M., 1990, 'Social interaction and learning among family groups visiting a museum' in *Museum Management and Curatorship* 9(1): 43–51.

Boast, Robin, 2011, Neocolonial collaboration: museum as contact zone revisited' in *Museum Anthropology* 34(1): 56–70.

Bogost, Ian, 2011, *How to Do Things with Video Games*. Minneapolis: University of Minnesota Press.

Bohman, James, 2004, 'Expanding dialogue: the internet, the public sphere and prospects for transnational democracy' in *Sociological Review* 52(1): 131–55.

Bourdieu, Pierre, 1984 (2010 edn), *Distinction: A Social Critique of the Judgement of Taste*. London: Routledge.

Bourriaud, Nicolas, 1997, *Relational Aesthetics*. Dijon: Presses du Réel.

Bowman, Shane and Willis, Chris, 2004, *We Media: How Audiences Are Shaping the Future of News and Information*. Thinking Paper of the American Press Institute. Available at http://www.hypergene.net/wemedia/weblog.php [Accessed 1 March 2007].

Bowrey, K. and Anderson, J., 2009, 'The politics of global information sharing: whose cultural agendas are being advanced?' in *Social and Legal Studies* 18(4): 479–504.

Boylan, Patrick, 1992, 'Museums 2000 and the Future of Museums' in Boylan, P. (ed.), *Museums 2000: Politics, People, Professionals and Profit*. London: Routledge.

Boyle, David and Harris, Michael, 2009, 'The Challenge of Co-Production'. Report for NESTA, http://www.nesta.org.uk/publications/challenge-co-production [Accessed May 2013].

Brabham, Daren C. 2013, *Crowdsourcing*. Cambridge, MA: MIT Press.

Bradburne, James, 2008, 'Foreword' in Tallon, Loïc and Walker, Kevin (eds), *Digital Technologies and the Museum Experience: Handheld Guides and Other Media*. Lanham, MD: AltaMira.

Bradburne, James, 2000, 'The Poverty of Nations: Should Museums Create Identity?' in Fladmark, J.M. (ed.), *Heritage and Museums: Shaping National Identity*. Shaftesbury: Donhead.

Brooker, Will and Jermyn, Deborah (eds), 2003, *The Audience Studies Reader*. London: Routledge.

Burton, C. and Scott, C. (2003), 'Museums: challenges for the 21st century' in *International Journal of Arts Management* 5(2): 56.

Cairns, Suse, 2013, '"I like your old stuff better than your new stuff". On 3D mashups, appropriation, and irreverence'. Available at http://museumgeek. wordpress.com/2013/10/29/i-like-your-old-stuff-better-than-your-new-stuff-on-3d-mashups-appropriation-and-irreverence/ [Accessed 29 October 2013].

Cameron, Fiona and Kelly, Lynda (eds), 2010, *Hot Topics, Public Culture, Museums*. Newcastle upon Tyne: Cambridge Scholars.

Carpentier, Nico, 2011, *Media and Participation: A Site of Ideological-Democratic Struggle*. Bristol: Intellect.

Carr, David, 2001 'A museum is an open work' in *International Journal of Heritage Studies* 16(1): 4–15.

Castells, Manuel, 2001, *The Internet Galaxy*. Oxford: Oxford University Press.

CFM (Center for the Future of Museums), 2008, *Museums and Society 2034: Trends and Potential Futures*. Available at http://www.aam-us.org/docs/center-for-the-future-of-museums/museumssociety2034.pdf [Accessed July 2013].

Chan, Seb, 2012, 'On storyworlds, immersive media, narrative and museums: an interview with Mike Jones'. Available at http://www.freshandnew.org/2012/10/storyworlds-immersive-media-narrative-interview-mike-jones/ [Accessed 19 September 2013].

Chan, Seb, 2009, Various posts, including http://www.powerhousemuseum. com/dmsblog/index.php/2009/03/05/qr-codes-in-the-museum-problems-and-opportunities-with-extended-object-labels/ on work at the Powerhouse Museum.

Charles, Alec, 2012, *Interactivity: New Media, Politics and Society*. Oxford: Lang.

Chatfield, Tom, 2010, *Fun Inc: Why Games are the 21st Century's Most Serious Business*. London: Virgin.

Chris, Cynthia and Gerstner, David A. (eds), 2013, *Media Authorship*. New York and London: Routledge.

Christen, Kimberley, 2005, 'Gone digital: Aboriginal remix and the cultural commons' in *International Journal of Cultural Property* 12(3): 315–45.

Chun, Susan, Trant, Jennifer and Wyman, Bruce, 2006, 'Steve.museum: An Ongoing Experiment in Social Tagging, Folksonomy, and Museums'. Presented at the Museums and the Web conference 2006, Albuquerque, New Mexico.

Available at http://www.archimuse.com/mw2006/papers/wyman/wyman.html [Accessed 24 April 2014].

Ciolfi, Luigina, Scott, Katherine and Barbieri, Sara, 2011, *Re-thinking Technology in Museums 2011: Emerging Experiences*. Proceedings of the international conference. Limerick: University of Limerick.

Clark, Nick, 2013, 'V&A museum appoints first ever "game designer in residence" to add virtual dimension to its collection' in the *Independent*, Thursday 30 May. Available at http://www.independent.co.uk/arts-entertainment/art/news/va-museum-appoints-first-ever-game-designer-in-residence-to-add-virtual-dimension-to-its-collection-8638393.html [Accessed 30 May 2013].

Clarke, M.J., 2013, *Transmedia Television: New Trends in Network Serial Production*. London and New York. Bloomsbury.

Clifford, James, 1997, *Routes: Travel and Translation in the Late Twentieth Century*. Cambridge, MA: Harvard University Press.

Coleman, Beth, 2012 'Everything is animated: pervasive media and the networked subject' in *Body and Society* 18(1): 79–98.

Confino, Alon, 1997, 'Collective memory and cultural history: problems of method' in *American Historical Review* 102(5): 1386–403.

Consalvo, Mia and Dutton, Nathan, 2006. 'Game analysis: developing a methodological toolkit for the qualitative study of games' in *Game Studies* 6(1): 1–17.

Constantinides, Panos, 2012. 'The development and consequences of new information infrastructures: The case of mashup platforms' in *Media Culture and Society* 34(5): 606–22.

Conway, M.A. 1990. *Autobiographical Memory: An Introduction*. Milton Keynes: Open University Press.

Cooke, Bill and Kothari, Uma (eds), 2001, *Participation: The New Tyranny?* London and New York: Zed Books.

Corbett, Rachel, 2011, 'A win for Richard Prince in copyright case'. Available at http://www.artnet.com/magazineus/news/corbett/prince-wins-right-to-appeal-in-cariou-v-prince.asp [Accessed November 2013].

Corliss, Jonathan, 2011, 'Introduction: the social science study of video games' in *Games and Culture* 6(1): 3–16.

Crane, S. (ed.), 2000, *Museums and Memory*. Palo Alto, CA: Stanford University Press.

Crossley, M.L., 2003 (2nd edn), *Introducing Narrative Psychology: Self, Trauma and the Construction of Meaning*. Buckingham: Open University Press.

Cubitt, Geoff, 2012, 'Museums and Slavery in Britain: The Bicentenary of 1807' in Araujo, Ana Lucia (ed.), *Politics of Memory: Making Slavery Visible in the Public Space*. New York and London: Routledge.

Culture:Unlimited, 2011, 'Culture shock! Digital storytelling in the North East', evaluation report. Available at http://www.cultureshock.org.uk/tpl/uploads/Microsoft%20Word%20-%20Culture%20Shock%20Evaluation%20Report%20-%20Executive%20Summary%281%29.pdf.

Dalbello M., 2011, 'A genealogy of digital humanities' in *Journal of Documentation* 67(3): 480–506.

Davidson, B., Heald, C. and Hein, G., 1991, Increased exhibit accessibility through multisensory interaction in *Curator: The Museum Journal* 34(4): 273–90.

Debord, Guy, 1967, *Society of the Spectacle*. Available at http://www.marxists.org/reference/archive/debord/society.htm [Accessed July 2013].

Delwiche, Aaron and Jacobs Henderson, Jennifer (eds), 2013, *The Participatory Cultures Handbook*. New York and Oxford: Routledge.

Dena, Christy, 2009, *Transmedia Practice: Theorising the Practice of Expressing a Fictional World across Distinct Media and Environments*. PhD thesis, University of Sydney. Available at http://talkingobjects.files.wordpress.com/2011/08/dissertation-by-christy-dena-transmedia-practice2.pdf [Accessed June 2013].

Deterding, Sebastian, Dixon, Dan, Khaled, Rilla and Nacke, Lennart, 2011, 'From Game Design Elements to Gamefulness: Defining "Gamification"'. Presentation at MindTrek'11, Tampere, Finland. Available at http://85.214.46.140/niklas/bach/MindTrek_Gamification_PrinterReady_110806_SDE_accepted_LEN_changes_1.pdf [Accessed September 2013].

Deuze, Mark, 2006, 'Participation, remediation, bricolage: considering principal components of a digital culture' in *The Information Society* 22(2): 63–75.

Dewdney, Andrew and Ride, Peter, 2014 (2nd edn), *The Digital Media Handbook*. London and New York: Routledge.

Dewdney, Andrew, Dibosa, David and Walsh, Victoria, 2013, *Post-Critical Museology: Theory and Practice in the Art Museum*. London and New York: Routledge.

Dewey, John, 1938 (1997 edn), *Experience and Education*. New York: Touchstone.

Dicks, Bella, 2003, *Culture of Display: The Production of Contemporary Visitability*. Maidenhead: Open University Press.

Din, Herminia and Hecht, Phyllis, 2007, *The Digital Museum: A Think Guide*. Washington: American Association of Museums.

Din, Herminia Wei-Hsin, 2006, 'Play to Learn: Exploring Online Educational Games in Museums'. Presented at SIGGRAPH 2006 in Boston, Massachusetts, July 33–3 August 2006.

Dodsworth, Clark, 1999, 'The Evolution of the Tools and the Devolution of the Users' in *Informal Learning Review* 36(1). Available at www.informallearning.com/archive/1999-0506-b.htm.

Dondi, Claudio, and Moretti, Michela, 2007, 'A methodological proposal for learning games selection and quality assessment' in *British Journal of Educational Technology* 38(3): 502–12.

Downing, J.D.H., Ford, T. Villarreal, G.G. and Stein, L., 2001, *Radical Media: Rebellious Communication and Social Movements*. Thousand Oaks, CA: Sage.

Drotner, Kirsten and Schrøder, Kim Christian (eds), 2013, *Museum Communication and Social Media: The Connected Museum*. New York and London: Routledge.

Dudley, Sandra and Message, Kylie, 2013 'Editorial' in *Museum Worlds: Advances in Research* 1(1): 1–6.

Duncan, Carol and Wallach, Alan, 1980, 'The universal survey museum' in *Art History* 3(4): 448–69.

Durbin, G., 2010, 'More than the Sum of its Parts: Pulling Together User Involvement in a Museum Web Site' in Trant, J. and Bearman, D. (eds), *Museums and the Web 2010: Proceedings*. Toronto: Archives and Museum Informatics. Available at http://www.archimuse.com/mw2010/papers/durbin/durbin.html [Accessed 6 October 2013].

Eco, Umberto, 1973 (1998 edn), *Faith in Fakes: Travels in Hyperreality*. London: Vintage.

Eden, Brian, 2013, 'Museum of Flickr'. Available at http://museumofflickr.org/About?

Edson, Michael and Cherry, Rich, 2010, 'Museum Commons: Tragedy or Enlightened Self-Interest?' Presentation to Museums and the Web 2010. Available at http://www.archimuse.com/mw2010/papers/edson-cherry/edson-cherry.html [Accessed October 2013].

Egenfeldt-Nielsen, Simon, Smith, Jonas Heide and Tosca, Susana Pajares, 2013 (2nd edn), *Understanding Video Games: The Essential Introduction*. Oxford and New York: Routledge.

Erll, Astrid, 2011, *Memory in Culture*, trans. Sara B. Young. Basingstoke: Palgrave Macmillan.

Eschenfelder, Kristin R. and Caswell, Michelle, 2010. 'Digital cultural collections in the age of reuse and remixes' in *First Monday* 15(11). Available at http://firstmonday.org/ojs/index.php/fm/article/view/3060/2640 [Accessed August 2013].

Fairclough, Graham 2012. 'Foreword' in Giaccardi, Elisa (ed.), *Heritage and Social Media*. London and New York: Routledge.

Falk, John H. and Dierking, Lynn D., 2008, 'Enhancing Visitor Interaction and Learning with Mobile Technologies' in Tallon, Loïc and Walker, Kevin (eds), *Digital Technologies and the Museum Experience: Handheld Guides and Other Media*. Lanham, MD: AltaMira.

Fantoni, Silvia Filippini, Stein, Rob and Bowman, Gray, 2012, 'Exploring the Relationship between Visitor Motivation and Engagement in Online Museum Audiences'. Presentation to the Museums and the Web conference, California, April 2012. Available at http://www.museumsandtheweb.com/mw2012/papers/exploring_the_relationship_between_visitor_mot [Accessed October 2013].

Farman, Jason, 2012, *Mobile Interface Theory: Embodied Space and Locative Media*. New York and London: Routledge.

Fenton, Natalie, 2012, 'The Internet and Social Networking' in Curran, James, Fenton, Natalie and Freedman, Des, *Misunderstanding the Internet*. New York and London: Routledge.

Ferdinand, Peter (ed.), 2000, *The Internet, Democracy and Democratization*. London and New York: Routledge.

Feshbach, N.D. and Feshbach, S., 'Empathy and Education' in Decety, J. and Ickes, W. (eds), *The Social Neuroscience of Empathy*. Cambridge, MA: MIT Press.

Finnegan, R., 1997, '"Storying the Self": Personal Narratives and Identity' in McKay, Hugh (ed.), *Consumption and Everyday Life*. London: Sage.

Fisher, Matthew and Adair, Bill, 2011, 'Online Dialogue and Cultural Practice: A Conversation' in Adair, Bill, Filene, Benjamin and Koloski, Laura, *Letting Go? Sharing Historical Authority in a User-Generated World*. Philadelphia: Pew Center for Arts and Heritage.

Fisher, Matthew and Twiss-Garrity, Beth, 2007, 'Remixing Exhibits: Constructing Participatory Narratives with On-Line Tools to Augment Museum Experiences'. Presentation at Museums and the Web 2007, San Francisco. Available at http://www.museumsandtheweb.com/mw2007/papers/fisher/fisher.html [Accessed 15 July 2013].

Fiske, John, 1992. 'Audiencing: a cultural studies approach to watching television' in *Poetics* 21(4): 345–59.

Fleck, Margaret, Frid, Marcos, Kindberg, Tim, Rajani, Rakhi, O-Brien-Strain, Eamonn and Spasojevic, Mirjana, 2002, 'From Informing to Remembering: Deploying a Ubiquitous System in an Interactive Science Museum'. Available at http://www.hpl.hp.com/techreports/2002/HPL-2002-54.pdf.

Fleming, Tom, 2009, 'Embracing the Desire Lines: Opening up Cultural Infrastructure'. Available at http://www.tfconsultancy.co.uk/reports/Embracing_the_Desire_Lines.pdf.

Flowers, Alex, 2010, 'Integrating QR Codes into Galleries'. Available at http://alexflowers.co.uk/2010/10/28/integrating-qr-codes-into-galleries/.

Fortugno, Nick and Zimmerman, Eric, 2010 'Learning to Play to Learn: Lessons in Educational Game Design'. Available at http://www.ericzimmerman.com/texts/learningtoplay.html [Accessed April 2012].

Foucault, Michel, 1969 (2002 edn), *The Archaeology of Knowledge*. London: Routledge.

Freedman, Des, 2012, 'Web 2.0 and the Death of the Blockbuster Economy' in Curran, James, Fenton, Natalie and Freedman, Des (eds), *Misunderstanding the Internet*. New York and London: Routledge.

Frykman, Sue Glover, 2009, 'Stories to tell? Narrative tools in museum education texts' in *Educational Research* 51(3): 299-319.

Fuchs, Christian, 2014, *Social Media: A Critical Introduction*. Los Angeles and London: SAGE.

Fulford, R., 1999, *The Triumph of Narrative: Storytelling in the Age of Mass Culture*. New York: Broadway.

Fusion Research and Analytics, 2012, 'Understanding the Mobile V&A Visitor: Autumn 2012'. Available at http://www.vam.ac.uk/__data/assets/pdf_file/0009/231975/V-and-A-Mobile-Visitor-Survey-Report-FINAL-16-Jan-.pdf [Accessed July 2013].

Gammon, Ben, 2008, 'Everything we currently know about making visitor-friendly mechanical exhibits' in *Informal Learning Review*. Available at http://www.informallearning.com/archive/1999-1112-a.htm.

Gammon, Ben, 1999, 'Visitors' use of computer exhibits: findings from 5 gruelling years of watching visitors getting it wrong' in *Informal Learning Review*. Available at http://www.informallearning.com/archive/1999-0910-a.htm.

Gammon, Ben and Burch, Alexandra, 2008, 'Designing Mobile Digital Experiences' in Tallon, Loïc and Walker, Kevin (eds), *Digital Technologies and the Museum Experience: Handheld Guides and Other Media*. Lanham, MD: AltaMira.

Garde-Hansen, J., 2011, *Media and Memory*. Edinburgh: Edinburgh University Press.

Garde-Hansen, J., Hoskins, A. and Reading, A. (eds), 2009, *Save As ... Digital Memories*. Basingstoke: Palgrave Macmillan.

Gee, James Paul, 2007, *What Video Games Have to Teach Us about Learning and Literacy*. New York: Palgrave Macmillan.

Gere, Charlie. 2002. *Digital Culture*. London: Reaktion.

Gere, Charlie, 1997, 'Museums, Contact Zones and the Internet'. Archives and Museum Informatics paper. Available at http://www.museumsandtheweb.com/biblio/museums_contact_zones_and_the_internet_0 [Accessed 11 June 2013].

Gerhards, Jürgen and Schäfer, Mike S. 2010. 'Is the internet a better public sphere? Comparing old and new media in the USA and Germany' in *New Media and Society* 12(1): 143–60.

Giaccardi, Elisa (ed.), 2012, *Heritage and Social Media: Understanding Heritage in a Participatory Culture*. London and New York: Routledge.

Gillmor, Dan, 2006, *We the Media: Grassroots Journalism by the People, for the People*. Sebastopol, CA: O'Reilly Media.

Goffman, E., 1974, *Frame Analysis: An Essay on the Organisation of Experience*. London: Penguin.

Goggin, Gerard, 2012, *New Technologies and the Media*. Basingstoke: Palgrave Macmillan.

Giovagnoli, Max, 2011, *Transmedia Storytelling: Imagery, Shapes and Techniques*. Max Giovagnoli and ETC Press.

Grewcock, Duncan, 2014, *Doing Museology Differently*. London and New York: Routledge.

Griffiths, Alison, 2008, *Shivers Down Your Spine: Cinema, Museums, and the Immersive View*. New York: Columbia University Press.

Griffiths, Alison, 2002, *Wondrous Difference: Cinema, Anthropology and the Turn of the Century Visual Culture*. New York: Columbia University Press.

Gripsrud, Jostein, 2006, 'Semiotics: Signs, Codes and Cultures' in Gillespie, Marie and Toynbee, Jason (eds), *Analysing Media Texts* (vol. 4). Maidenhead: Open University Press.

Gurian, Elaine Heumann, 2010, 'Foreword' in Cameron, Fiona and Kelly, Lynda (eds), *Hot Topics, Public Culture, Museums*. Newcastle upon Tyne: Cambridge Scholars.

Gurian, Elaine Heumann, 2006, *Civilizing the Museum: The Collected Writings of Elaine Heumann Gurian*. Abingdon: Routledge.

Hall, Sebastian, 2013, 'Creating Strong Cross Media Concepts for Museum Exhibitions' Unpublished MA thesis. Available at http://www.diva-portal.org/smash/get/diva2:630513/FULLTEXT01.pdf [Accessed 16 September 2013].

Hall, Stuart, 1980, 'Encoding/Decoding' in Hall, Stuart, Hobson, Dorothy, Lowe, Andre and Willis, Paul (eds), *Culture, Media Language*. London: Hutchinson.

Hall, Stuart (ed.), 1997, *Representation: Cultural Representations and Signifying Practices*. Milton Keynes: Open University Press.

Hall, Stuart and du Gay, Paul (eds), 1996 (2002 edn), *Questions of Cultural Identity*. London and Thousand Oaks, CA: Sage.

Halligan, Brian and Shah, Dharmesh, 2009, *Inbound Marketing: Get Found Using Google, Social Media and Blogs*. Hoboken, NJ: Wiley.

Hamma, K., 2005, 'Public domain art in an age of easier mechanical reproducibility' in *D-Lib Magazine*. Available at http://www.dlib.org/dlib/november05/hamma/11hamma.html.

Hänska-Ahy, Maximillian T. and Shapour, Roxanna, 2013, 'Who's reporting the protests? Converging practices of citizen journalists and two BBC World Service newsrooms, from Iran's election protests to the Arab uprisings' in *Journalism Studies* 14(1): 29–45.

Hargreaves, Ian, 2011. *Digital Opportunity: A Review of Intellectual Property and Growth*. Available at http://www.ipo.gov.uk/ipreview-finalreport.pdf [Accessed September 2012].

Harrison, Nate, 2013, 'Appropriation Art, Subjectivism, Crisis: The Battle for Fair Uses' in Chris, Cynthia and Gerstner, David A. (eds), *Media Authorship*. New York and London: Routledge.

Hartley, J., 2002 (3rd edn), *Communication, Cultural and Media Studies: The Key Concepts*. London: Routledge.

Hartley, John, 2012. *Digital Futures for Cultural and Media Studies*. Chichester: Wiley-Blackwell.

Hartley, John, Potts, Jason, Cunningham, Stuart, Flew, Terry, Keane, Michael and Banks, John, 2012, *Key Concepts in Creative Industries*. Washington DC: Sage.

Hatala, M. and Wakkary, R. 2005, 'Ontology-based user modeling in an augmented reality system for museums' in *User Modeling and User-Adapted Interaction* 15(3–4): 339–80.

Hecht, Gabrielle and Thad Allen, Michael, 2001, 'Authority, Political Machines and Technology's History' in Thad Allen, Michael and Hecht, Gabrielle (eds), *Technologies of Power: Essays in Honor of Thomas Parke Hughes and Agatha Chipley Hughes*. Cambridge, MA: MIT Press.

Hein, George, 1998, *Learning in the Museum*. New York and London: Routledge.

Hein, Hilda, 2006, *Public Art: Thinking Museums Differently*. Lanham, MD: AltaMira.

Hein, Hilda, 2000, *The Museum in Transition: A Philosophical Perspective*. Washington DC: Smithsonian Institution Press.

Henning, Michelle, 2006, *Museums, Media and Cultural Theory*. Maidenhead: Open University Press.

Henson, Martha and Birchall, Danny, 2011, 'Gaming the Museum'. Paper to the Museums and the Web conference 2011. Available at http://www. museumsandtheweb.com/mw2011/papers/gaming_the_museum.html [Accessed 18 December 2012].

Hermida, Alfred and Thurman, Neil, 2008, 'A clash of cultures' in *Journalism Practice* 2(3): 343–56.

Hermida, Alfred and Thurman, Neil, 2007, 'Comments Please: how the British news media are struggling with user-generated content'. Available at https:// online.journalism.utexas.edu/2007/papers/Hermida.pdf [Accessed January 2012].

Hewison, Robert, 1987, *The Heritage Industry: Britain in a Climate of Decline*. London: Methuen.

Hickey, Samuel and Mohan, Giles (eds), 2004, *Participation: From Tyranny to Transformation? Exploring New Approaches to Participation in Development*. New York: Zed Books.

Hindman, Matthew, 2009, *The Myth of Digital Democracy*. Princeton: Princeton University Press.

Hirsch, M., 1997, *Family Frames: Photography, Narrative, and Postmemory*. Cambridge, MA: Harvard University Press.

HM Government, 2011, 'The Government Response to the Hargreaves Review of Intellectual Property and Growth'. Available at http://www.ipo.gov.uk/ ipresponse-full.pdf [Accessed October 2013].

Hoggart, Richard, 1957, *The Uses of Literacy*. London: Penguin.

Hooper-Greenhill, Eilean, 2000, 'Changing values in the art museum: rethinking communication and learning' in *International Journal of Heritage Studies* 6(1): 9–31.

Hooper-Greenhill, Eilean, 1994, *Museums and Their Visitors*. London and New York: Routledge.

Hooper-Greenhill, Eilean, 1992. *Museums and the Shaping of Knowledge*. London: Routledge.

Hooper-Greenhill, Eilean (ed.), 1995, *Museum, Media, Message*. New York and London: Routledge.

Hornecker, E., 2008a, 'Tangible interaction: an inclusive perspective'. *Form und Zweck* 22(40): English pages 78–85. Available at http://www.formundzweck. de.

Hornecker, E., 2008b, '"I Don't Understand it Either, But it is Cool": Visitor Interactions with a Multi-Touch Table in a Museum'. Proceedings of IEEE Tabletop (October): 121–8.

Hornecker, Eva and Nicol, Emma, 2011, *Towards the Wild: Evaluating Museum Installations in Semi-Realistic Situations*. Proceedings of Re-thinking Technology in Museums 2011 conference. University of Limerick, Ireland.

Hoskins, Andrew, 2009, 'Flashbulb memories, psychology and media studies: fertile ground for interdisciplinarity?' in *Memory Studies* 2(2): 147–50.

Hourston Hanks, Laura, Hale, Jonathan and MacLeod, Suzanne, 2012, 'Introduction: Museum Making: The Place of Narrative' in MacLeod, Suzanne, Hourston Hanks, Laura and Hale, Jonathan (eds), *Museum Making: Narrative, Architectures, Exhibitions*. London and New York: Routledge.

Howe, Jeff, 2009, *Crowdsourcing: How the Power of the Cloud is Driving the Future of Business*. London and New York: Random House.

Hsi, S., 2003, 'A study of user experiences mediated by nomadic web content in a museum' in *Journal of Computer Assisted Learning* 19(3): 308–19.

Hull, Glynda and Scott, John, 2013, 'Curating and Creating Online: Identity, Authorship, and Viewing in a Digital Age' in Drotner, Kirsten and Schrøder, Kim Christian (eds), *Museum Communication and Social Media: The Connected Museum*. New York and London: Routledge.

Hunter, Dan, Lobato, Ramon, Richardson, Megan and Thomas, Julian (eds), 2014, *Amateur Media: Social, Cultural and Legal Perspectives*. London and New York: Routledge.

Huyssen, A., 2003a, *Present Pasts: Urban Palimpsests and the Politics of Memory*. Stanford, CA: Stanford University Press.

Huyssen, A., 2003b, 'Trauma and Memory: A New Imaginary of Temporality' in Bennett, J. and Kennedy, R. (eds), *World Memory: Personal Trajectories in Global Time*. (Basingstoke: Palgrave Macmillan.

ICOM [International Council of Museums], 2007, Museum Definition'. Available at http://icom.museum/the-vision/museum-definition/ [Accessed August 2013].

Iversen, Ole Sejer and Smith, Rachel Charlotte, 2012, 'Connecting to Everyday Practices' in Giaccardi, Elisa (ed.), *Heritage and Social Media: Understanding Heritage in a Participatory Culture*. London and New York: Routledge.

Jackson, A. and Kidd, J., 2008, 'Performance, Learning and Heritage' final report. Available at http://www.plh.manchester.ac.uk.

Jackson, A. and Kidd, J. (eds), 2011, *Performing Heritage: Research, Practice and Innovation in Museum Theatre and Live Interpretation*. Manchester: Manchester University Press.

Jagoda, Patrick, 2013, 'Gamification and other forms of play' in *Boundary 2* 40(2): 113–44.

Janes, Robert R., 2009. *Museums in a Troubled World: Renewal, Irrelevance or Collapse?* London and New York: Routledge.

Jansen, Bernard J., Zhang, Mimi, Sobel, Kate and Chowdury, Abdur, 2009, 'Twitter power: tweets as electronic word of mouth' in *Journal of the American Society for Information Science and Technology* 60(11): 2169–88.

Java, Akshay, Finin, Tim, Song, Xiaodan and Tseng, Belle, 2007, 'Why we Twitter: Understanding Microblogging Usage and Communities'. Available at http://ebiquity.umbc.edu/paper/html/id/367/.

Jenkins, H., Purushotma, R., Weigel, M., Clinton, K. and Robison, A.J., 2009, *Confronting The Challenges of Participatory Culture: Media Education for the 21st Century*. Cambridge, MA: MIT Press.

Jenkins, Henry, 2013, 'The Guiding Spirit and the Powers That Be' in Delwiche, Aaron and Jacobs Henderson, Jennifer (eds), *The Participatory Cultures Handbook*. New York and Oxford: Routledge.

Jenkins, Henry, 2011, 'Transmedia 202: Further Reflections'. Available at http://henryjenkins.org/2011/08/defining_transmedia_further_re.html [Accessed 13 July 2013].

Jenkins, Henry, 2010, 'Transmedia Education: The 7 Principles Revisited'. Available at http://henryjenkins.org/2010/06/transmedia_education_the_7_pri.html [Accessed 26 July 2013].

Jenkins, Henry, 2009, 'Transmedia missionaris [sic]: Henry Jenkins' video. Available at http://www.youtube.com/watch?v=bhGBfuyN5gg [Accessed November 2013].

Jenkins, Henry, 2007, 'Transmedia Storytelling 101'. Available at http://henryjenkins.org/2007/03/transmedia_storytelling_101.html [Accessed 24 August 2013].

Jenkins, Henry, 2006, *Convergence Culture: Where Old and New Media Collide*. New York: New York University Press.

Jenkins, Henry, 1992, *Textual Poachers: Television Fans and Participatory Culture*. New York: Routledge.

Jenkins, Henry, Ford, Sam and Green, Joshua, 2013, *Spreadable Media: Creating Value and Meaning in a Networked Culture*. New York: New York University Press.

Johnson, Steven, 1997, *Interface Culture: How New Technology Transforms the Way We Create and Communicate*. New York: Basic Books.

Johnston, H., 1995, *Social Movements and Culture*, Minneapolis: Minnesota University Press.

Jones, Mike, 2012, 'On Storyworlds, Immersive media, narrative and museums: an interview with Mike Jones'. Available at http://www.freshandnew.org/2012/10/storyworlds-immersive-media-narrative-interview-mike-jones/ [Accessed 19 September 2013].

Jones-Garmil, Katherine, 1997, *The Wired Museum: Emerging Technology and Changing Paradigms*. Washington DC: American Association of Museums.

Jönsson, Anna Maria and Örnebring, Henrik, 2011, 'User generated content and the news: empowerment of citizens or interactive illusion?' in *Journalism Practice* 5(2): 127–44.

Kacandes, I., 1999, 'Narrative Witnessing as Memory Work: Reading Gertrud Kolmar's *A Jewish Mother*' in Bal, M., Crewe, J. and Spitzer, L. (eds), *Acts of*

Memory: Cultural Recall in the Present. Hanover, NH and London: University Press of New England.

Kalay, Yehuda E., Kvan, Thomas and Affleck, Janice, 2008, *New Heritage: New Media and Cultural Heritage*. London: Routledge.

Kaplan, E. Ann, 2011, 'Empathy and Trauma Culture: Imaging Catastrophe' in Coplan, A. and Goldie, P. (eds), *Empathy: Philosophical and Psychological Perspectives*. Oxford: Oxford University Press.

Karaganis, Joe, 2007, *Structures of Participation in Digital Culture*. New York: Social Science Research Council.

Kavanagh, Gaynor, 2000, *Dream Spaces: Memory and the Museum*. London and New York: Continuum.

Kawashima, Nobuko, 2010, 'The rise of "user-creativity": Web 2.0 and a new challenge for copyright law and cultural policy' in *International Journal of Cultural Policy* 16(3): 337–53.

Kelly, Kristin, 2013, *Images of Works of Art in Museum Collections: The Experience of Open Access. A Study of 11 Museums*. Washington: Council on Library and Information Resources.

Kelly, Lynda, 2013, 'The Connected Museum in the World of Social Media' in Drotner, Kirsten and Schrøder, Kim Christian (eds), *Museum Communication and Social Media: The Connected Museum*. New York and London: Routledge.

Kelly, Lynda, 2010a, 'How Web 2.0 is changing the nature of museum work' in *Curator: The Museum Journal* 53(4): 405–10.

Kelly, Lynda, 2010b, 'The Role of Narrative in Museum Exhibitions'. Available at http://australianmuseum.net.au/BlogPost/Museullaneous/The-role-of-narrative-in-museum-exhibitions [Accessed 23 September 2013].

Kelty, Christopher M., 2013, 'From Participation to Power' in Delwiche, Aaron and Jacobs Henderson, Jennifer (eds), *The Participatory Cultures Handbook*. New York and Oxford: Routledge.

Kember, Sarah and Zylinska, Joanna, 2012, *Life After New Media: Mediation as a Vital Process*. Cambridge, MA: MIT Press.

Kidd, Jenny, 2014, 'Review of Life Online Galleries, National Media Museum, UK' in *The Senses and Society* 9(1): 118–23.

Kidd, Jenny, 2013, 'Hot Topics, Public Culture, Museums Fiona Cameron and Lynda Kelly (eds). Newcastle upon Tyne: Cambridge Scholars, 2010. 323 pages. Hardcover: $67.99' in *The Curator: The Museum Journal* 56(2): 289–93.

Kidd, Jenny, 2012, 'The museum as narrative witness: heritage performance and the production of narrative space' in McLeod, Suzanne, Hourston Hanks, Laura and Hale, Jonathan (eds), *Museum Making: Narratives, Architectures, Exhibitions*. London and New York: Routledge.

Kidd, Jenny, 2011a, 'Enacting engagement online: framing social media use for the museum' in *Information, Technology and People* 24(1): 64–77.

Kidd, Jenny, 2011b, 'Challenging history: reviewing debate within the heritage sector on the "challenge" of history in *Museum and Society* 9(3):

244–8. Available at http://www2.le.ac.uk/departments/museumstudies/ museumsociety/volumes/volume-9-2011.

Kidd, Jenny, 2011c, 'Performing the knowing archive: heritage performance and authenticity' in *The International Journal of Heritage Studies* 17(1): 22–35.

Kidd, Jenny, 2009a, 'Capture Wales Digital Storytelling: Community Media Meets the BBC' in Rodriguez, C., Kidd, D. and Stein, L. (eds), *Making Our Media.* Cresskill, NJ: Hampton.

Kidd, Jenny, 2009b, 'Digital Storytelling and the Performance of Memory' in Garde-Hansen, J., Hoskins, A. and Reading, A. (eds), *Save As ... Digital Memories.* Basingstoke: Palgrave Macmillan.

Kidd, Jenny, Cairns, Sam, Drago, Alex, Ryall, Amy and Stearn, Miranda (eds), 2014, *Challenging History in the Museum.* Farnham: Ashgate.

Kirschenblatt-Gimblett, Barbara, 2003, 'Kodak moments, flashbulb memories: reflections on 9/11' in *Drama Review* 47(1): 11–48.

Knell, Simon J. (ed.), 2004, *Museums and the Future of Collecting.* Aldershot: Ashgate.

Korn Naomi, 2013a, 'Who Owns What, Why and for How Long? Copyright and UGC'. Presentation at iSay conference, November 2013, University of Leicester.

Korn, Naomi, 2013b, 'Why LACA supports the proposed new copyright exceptions'. Available at http://www.cilip.org.uk/cilip/news/why-laca-supports-proposed-new-copyright-exceptions#sthash.8EadtVMa.K1ttpPn6.dpuf [Accessed October 2013].

Kovach, Bill and Rosenstiel, Tom, 2001, *The Elements of Journalism: What Newspeople Should Know and the Public Should Expect.* New York: Crown.

LaCapra, D., 2001, *Writing History, Writing Trauma.* Baltimore, MD: Johns Hopkins University Press.

Lang, Caroline, Reeve, John and Woollard, Vicky (eds), 2006, *The Responsive Museum: Working with Audiences in the Twenty-First Century.* Aldershot: Ashgate.

Langois, Ganaele, 2011, 'Meaning, semiotechnologies and participatory media' in *Culture Machine* 12. Available from http://www.culturemachine.net/index. php/cm/article/view/437/467.

Lankshear, Colin and Knobel, Michele, 2007, 'Digital Remix: The Art and Craft of Endless Hybridization'. Keynote presented to the International Reading Association Pre-Conference Institute 'Using Technology to Develop and Extend the Boundaries of Literacy', Toronto, 13 May 2007. Available at http://extendboundariesofliteracy.pbworks.com/f/remix.pdf [Accessed 13 October 2013].

Lapenta, Francesco, 2011, 'Locative media and the digital visualisation of space, place and information' in *Visual Studies* 26(1): 1–3.

Lasn, Kalle, 2000, *Culture Jam: How to Reverse America's Suicidal Consumer Binge – and Why We Must.* New York: First Quill.

Leadbeater, Charles 2009, 'The art of with'. Available at http://www. charlesleadbeater.net/cms/xstandard/The%20Art%20of%20With%20PDF.pdf [Accessed July 2010].

Leadbeater, Charles and Miller, Paul, 2004, *The Pro-Am Revolution: How Enthusiasts are Changing our Economy and Society*. London: Demos. Available at http://www.demos.co.uk/files/proamrevolutionfinal.pdf [Accessed October 2013].

Lessig, Lawrence, 2008, *Remix: Making Art and Commerce Thrive in the Hybrid Economy*. New York: Penguin.

Lessig, Lawrence, 2004, *Free Culture: How Big Media Uses Technology and the Law to Lock Down Culture and Control Creativity*. New York: Penguin.

Leung, Louis, 2009, 'User-generated content on the internet: an examination of gratifications, civic engagement and psychological empowerment' in *New Media and Society* 11(8): 1327–47.

Lévi-Strauss, Claude, 1962 (1966 trans.), *The Savage Mind*. Chicago: University of Chicago Press.

Lin, Aleck C.H. and Gregor, Shirley, 2006, *Designing Websites for Learning and Enjoyment: A Study of Museum Experiences. Available at* http://www.irrodl. org/index.php/irrodl/article/view/364/735 [Accessed May 2012].

Lindsey, Bruce, 2003, 'Topographic Memory' in Spellman, Catherine (ed.), *Re-Envisioning Landscape/Architecture*. Barcelona: Actar.

Livingstone, Sonia, 2013, 'The participation paradigm in audience research' in *The Communication Review* 16(1–2): 21–30.

Livingstone, Sonia, 2005, 'Media Audiences, Interpreters and Users' in Gillespie, Marie (ed.), *Media Audiences*, vol. 2. Maidenhead: Open University Press.

Lobato, Ramon, Thomas, Julian and Hunter, Dave, 2014 (2nd edn), 'Histories of User-Generated Content: Between Formal and Informal Media Economies' in Hunter, Dan, Lobato, Ramon, Richardson, Megan and Thomas, Julian (eds), *Amateur Media: Social, Cultural and Legal Perspectives*. London and New York: Routledge.

Løvlie, Anders Sundnes, 2011, 'Annotative locative media and G-P-S: granularity, participation, and serendipity' in *Computers and Composition* 28(3): 246–54.

Lwin, Soe Marlar, 2012, 'Whose stuff is it? A museum storyteller's strategies to engage her audience' in *Narrative Inquiry* 22(2): 226–46.

Lynch, Bernadette, 2014, 'Challenging Ourselves: Uncomfortable Histories and Current Museum Practices' in Kidd, Jenny, Cairns, Sam, Drago, Alex, Ryall, Amy and Stearn, Miranda (eds), *Challenging History in the Museum*. Farnham: Ashgate.

Lynch, Bernadette, 2011, 'Whose Cake is it Anyway?' Report for the Paul Hamlyn Foundation. Available at http://eff.org.uk/wp-content/uploads/2013/05/ Whose-cake-is-it-anyway.pdf [Accessed Janurary 2011].

McDaniel, Rudy and Vick, Erik Henry, 2010, 'Games for good: why they matter, what we know, and where we go from here' in *International Journal of Cognitive Technology* 14(2) and 15(1): 66–73.

MacDonald, Sharon (ed.), 1998, *The Politics of Display: Museums, Science, Culture*. New York: Routledge.

MacDonald, Sharon and Fyfe, Gordon (eds), 1996, *Theorizing Museums*. Oxford: Blackwell.

MacLeod, Suzanne, Hourston Hanks, Laura and Hale, Jonathan (eds), 2012, *Museum Making: Narrative, Architectures, Exhibitions*. London and New York: Routledge.

Mandiberg, Michael (ed.), 2012, *The Social Media Reader*. New York and London: New York University Press.

Manovich, Lev, 2009, 'The practice of everyday (media) life: from mass consumption to mass cultural production?' in *Critical Inquiry* 35(2): 319–31. Available at http://www.jstor.org/stable/10.1086/596645 [Accessed 11 October 2013].

Manovich, Lev, 2007, 'What Comes After Remix?' Available at http://remixtheory. net/?p=169 [Accessed 13 October 2013].

Manovich, Lev, 2001, *The Language of New Media*. Cambridge. MA: MIT Press.

Marstine, Janet (ed.), 2011, *Routledge Companion to Museum Ethics: Redefining Ethics for the Twenty-First Century Museum*. London and New York: Routledge.

Marstine, Janet (ed.), 2006, *New Museum Theory and Practice: An Introduction*. Malden, MA and Oxford: Blackwell.

Mastai, J. 2007. 'There is No Such Thing as a Visitor' in Pollock, G. and Zemans, J. (eds), *Museums after Modernisation: Strategies of Engagement*. Malden, MA: Blackwell.

McAdams, Dan, 1993, *The Stories We Live By: Personal Myths and the Making of the Self*. New York: Guilford Press.

McGonigal, Jane, 2011, *Reality is Broken: Why Games Make us Better and How They Can Change the World*. London: Jonathan Cape.

McGuigan, Jim, 2011, 'The Cultural Public Sphere' at http://openinstitutions. net/2011/03/the-cultural-public-sphare/ [Accessed August 12 2013].

McGuigan, Jim 2005, 'The cultural public sphere' in *European Journal of Cultural Studies* 8(4): 427–43.

McGuigan, Jim, 1996, *Culture and the Public Sphere*. New York and London: Routledge.

McIntyre H.M, 2003. 'Engaging or Distracting? Visitor Responses to Interactives in the V&A British Galleries', V&A British Galleries Summative Evaluation, London.

McLean, K., 1993, *Planning for People in Museum Exhibitions*. Washington DC: Association of Science-Technology Centers.

McLeod, J., 1997, *Narrative and Psychotherapy*. London: Sage.

McLuhan, Marshall, 1964 (2005 edn), *Understanding Media*. London: Routledge.

McTavish, Lianne, 2006, 'The Virtual Museum: Art and Experience Online' in Marstine, Janet (ed.), *New Museum Theory and Practice: An Introduction*. Malden, MA and Oxford: Blackwell.

Meadows, Daniel, 2003, 'Digital storytelling: research-based practice in new media' in *Visual Communication* 2(2): 189–93.

Message, Kylie, 2006, *New Museums and the Making of Culture*. Oxford: Berg.

Miller, V., 2008, 'New media, networking, and phatic culture' in *Convergence* 14(4): 387–400.

Miranda, Carolina A., 2013, 'Why can't we take pictures in art museums?', 13 May. Available at http://www.artnews.com/2013/05/13/photography-in-art-museums/ [Accessed 11 November 2013].

Morris-Suzuki, Tessa, 2005, *The Past Within Us: Media, Memory, History*. London and New York: Verso.

Mosse, David, 2001, '"People's Knowledge", Participation and Patronage: Operations and Representations in Rural Development' in Cooke, Bill and Kothari, Uma (eds), *Participation: The New Tyranny?* London and New York: Zed Books.

Munslow, Alun, 2007, *Narrative and History*. Basingstoke: Palgrave Macmillan.

Murray, J., 1999 (2nd edn), *Hamlet on the Holodeck: The Future of Narrative in Cyberspace*. Cambridge, MA: MIT Press.

National Endowment for the Arts, 2013, 'How a Nation Engages with Art: Highlights from the 2012 Survey of Public Participation in the Arts'. Available at http://arts.gov/publications/highlights-from-2012-sppa#sthash.6zs7sRmA. dpuf [Accessed October 2013].

Naumann, B.A., Schleicher, R. and Wechsung, I., 2008, *Views on Usability and User Experience: from Theory and Practice*. Deutsche Telekom Laboratories, TU Berlin. Available at http://www.cs.uta.fi/~ux-emotion/submissions/ Wechsung-etal.pdf.

National Gallery, 2013, *Michael Landy: Saints Alive* (exhibition catalogue). London: National Gallery.

Navas, Eduardo, 2012, *Remix Theory: The Aesthetics of Sampling*. Vienna and New York: Springer.

Neiger, Motti, Meyers, Oren and Zandberg, Eyal, 2011, *On Media Memory: Collective Memory in a New Media Age*. Basingstoke and New York: Palgrave Macmillan.

Nesta, 2013, *Digital Culture: How Arts and Cultural Organisations in England Use Technology*. Available at http://native.artsdigitalrnd.org.uk/wp-content/ uploads/2013/11/DigitalCulture_FullReport.pdf [Accessed 24 April 2014]. Nesta Digital R&D Fund for the Arts.

O'Flynn, Siobhan, 2012 'Documentary's metamorphic form: Webdoc, interactive, transmedia, participatory and beyond' in *Studies in Documentary Film* 6(2): 141–57.

Olick, Jeffrey K., Vinitzky-Seroussi, Vered and Levy, Daniel, 2011, *The Collective Memory Reader*. Oxford and New York: Oxford University Press.

Olson, Kathleen K., 2013, 'Intellectual Property' in Stewart, Daxton R. (ed.), *Social Media and the Law: A Guidebook for Communication Students and Professionals*. New York and London: Routledge.

Olsson, Tobias and Viscovi, Dino, 2013, 'Impediments to Participation: UGC and Professional Culture' in Tomanić Trivundža, Ilija et al. (eds), *Past, Future and Change: Contemporary Analysis of Evolving Media Scapes*. Ljubljana: University of Ljubljana Press.

Papacharissi, Zizi, 2009, 'The Virtual Sphere 2.0: The Internet, the Public Sphere, and Beyond' in Chadwick, Andrew and Howard, Philip N. (eds), *Routledge Handbook of Internet Politics*. London and New York: Routledge.

Papacharissi, Zizi, 2002, 'The virtual sphere: the internet as a public sphere' in *New Media and Society* 4(9): 9–27.

Parry, Ross, 2013a, 'The Trusted Artifice' in Drotner, Kirsten and Schrøder, Kim Christian (eds), *Museum Communication and Social Media: The Connected Museum*. New York and London: Routledge.

Parry, Ross, 2013b, 'The end of the beginning: normativity in the postdigital museum' in *Museum Worlds* 1(1): 24–39.

Parry, Ross, 2011, 'Transfer Protocols: Museum Codes and Ethics in the New Digital Environment', in Janet Marstine (ed.), *Routledge Companion to Museum Ethics: Redefining Ethics for the Twenty-First Century Museum*. London and New York: Routledge.

Parry, Ross, 2007, *Recoding the Museum: Digital Heritage and the Technologies of Change*. London and New York: Routledge.

Paul, Christiane, 2006, 'The Myth of Immateriality: Presenting and Preserving New Media' in Grau, Oliver (ed.), *MediaArtHistories*. Cambridge, MA: MIT Press.

Paulussen, Steve and D'heer, Evelien, 2013, 'Using citizens for community journalism' in *Journalism Practice* 7(5): 588–603.

Perryman, Neil, 2008, 'Doctor Who and the convergence of media: a case study in "transmedia storytelling"' in *Convergence: The International Journal of Research into New Media Technologies* 14(1): 21–39.

Petersen, Søren Mørk, 2008, 'Loser generated content: from participation to exploitation' in *First Monday* 13(3). Available at http://firstmonday.org/article/view/2141/1948 [Accessed June 2011].

Phillips, Ruth, 2005, 'Re-placing objects: historical practices for the second museum age' in *Canadian Historical Review* 86(1): 83–110.

Pierroux, Palmyre and Ludvigsen, Sten, 2013, 'Communication Interrupted: Textual Practices and Digital Interactives in Art Museums' in Drotner, Kirsten and Schrøder, Kim Christian (eds), *Museum Communication and Social Media: The Connected Museum*. New York and London: Routledge.

Pine, B.J. and Gilmore, J.H., 1999, *The Experience Economy: Work is Theatre and Every Business a Stage*. Boston, MA: Harvard Business School Press.

Poster, Mark, 2001, 'Postmodern Virtualities' in Durham, Meenakhi Gigi and Kellner, Douglas M. (eds), 2001, *Media and Cultural Studies Keyworks*. Oxford: Blackwell.

Postman, Neil, 1985, *Amusing Ourselves to Death: Public Discourse in the Age of Show Business*. New York: Penguin.

Pratten, Robert, 2011, *Getting Started in Transmedia Storytelling*. [s.l.]: Robert Pratten/Create Space.

Proctor, Nancy, 2013 'Crowdsourcing: an introduction: from public goods to public good' in *Curator: The Museum Journal* 56(1): 105–6.

Proctor, Nancy, 2010, 'Digital: museum as platform, curator as champion, in the age of social media' in *Curator: The Museum Journal* 53(1): 35–43.

Pruulmann-Vengerfeldt, Pille and Runnel, Pille, 2011, 'When the museum becomes the message for participating audiences' in *CM: Communication Management Quarterly*/Časopis za upravljanje komuniciranjem 6(21): 159–80.

Rabinovitz, L. and Geil, A. (eds), 2004, *Memory Bytes: History, Technology, and Digital Culture*. Durham, NC: Duke University Press.

Ramsay, Grahame, 1998, 'Investigating "Interactives" at the Powerhouse Museum: Personal, Social AND Physical Context'. Available at http://www.ascilite.org.au/aset-archives/confs/edtech98/pubs/articles/ramsay.html.

Rancière, Jacques, 2009, *The Emancipated Spectator* London and New York: Verso.

Rayner, Rick, 2011, 'Gamification: using game mechanics to enhance elearning' in *eLearning Magazine*. Available at http://elearnmag.acm.org/featured.cfm?aid=2031772 [Accessed October 2013].

Rees Leahy, Helen, 2012, *Museum Bodies: The Politics and Practices of Visiting and Viewing*. Farnham: Ashgate.

Reuters 2013a, '"To Kill a Mockingbird" author in dispute with U.S. museum over book's title'. Available at http://www.reuters.com/article/2013/09/20/usa-alabama-harperlee-idUSL2N0HG27Q20130920 [Accessed 23 October 2013].

Reuters 2013b, 'RPT: Alabama town of Harper Lee's "To Kill a Mockingbird" stung by her lawsuit', Available at http://www.reuters.com/article/2013/11/04/usa-alabama-harperlee-idUSL2N0IP0LP20131104 [Accessed 11 November 2013].

Rheingold, Howard, 2013, 'Participative Pedagogy for a Literacy of Literacies' in Delwiche, Aaron and Jacobs Henderson, Jennifer (eds), *The Participatory Cultures Handbook*. New York and Oxford: Routledge.

Rheingold, Howard, 2002, *Smart Mobs: The Next Social Revolution*. Cambridge, MA: Basic Books.

Richardson, Jim, 2009a, 'Five ways in which museums are using flickr'. Available at http://www.museumnext.org/2010/blog/five-ways-in-which-museums-are-using-flickr [Accessed September 2013].

Richardson, Jim, 2009b, 'Creating a social media plan for a museum'. Available at http://www.museummarketing.co.uk/2009/06/26/creating-a-social-media-plan-for-a-museum/ [Accessed February 2010].

Ricoeur, P., 1984, *Time and Narrative*, vol. 1, trans. Kathleen McLaughlin and David Pellauer. Chicago: University of Chicago Press.

Ridge, Mia, 2012, 'Mia Ridge talking about using games within the context of museums'. Available at http://www.museumnext.org/conference/films_mia_ridge.html [Accessed 20 December 2012].

Ridge, Mia, 2007, Sharing authorship and authority: user generated content and the cultural heritage sector'. Available at http://www.miaridge.com/projects/usergeneratedcontentinculturalheritagesector.html [Accessed December 2012].

Rizzo F. and Garzotto F., 2007, *'The Fire and the Mountain': Tangible and Social Interaction in a Museum Exhibition for Children*, Department of Electronics and Information, Politecnico of Milano. Presented in IDC 2007 Proceedings: Tangible Interaction, Aalborg, Denmark.

Roddick, Andy, 2001, *Understanding Audiences: Theory and Method*. London: Sage.

Rodriguez, Clemencia, Kidd, Dorothy and Stein Laura (eds), 2009, *Making Our Media: Global Initiatives Toward a Democratic Public Sphere*. Creskill, NJ: Hampton Press.

Rodriguez, Clemencia, 2001, *Fissures in the Mediascape: An International Study of Citizen's Media*. Creskill, NJ: Hampton Press.

Rose, Frank, 2011, *The Art of Immersion: How the Digital Generation is Remaking Hollywood, Madison Avenue, and the Way We Tell Stories*. New York and London: Norton.

Rosen, Jay, 2006, 'The people formerly known as the audience' in *Huff Post Media*, 30 June. Available at http://www.huffingtonpost.com/jay-rosen/the-people-formerly-known_1_b_24113.html [Accessed November 2010].

Rosenbloom, P.S., 2010, 'Towards a conceptual framework for the digital humanities'. Available at http://pollux.usc.edu/~rosenblo/Pubs/TCFDH.pdf.

Ross, Ivan, 2013, 'Digital ghosts in the history museum: the haunting of today's mediascape' in *Continuum: Journal of Media and Cultural Studies* 27(6): 825–36.

Rowe, Shawn M., Wertsch, James V. and Kosyaeva, Tatyana Y., 2002, 'Linking little narratives to big ones: narrative and public memory in history museums' in *Culture and Psychology* 8(1): 96–112.

Russo, Angelina, 2012, 'The Rise of the "Media Museum"' in Giaccardi, Elisa (ed), *Heritage and Social Media: Understanding Heritage in a Participatory Culture*. London and New York: Routledge.

Russo, Angelina, 2011, 'Transformations in cultural communication: social media, cultural exchange, and creative connections' in *Curator: The Museum Journal* 54(3): 327–46.

Russo, Angelina, Watkins, Jerry, Kelly, Lynda and Chan, Sebastian, 2008, 'Participatory communication with social media' in *Curator: The Museum Journal* 51(1): 21–31.

Ryan, Marie-Laure, 2013, 'Transmedial storytelling and transfictionality' in *Poetics Today* 34(3): 361–88. Available at http://users.frii.com/mlryan/transmedia.html [Accessed 26 July 2013].

Ryan, Marie-Laure, 2006, *Avatars of Story*. Minneapolis: University of Minnesota Press.

Salen, Katie and Zimmerman, Eric, 2004, *Rules of Play: Game Design Fundamentals* Cambridge, MA and London: MIT Press.

Samis, Peter, 2008, 'The Exploded Museum' in Tallon, Loïc and Walker, Kevin (eds), *Digital Technologies and the Museum Experience: Handheld Guides and Other Media*. Lanham, MD: AltaMira.

Samuel, R., 1994, *Theatres of Memory: 1: Past and Present in Contemporary Culture*. London: Verso.

Sarup, M., 1996, *Identity, Culture and the Postmodern World*. Edinburgh: Edinburgh University Press.

Satwicz, Tom and Morrissey, Kris, 2011, 'Public Curation: From Trend to Research-Based Practice' in Adair, Bill, Filene, Benjamin and Koloski, Laura, *Letting Go? Sharing Historical Authority in a User-Generated World*. Philadelphia: Pew Center for Arts and Heritage.

Sawyer, S., 2005, 'Social informatics: overview, principles and opportunities' in *Bulletin of the American Society for Information Science and Technology* 31(5): 9–12.

Schechner, Richard, 1973 (rev. edn 2000) *Environmental Theatre*. New York: Applause.

Schlereth, Thomas J., 1984, 'Object Knowledge: Every Museum Visitor and Interpreter' in Nichols, Susan K. (ed.), *Museum Education Anthology, 1973–1983: Perspectives on Informal Learning, a Decade of Roundtable Reports*. Washington DC: Museum Education Roundtable.

Scott, David Meerman, 2013 (4th edn), *The New Rules of Marketing and PR*. Hoboken, NJ: Wiley.

Scott, Suzanne, 2013, 'Who's Steering the Mothership? The Role of the Fanboy Auteur in Transmedia Storytelling' in Delwiche, Aaron and Jacobs Henderson, Jennifer (eds), *The Participatory Cultures Handbook*. New York and Oxford: Routledge.

Sennett, Richard, 2013, *Together: The Rituals, Pleasures and Politics of Cooperation*. London: Penguin.

Shaw, Adrienne, 2010, 'What is video game culture? Cultural studies and game studies' in *Games and Culture* 5(4): 403–24.

Shields, David, 2010, *Reality Hunger: A Manifesto*. New York: Knopf.

Silberman, Neil and Purser, Margaret, 2012, 'Collective Memory as Affirmation: People-Centered Cultural Heritage in a Digital Age' in Giaccardi, Elisa (ed.), *Heritage and Social Media: Understanding Heritage in a Participatory Culture*. London and New York: Routledge.

Silva, Fábio, Analide, Cesar, Rosa, Luis, Felgueiras, Gilberto and Pimenta, Cedric, 2013, 'Gamification, social networks and sustainable environments' in *International Journal of Artificial Intelligence and Interactive Multimedia* 2(4): 52–9.

Silverstone, Roger, 1988, 'Museums and the media: theoretical and methodological exploration' in *International Journal of Museum Management and Curatorship* 7(3): 231–41.

Simon, Nina, 2013, 'Thinking about User Participation in Terms of Negotiated Agency'. Available at http://museumtwo.blogspot.co.uk/2013/05/thinking-about-user-participation-in.html [Accessed 26 May 2013].

Simon, Nina, 2012, 'Citizen Placemaker: Nina Simon on Museums as Community Hubs'. Available at http://www.pps.org/blog/citizen-placemaker-nina-simon-on-museums-as-community-hubs/ [Accessed 9 January 2014].

Simon, Nina, 2010, *The Participatory Museum*. Santa Cruz: Museum 2.0.

Singer, J.A. and Blagov, P., 2004, 'The Integrative Function of Narrative Processing: Autobiographical Memory, Self-Defining Memories, and the Life Story of Identity' in Beike, D.R. Lampinen, J.M. and Behrend, D.A. (eds), *The Self and Memory*. New York: Psychology Press.

Sklar, Joel, 2009, *Principles of Web Design*. Boston: Course Technology.

Sloane, S., 2000, *Digital Fictions: Storytelling in a Material World*. Stamford, CT: Ablex.

Smith, G., 2006, *Erving Goffman*. London and New York: Routledge.

Smith, Laurajane, 2006, *Uses of Heritage*. London: Routledge.

Smith, Laurajane, Cubitt, Geoff, Fouseki, Kalliopi and Wilson, Ross, 2011, *Representing Enslavement and Abolition in Museums: Ambiguous Engagements*. New York: Routledge.

Snow, D., Burke Rochford Jr, E., Worden, S. and Benford, R., 1986, 'Frame alignment processes, micromobilization, and movement participation' in *American Sociological Review* 51(4): 464–81.

Sonvilla-Weiss, Stefan (ed.), 2010, *Mashup Cultures*. Vienna and New York: Springer.

Spock, Daniel, 2009, 'Museum authority up for grabs: the latest thing, or following a long trend line?' in *Exhibitionist* (Fall): 6–10.

Spurgeon, C., Burgess, J., Klaebe, H., McWilliam, K., Tacchi, J. and Tsi, M., 2009, 'Co-Creative Media: Theorising Digital Storytelling as a Platform for Researching and Developing Participatory Culture'. Paper at ANZCA09 Communication, Creativity and Global Citizenship. Brisbane, July 2009.

Stewart, Daxton R. (ed.), 2013, *Social Media and the Law: A Guidebook for Communication Students and Professionals*. New York and London: Routledge.

Steyn, Juliet, 2014. 'Vicissitudes of Representation: Remembering and Forgetting' in Kidd, Jenny, Cairns, Sam, Drago, Alex, Ryall, Amy and Stearn, Miranda (eds), *Challenging History in the Museum*. Farnham: Ashgate.

Steyn, Juliet, 2009, 'The experience of art' in *Journal of Cultural Policy Criticism and Management Research* 4(April). Available at http://culturalpolicyjournal.files.wordpress.com/2011/05/juliet_steyn.pdf.

Stogner, Maggie Burnette, 2009, 'The Media-Enhanced Museum Experience: Debating the Use of Media Technology in Cultural Exhibitions'. Presented at Media in Transition 6. Available at http://web.mit.edu/comm-forum/mit6/papers/Stogner.pdf [Accessed 27 May 2013].

Suits, Bernard, 2005, *The Grasshopper: Games, Life and Utopia*. Peterborough, Ontario: Broadview Press.

Swift, Paul, 2011, 'Museums enjoy digital remix' in *Education Review Series* (March). Available at http://www.educationreview.co.nz/nz-teacher/march-2011/museums-enjoy-digital-remix/#.UrBOV43KpmQ [Accessed October 2013].

Takahisa, Sonnet, 2011, 'Review of *The Participatory Museum*' in *Curator: The Museum Journal* 54(1): 111–15.

Tallon, Loïc and Walker, Kevin (eds), 2008, *Digital Technologies and the Museum Experience: Handheld Guides and Other media*. Lanham, MD: AltaMira.

Tan, E.S. and Muller, H., 2003, 'Integration of Specialist Tasks in the Digital Image Archive' in van Oostendorp, H. (ed.), *Cognition in a Digital World*. London: Lawrence Erlbaum.

Taylor, Astra, 2014, *The People's Platform: Taking Back Power and Culture in the Digital Age*. London: Fourth Estate.

Taylor, Paul A., 2013, 'Participation and the Technological Imaginary: Interactivity or Interpassivity' in Delwiche, Aaron and Jacobs Henderson, Jennifer (eds), *The Participatory Cultures Handbook*. New York and Oxford: Routledge.

Terras, Melissa, 2010, 'Digital curiosities: resource creation via amateur digitisation' in *Literary and Linguistic Computing* 25(4): 425–38.

Thomas, Selma, 2007, 'Introduction' in Din, Herminia and Hecht, Phyllis (eds), *The Digital Museum: A Think Guide*. Washington: American Association of Museums.

Thornberg, Robert and Charmaz, Kathy, 2012, 'Grounded Theory' in Lapan, S.D., Quartaroli, M.T and Riemer, F.A. (eds), *Qualitative Research: An Introduction to Methods and Designs*. San Francisco: Jossey-Bass.

Thuman, Neil, 2008, 'Forums for citizen journalists? Adoption of user generated content initiatives by online news media' in *New Media and Society* 10(1): 139–57.

Thumim, Nancy, 2012, *Self-Representation and Digital Culture*. Basingstoke and New York: Palgrave MacMillan.

Turner, Victor, 1982, *From Ritual to Theatre: The Human Seriousness of Play*. New York: Performing Arts Journals.

Ullmer, B. and Ishii, H., 2000, 'Emerging frameworks for tangible user interfaces' in *IBM Systems Journal* 39(3–4): 915–31.

Ullmer, B. and Ishii, H., 1997, 'The metaDESK: Models and Prototypes for Tangible User Interfaces' in UIST '97: Proceedings of the 10th Annual ACM Symposium on User Interface Software and Technology. New York: Association for Computing Machinery.

Undeen, Don, 2013, '3D Scanning, Hacking, and Printing in Art Museums, for the Masses'. Available at http://www.metmuseum.org/about-the-museum/museum-departments/office-of-the-director/digital-media-department/digital-underground/posts/2013/3d-printing [Accessed 29 October 2013].

University of Salford, 2013, *The Imperial War Museum's Social Interpretation Project* report. Available at http://www.nesta.org.uk/library/documents/Academic_report_Social_Interpretation2.pdf [Accessed August 2013].

Vaidhyanathan, Siva, 2005, 'Open Source as Culture/Culture as Open Source' in Brandt, Clemens (ed.), *Open Source Annual 2005*. Berlin: Technische University. Available at http://ssrn.com/abstract=713044.

van Oostendorp, H. (ed.), 2003, *Cognition in a Digital World*. London: Lawrence Erlbaum.

Vergo, Peter (ed.), 1989, *The New Museology*. London: Reaktion.

Voigts, Eckart and Nicklas, Pascal, 2013, 'Introduction: adaptation, transmedia storytelling and participatory culture' in *Adaptation* 6(2): 139–42.

vom Lehn, Dirk and Heath, Christian, 2005, 'Accounting for new technology in museum exhibitions' in *International Journal of Arts Management*, 7(3): 11–21.

vom Lehn, Dirk and Heath, Christian, 2003, 'Displacing the Object: Mobile Technologies and Interpretive Resources'. Paper from ICHIM 2003, Paris, Archives and Museum Informatics Europe.

Walker, Jill, 2004, 'Distributed Narrative: Telling Stories Across Networks' in Consalvo, Mia and O'Riordan, Kate (eds), *Internet Research Annual*. Brighton: Lang.

Walkowitz, Daniel, J. and Knauer, Lisa Maya, 2009, *Contested Histories in Public Space: Memory, Race and Nation*. Durham, NC and London: Duke University Press.

Wardle, Claire and Williams, Andy, 2010, 'Beyond user-generated content: a production study examining the ways in which UGC is used at the BBC' in *Media, Culture and Society* 32(5): 781–99.

Weedon, C., 2004, *Identity and Culture: Narratives of Difference and Belonging*. Maidenhead: Open University Press.

Werbach, Kevin and Hunter, Dan, 2012, *For the Win: How Game Thinking Can Revolutionize Your Business*. Philadelphia: Wharton Digital Press.

White, M. and Epston, D., 1990, *Narrative Means to Therapeutic Ends*. New York and London: Norton.

Widdop, Paul and Cutts, David, 2012, 'Impact of place on museum participation' in *Cultural Trends* 21(1): 47–66.

Williams, Andy, Wardle, Claire and Wahl-Jorgensen, Karin, 2010, 'Have they got news for us?' in *Journalism Practice* 5(1): 85–99.

Williams, Matt, 2013, 'Justin Bieber hopes Anne Frank "would have been a belieber"', *Guardian Online*, 14 April. Available at http://www.guardian. co.uk/music/2013/apr/14/justin-bieber-anne-frank-belieber. [Accessed 15 April 2013].

Williams, P., 2010, 'Hailing the Cosmopolitan Conscience' in Cameron, F. and Kelly, L. (eds), *Hot Topics, Public Culture, Museums*. Newcastle upon Tyne: Cambridge Scholars.

Williams, Raymond, 1976 (3rd edn), *Communications*. Harmondsworth and New York: Penguin.

Winter, Jay, 2013, 'Silence as a Language of Memory'. Keynote presentation at the Challenging Memories conference, 18–19 July 2013. Available at http://www.youtube.com/watch?v=jOCu_qukOfk [Accessed December 2013].

Wispé L., 1987, 'History of the Concept of Empathy' in Eisenberg, N. and Strayer, J. (eds), *Empathy and its Development*. Cambridge: Cambridge University Press.

Witcomb, Andrea, 2003, *Re-imagining the Museum: Beyond the Mausoleum*. London and New York: Routledge.

Woodruff, Allison, Aoki, Paul M., Hurst, Amy and Szymanski, Margaret H., 2001, 'Electronic Guidebooks and Visitor Attention'. Paper from ICHIM 2001. Available at http://conference.archimuse.com/biblio/electronic_guidebooks_and_visitor_attention.

Woodward, Simon, 2012, 'Funding museum agendas: challenges and opportunities' in *Managing Leisure* 17(1): 14–28.

Zapp, Andrea, 2004, *Networked Narrative Environments: As Imaginary Spaces of Being*. Manchester: Cornerhouse.

Zerubavel, E., 2003, *Time Maps: Collective Memory and the Social Shape of the Past*. Chicago: University of Chicago Press.

Zimmerman, Eric, 2004, 'Narrative, Interactivity, Play, and Games: Four Naughty Concepts in Need of Discipline'. Available at http://ericzimmerman.com/files/texts/Four_Concepts.htm.

Index

Page numbers in *italics* refer to figures and tables.

15 Second Place project 80–82, 84
9/11 Memorial Museum 82–84

access 12–13, 133
Ames, M.A. 74
Appadurai, Arjun 17
Arab Spring 60–61
Art Steps 62
audiences/visitors
 active/passive 1, 3–4, 59
 as contributors/participants 10, 27,
 41, 75, *see also* remix; user-created
 content
 as customers 7
 defining 17–18
 development/outreach 7
 differences in 32–33
 expectations 5, 28–29, 93
 experiences 8, 88–89
 numbers 8
 recipients 4–5
 understanding 89–90, 93, 102
aura 4, 66, 120–21
Australian Centre for the Moving Image
 (ACMI) 80–82
authenticity 57, 66–67, 71, 74, 78
authority
 institutional 1, 5, 12, 54, 121, 134
 shared 63, 64, 64–65, 66
 of storytellers 73
authorship 63, 117, 119

Bal, Mieke 73
Barthes, Roland 117
Baudrillard, Jean 6
Baym, Nancy K. 44
BBC 51, 60–61
Belman, J. 112–13
Benjamin, Walter 4, 120–21

Bennett, Tony 18, 74–75
Besser, Howard 63

Bidwell, Nicola J. 80
Birmingham Museum and Art Gallery
 37, 47, 48
Bishop, Claire 11
Black, Graham 8
Blagov, P. 78
blogs 31, 37, 51
Bogost, Ian 113
boundaries 12, 26
 amateur/professional 62–64
 authenticity/quality 65–67, *66*
 grassroots/top-down 64–65
 open/closed 67–68
Bourdieu, Pierre 7
Brabham, Daren 64
Bradburne, James 3, 9, 34, 75, 89
bricolage 122
British Library, London 33, 47, 51, 52, 127
Brooker, Will 40
Brooklyn Museum, New York 63, 126
Brunel, Isambard Kingdom 31, 32
Burch, Alexandra 89–90, *90*, 93

Cairns, Susie 126
Canadian War Museum 111–12
Cardiff Story 35, 37, 38, 51
Cariou, Patrick 131
Carpentier, Nico 10
Carr, David 41
case study sites *24*
Caswell, Michelle 129, 130, 132
Center for the Future of Museums
 (CFM) 9, 29
challenges, institutional 14–16, 39–40,
 129
Charles, Alec 111

Cherry, Rich 127–28
children 92–93, 99, 100, 107
Chris, Cynthia 17, 117, 128
Christen, Kimberley 133
Ciolfi, Luigina 8
Clarke, M.J. 38
Click! exhibitions 63
co-location 33–35, 51, 68, 122
collective memory 77, 84–85
commons 118, 127–28, 133
communication 4
 see also social media
community 5, 6, 44, 50, 55, 64
conflict 15, 44, 103
control 11–12, 60, 64, 106, 130
Conway, Martin 73, 78
Cooke, Bill 13, 14
copying 120–21
copyright 117, 118, 120, 127, 129–131
crowdsourcing 64–65
Culture Shock! project 77–80, 84
'Curate Your Own' project 64

Davidson, B. 93
democratisation 5, 10, 11, 44–45, 74–75
Deuze, Mark 121
Dewdney, Andrew 2, 17, 19
Dibosa, David 2
Dicks, Bella 121
Dierking, Lynn D. 28–29, 91, 102
digital media, defined 17
digital memories 75–77
digital narrative archives 76
 case studies 77
 9/11 Memorial Museum 82–84
 Australian Centre for the Moving
 Image 80–82
 Tyne and Wear Archives and
 Museums 77–80
 as collective memory 84–85
 use-value 85–86
digital technology, pervasiveness of 2
Din, Herminia 107
disintermediation 35–36
Dodsworth, Clark 88, 90, 91
Dondi, Claudio 108
Drotner, Kirsten 41–42

Edson, Michael 127–28
education 26–27, 103, 105, 107–8,
 109–10, 114
Egenfeldt-Nielsen, Simon 108
empathy 109–14
empowerment 10, 11, 59
Erll, Astrid 85
Eschenfelder, Kristin R. 129, 130, 132
Europeana 25, 33, 127
externalism 134

Facebook 13, 30, 31, 33, 42
 posts analysis 45–52, *46, 47, 49*
Fairclough, Graham 54–55
Falk, John H. 28–29, 91, 97, 102
Fenton, Natalie 45, 48–49
Feshbach, N.D. 109
Feshbach, S. 109
Finnegan, Ruth 72
Flanagan, M. 112–13
flashbulb memory 82–84
Fleming, Tom 9, 44
Flickr 33–34, 67, 68, 127
Fortugno, Nick 114
Foucault, Michel 1
frame alignment theory 61
Fulford, Richard 72
future predictions 9

Gagosian Gallery, New York 131
games, online 103–4, 114–15
 empathy 108–9, 112–14
 Canadian War Museum 111–12
 Jewish Museum, Berlin 109–11
 Te Papa Museum, New Zealand
 111
 study findings 106–8
 study method 105–6
Gammon, Ben 89–90, 90, 91, 93
Garde-Hansen, J. 75, 76
Geil, A. 74
Gere, Charlie 13, 19
Gerstner, David A. 17, 117, 128
Giovagnoli, Max 35
GO project 63
Goffman, Irving 61
Goggin, Gerard 10
Google Art Project 25, 33, 51, 62, 127

granularity 35–36, 51, 122
ss Great Britain, Bristol 30–32
Gregor, Shirley 107
Grewcock, Duncan 9
Griffiths, Alison 6, 9, 38–39

Halbwachs, Maurice 77
Hamma, K. 129–130
Hargreaves report, UK 131
Hartley, John 5, 122
Heald, C. 93
Heath, Christian 89, 92
Hein, G. 93
Hein, Hilde 8
Henning, Michelle 3, 4, 6, 8, 19
The Hepworth, Wakefield 36
heritage 1–2, 7, 16, 39
Hickey, Samuel 13
Hirsch, Marianne 109
Historic Royal Palaces (HRP), London
 52, 54
Hoggart, Richard 74
Hooper-Greenhill, Eilean 1
Hornecker, Eva 87
Hull, Glynda 8–9
Huyssen, Andreas 76, 85
hyperreality 6–7

immersion 27, 37–38
Imperial War Museums 47, 51
incompleteness 36–37
infrastructures 14–15
Instagram 51, 58, 67
interactives 87–88, 102
 benefits to museums 89
 computer vs. touchscreen 88
 games 105–6
 within museum framework 90–91
 Museum of London case study *95*,
 95–96
 connection to museum narrative
 101–2
 social interaction/social learning
 96–98
 usability/functionality 98–101
 on site observations 91–96
 children 92–93
 computer vs. touchscreen 92

innovation, views of 93
 learning outcomes 92–93
 measuring use-value 94–95
 pacing 93
 positionality 93–94
 social interaction 91–92
 visitor experiences 88–89
 visitor understanding/perception
 89–90
internalism 134
Internet 7–8, 15, 33, 65–66, 85, 134

Janes, Robert R. 9
Jenkins, Henry 11, 12, 25, 26, 26–27,
 39, 120
Jermyn, Deborah 40
Jewish Museum, Berlin 109–11
Jones, Mike 40
Jönsson, Anna Maria 59

Kavanagh, Gaynor 76, 86
Kelly, Kristin 128, 132
Kelly, Lynda 3, 28, 43
Kember, Sarah 17
Kirschenblatt-Gimblett, Barbara 6, 82
Knobel, Michele 118, 119–120, 129
Korn, Naomi 130
Kothari, Uma 13, 14

LaCapra, D. 113
Landy, Michael 122–25
language 51, 83, 100, 119
Lankshear, Colin 118, 119–120, 129
Laurel, Brenda 107
learning 28, 35, 92–93, 96, 106, 107–8,
 109, 114
'Leda and the Marsyas' *125*, 125–26
Lee, Harper 130–31
Lessig, Lawrence 118–19
Leung, Louis 59
Lévi-Strauss, Claude 122
Life after New Media (Kember and
 Zylinska) 17
Lin, Aleck C.H. 107
Lindsey, Bruce 81
Livingstone, Sonia 10, 13, 18
Lobato, Ramon 119
Lynch, Bernadette 15

Magna Science Adventure Centre,
 Rotherham 36
Make History project 82–84, 85
Mandiberg, Michael 57–58
Manovich, Lev 119, 120, 132–33
mashups 117, 118, 124, 125
McAdams, Dan P. 73
McGonigal, Jane 104, 107
McGuigan, Jim 44
McLean, K. 92
McTavish, Lianne 37–38
meaning 4, 7, 36, 61, 74, 120
meaning-making 9, 57, 89
memory 75–77, 84, 109
 see also digital narrative archives;
 personal narratives
Message, Kylie 17
Metropolitan Museum of Art, New York
 125, 125–26
Meyers, Oren 77
Miller, V. 49
mobile phones 13, 33, 34, 80, 93
Mohan, Giles 13
Monroe County Heritage Museum,
 Alabama 130–31
Moretti, Michela 108
Morris-Suzuki, Tessa 12
Morrissey, Kris 68–69
Mosse, David 14
Murray, J. 74
museology, new 1, 6, 74, 75
Museum Bodies (Rees Leahy) 7
museum narratives, defining 29–30
Museum of London interactives case study
 95, 95–96
 connection to museum narrative 101–2
 social interaction/social learning
 96–98
 usability/functionality 98–101
Museum of Science and Industry,
 Manchester 33, 47
museums
 changing context 5–9
 defining 16
 as media makers 3–5
 as object makers 4
 study sample *24*
 as transmedia *see* transmedia museums

Museums, Media and Cultural Theory
 (Henning) 19

National Army Museum, London 13,
 35–36, 53
National Football Museum, Manchester
 36, 47, 51
National Gallery, London 37, 38, 53,
 122–25, *123*
National Media Museum, Bradford 38,
 65–66, *66*
National Museum Wales (Amgueddfa
 Cymru) 33, 53
National Waterfront Museum, Swansea
 33, 36, 38
Natural History Museum, London 65
Navas, Eduardo 133
Neiger, Motti 77
new media, defined 17
New Walk Museum, Leicester 48
Ngā Mōrehu game 111
Nicklas, Pascal 120
norms of remembrance 73
norms of spaces 34–35
Notes from Nature project 65

Olsson, Tobias 60
On Collective Memory (Halbwachs) 77
OPAL project 65
open access 8, 118, 128
'Open Source as Culture/ Culture as Open
 Source' (Vaidhyanathan) 132
openness 43–44, 45, 55, 127, 128
the ordinary 74
Örnebring, Henrik 59
Over the Top game 111–12
ownership 65, 83, 117, 118, 119, 120, 122

Parry, Ross 3, 8, 29, 38, 42, 50, 62–63,
 130
Participation (Cooke and Kothari) 13
Participation (Hickey and Mohan) 13
participation paradigm 10–14
participatory art 65–67, *66*
The Participatory Museum (Simon) 11
People's History Museum, Manchester 36,
 36–37, 47, 51
personal narratives 71–72

democratisation 74–75
and selfhood 72–73
as therapy 83–84
see also digital narrative archives
pervasiveness 33
photo sharing sites 67–68
Pinterest 51, 63
place 80–82
playfulness 37, 38–39, 94, 114, 125
poaching 120, 121
politics 7, 43–44, 45, 120–21
porosity 44
Poster, Mark 74
postmemory 109
power 1, 10, 11–12, 13–14, 40, 86
Prince, Richard 131
Proctor, Nancy 65
Pruulmann-Vengerfeldt, Pille 45
public curation 62–64
publicity 31–32, *32*, 45
Purser, Margaret 85, 85–86

quality 60, 67, 107–8

Rabinovitz, L. 74
Rancière, Jacques 10–11
Read Aloud (Phillips) *66*, 66
Read/Write culture 119–120
Rees Leahy, Helen 6, 7, 28
reflexivity 37, 55
remix 117–18, 132–34
 as creativity 126–28
 as criminality 129–131
 pre-digital age 119–120
 as professional artistic practice
 122–26
 understanding 118–122
Remix (Lessig) 118
representation 74–75
Rheingold, Howard 33, 69
Richard III 48
Richardson, Jim 67
Ride, Peter 17
Rijksmuseum, Netherlands 62, 63, 127
Rijksstudio facility 62, 63
Rose, Frank 103, 106, 115
Rosen, Jay 59
Runnel, Pille 45

Russo, Angelina 3, 54, 57
Ryan, Marie-Laure 73

Saints Alive exhibition 122–25, *123*
Satwicz, Tom 68–69
Save As...Digital Memories (Garde-
 Hansen) 76
Schlereth, Thomas J. 74
Schrøder, Kim Christian 41–42
Scott, John 8–9
selfhood 72–73
Sennet, Richard 14
Shields, David 4, 23, 30, 120, 126
Shivers Down Your Spine (Griffiths) 6
Silberman, Neil 85, 85–86
Silverstone, Roger 3–4, 30, 121
Simon, Nina 11, 15, 50, 65, 92
simulation 6–7
Singer, J.A. 78
smartphones 32, 34, 93
Snow, D. 61
social interaction 91–92, 96–98, 99, 109
 see also social media
social learning 96–98
social media 41–43
 communication, framing of 54–55
 community 44
 democratisation 44–45
 Facebook/Twitter posts analysis
 45–52, *46*, *47*, *49*
 openness 43–44
 publicity 45
 YouTube sample analysis 52–54, *53*
social networking sites (SNS) 41
 see also Facebook; Twitter; YouTube
spaces, museum 3, 33–34, 37–38, 93–94
the spectacular 74
Spock, Daniel 11–12
Staffordshire Hoard 48
Steyn, Juliet 114
Stogner, Maggie Burnette 5
storying 72, 83–84
storytelling, transmedia 23, 26, 34–35
Suits, Bernard 107
Swift, Paul 134

Takahisa, Sonnet 11
Tallon, Loïc 57

Tate Britain, London 33, 52, 53
Taylor, Paul A. 88
Te Papa Museum, New Zealand 111
Titanic Belfast 33, 47
To Kill A Mockingbird (Lee) 130–31
Tower of London 53
training 15
transaction 12
transmedia, defining 25–29
transmedia museums 30–33
 characteristics
 granular and disintermediated
 35–36
 immersive and playful 37–39
 incomplete 36–37
 pervasive and co-located 33–35
 questions and challenges 39–40
Twitter 31, 33, 42, 126
 posts analysis 45–52, *46, 47, 49*
Tyne and Wear Archives and Museums
 77–80
tyranny 13–14

user-created content 57, 61–62
 crowdsourcing 64–65
 defining 57–58
 participatory art 65–67, *66*
 photo sharing sites 67–68
 public curation 62–64
user-generated content (UGC) 57–58
 at BBC 60–61
 claims about 58–59
 and empowerment 59
 moderation 60
 negative associations 59–60
 and place 80

Vaidhyanathan, Siva 132
Victoria and Albert Museum, London
 65
virtual museums 37, 38
Viscovi, Dino 60
visitors *see* audiences/visitors
voice, institutional 54
Voigts, Eckart 120
vom Lehn, Dirk 89, 92
vulnerability 44

Wakefield Museum 64
Walsh, Victoria 2
Wardle, Claire 60
Web 2.0 12, 43
websites 8–9
Wellcome Collection, London 53, 54
What Time Is It? game 109–11
Williams, Andy 60
Williams, Raymond 4, 69, 133
Winschiers-Theophilus, Heike 80
wireless access 15
*The Work of Art in the Age of Mechanical
 Reproduction* (Benjamin) 120
World War I 86, 111–12
Writing History, Writing Trauma
 (LaCapra) 113

Yes, Rasta (Cariou) 131
YouTube 32, 33, 37, 42–43, 51, 127
 sample analysis 52–54, *53*

Zandberg, Eyal 77
Zerubavel, E. 73, 77
Zimmerman, Eric 105, 114
Zylinska, Joanna 17